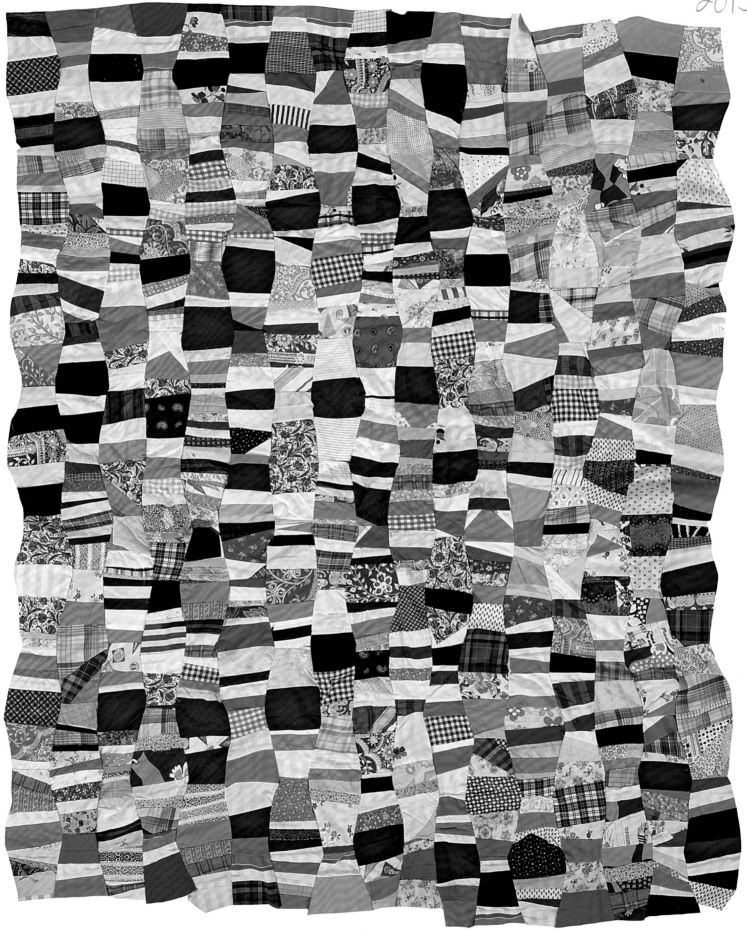

brac
2015

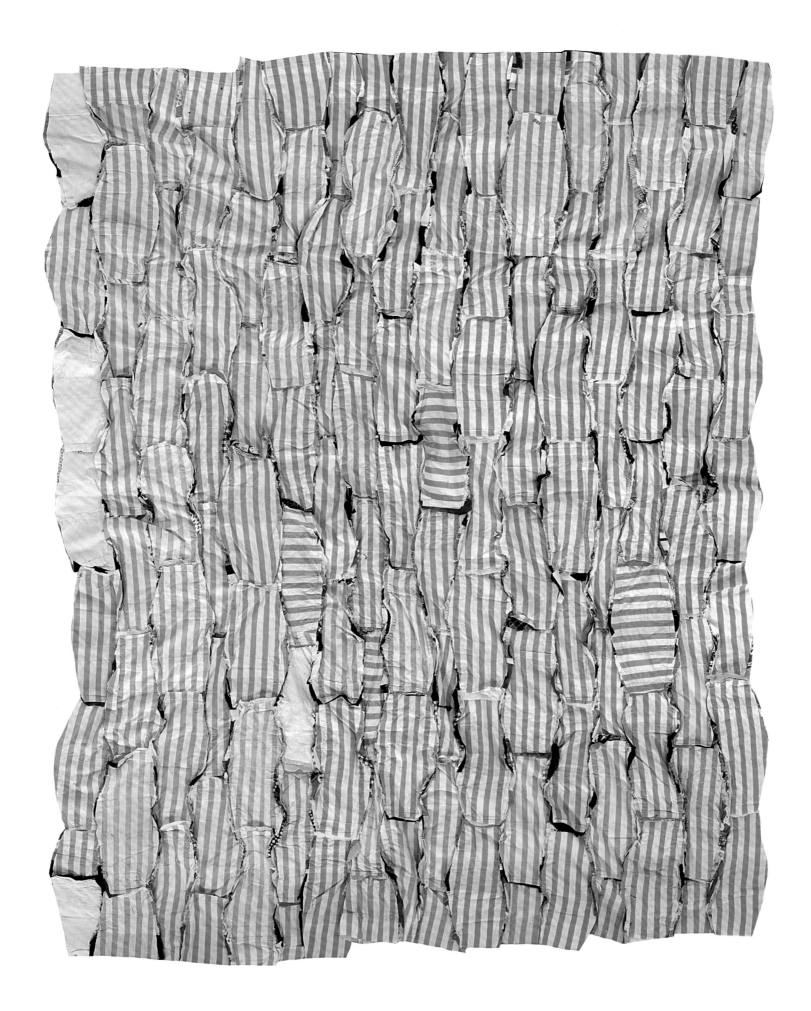

UNCONVENTIONAL & UNEXPECTED

American Quilts
Below the Radar
1950–2000

RODERICK KIRACOFE

STC CRAFT | A MELANIE FALICK BOOK

STEWART, TABORI & CHANG NEW YORK

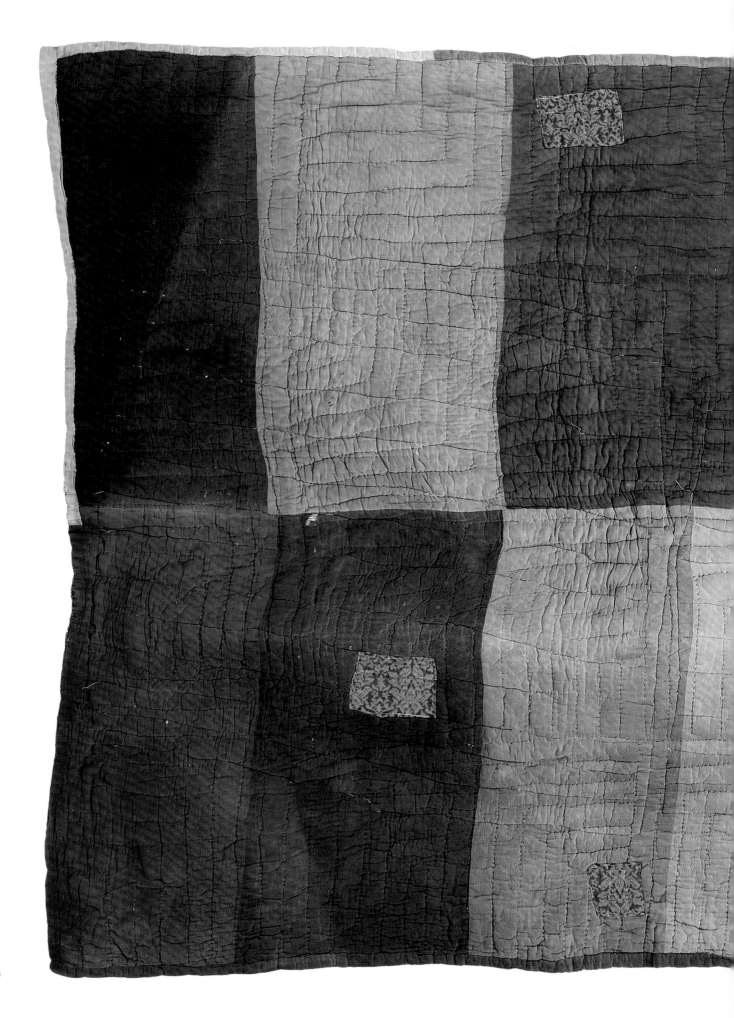

With deep gratitude, this book is dedicated to

Jennifer, Jack, Jason & Raymond

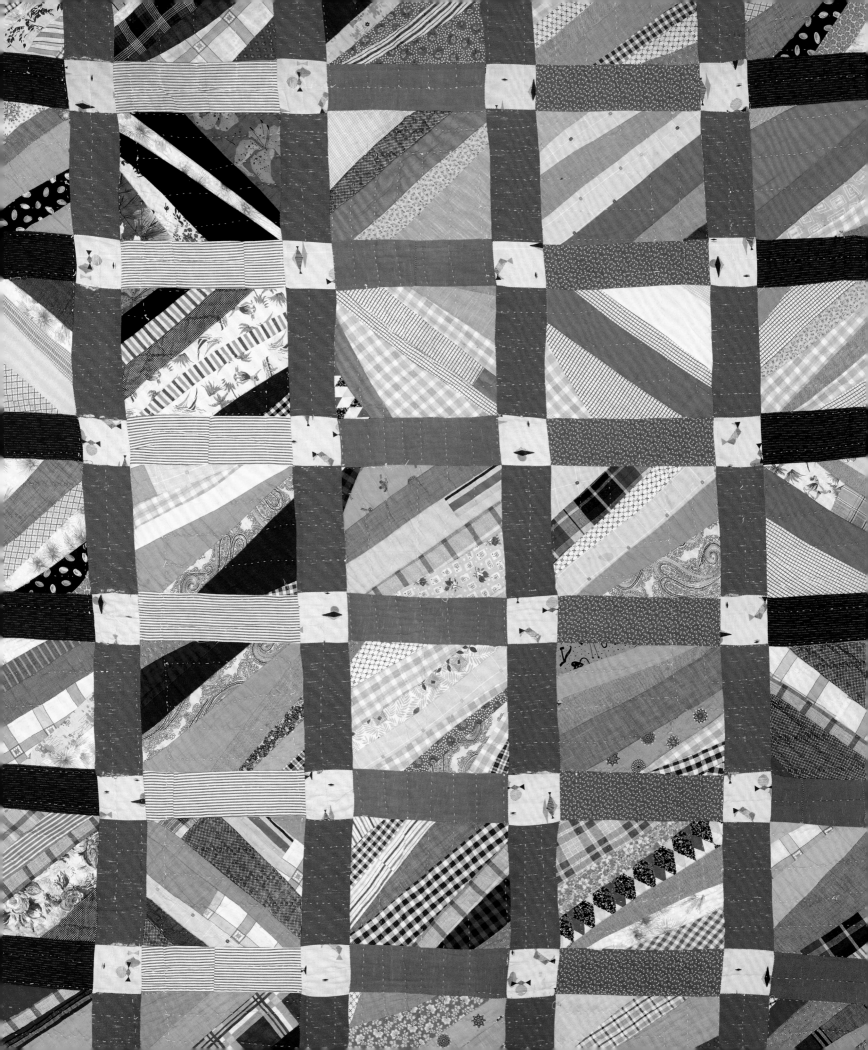

Introduction

At age twenty-one, my girlfriend and I found our way to Los Angeles. We didn't have many things from home but she brought a quilt an aunt in Wisconsin had made and placed it on our bed. While I grew up in the Midwest, this was the first quilt I had ever seen. It was a sweet quilt with pastel colors, plain and printed cotton butterflies appliquéd on a white background, and outline-embroidered with black yarn and a yellow binding. It wasn't an outstanding quilt but I remember being enamored by the idea that it had been handmade by a woman. In some ways, it was a daily reminder of my maternal grandmother and the time I had spent watching her sew as a child and young adult. My girlfriend and I slept under the quilt her aunt had made; it decorated our bed and room; we put it in the washer and dryer; it became worn and ragged and finally began to fall apart. Essentially, we used it up.

The following year I was in the home of a teacher I would be assisting at Pacific Oaks College in Pasadena, California, and was surprised to see a textile hanging on her wall. It wasn't one of the hippie bedspreads I had often seen adorning the beds or dorm room walls of fellow students back in Bloomington, Indiana. Instead, my instructor had chosen to make an unfinished Log Cabin quilt top she had found at a yard sale for five or ten dollars the focal point of her living room wall. Her quilt top was sewn of silks and satins and probably velvet and cotton in dark colors—black, brown, maroon—with some lighter colors sprinkled throughout. At the time, I didn't know the pattern or the materials or that it was unfinished, but what I could appreciate subconsciously was that what she was doing was in some ways subversive. She had taken something destined for a bed and used for warmth and comfort and reimagined it as a piece of art for her wall. Moving the quilt from the surface of a bed to the wall allowed me to consider this art form in a radically new way and the act effectively disrupted my understanding of how I could think about, and interact with, this curious and beautiful object.

OPPOSITE (DETAIL,
FULL CAPTION ON PAGE 91)

Original Design

c.1925–1965

Two years later, another quilt, in a different home, caught my interest. This time, it was at my boyfriend Michael Kile's house in Yellow Springs, Ohio. I had moved back to the Midwest to work as a social worker but my passion for the field quickly dissipated. After visiting country auctions and having long and exciting conversations about quilts and antiques, I noticed that a much more sustainable fire was burning within me and it was for the world of the handmade, the quilt.

A year later, realizing that a quilt business might be a viable enterprise, Michael and I stumbled upon Doug and Jacqueline Eichhorn's space in Centerville, Indiana. Centerville was one of those quintessential nineteenth-century American towns with dozens of small, independently owned shops lining the street. Although these shops and towns pepper the American landscape, the Eichhorn's 150-year-old stone building was different. Inside those stone walls were stark white, gallery walls and lighting one would normally find in a much larger city gallery. The Eichhorns had an eye for the unique and different and they created a serene space where visitors were held in a state of reverence for the treasures they had displayed. I'll never forget their display of tied comforters and quilt tops; these quilts were not perfect but had found a state of perfection in their quirkiness. Michael and I spent hours in their space looking at and examining what they had for sale and eventually the quilts from their walls, channeled through us, found their way to a contemporary art gallery in Los Angeles and to various corporate art collections around the country.

Needless to say, our curiosity went into overdrive and Michael and I drove the four corners of Ohio seeking out dealers and pickers who specialized in finding quilts. We began to establish a network and then extended our search into Indiana. During that time, we went to every farm auction we could find that listed quilts for sale. We touched and unfolded thousands of quilts from a variety of time periods. While we were looking for workmanship and form and construction, we relied on our senses, too. If feelings of joy and excitement rose up within us when a quilt was turned multiple times, we knew we had found something unique and very special.

As our inventory grew and our network expanded, our journey moved from Indiana into Pennsylvania, New York, the rest of New England, and finally a relocation to

San Francisco in 1978. Our lives at the time were not organized by a traditional nine-to-five schedule. Instead, we followed our gut and would move between the worlds of the best dealers in New York City one morning to a picker's home in Pennsylvania later that night, always searching for those perfect pieces.

Once established in California, we began intersecting with the many quilt guilds surrounding the Bay Area, antique quilt collectors across the country, quilt history groups like the American Quilt Study Group, and contemporary quiltmakers. Michael and I began to realize that the conversations happening in the worlds of antique quilts and the contemporary quiltmakers needed to be organized, documented, and published in a single, accessible space. In 1983 we created and published the first edition of *The Quilt Digest*, an annual publication featuring thoroughly researched and well-written articles on quilt history alongside beautifully reproduced images of contemporary and antique quilts.

In each edition of *The Quilt Digest*, I curated a section called "Showcase" that juxtaposed spectacular antique quilts with traditionally made contemporary quilts and quilts created by their makers to be viewed as art objects. Shortly after presenting my first "Showcase," I began receiving letters and phone calls from quilt collectors all over America sharing how surprised and delighted they were to see these juxtapositions and confiding in me that, while they loved antique quilts, they'd never spent much time considering the contemporary quilt movement. Made with the intention to hang on the wall as art, the works of the Art Quilt movement were being made by artists who had left traditional fine art practices and had turned to quilting techniques as their main medium, while other makers were self-taught. It goes without saying that this was an exciting time in the quilt world and I was honored to not only be creating the platform where these two distinct spheres intersected but also participating in and contributing to the dialogue happening all across the country.

In 1971, while hitchhiking around Europe, I came upon an exhibition in Bern, Switzerland, of the work of artist Paul Klee. The curator of the show had organized the exhibition as a chronological survey of the artist's lifetime painting and drawing

practice. I marveled at seeing the developments in his styles, how his concerns and interests shifted throughout his career, and was fascinated by the themes that he returned to again and again. So, when I was approached by a book publisher in 1986 to write the history of America's quilts, the "quilt bible" as they referred to it, I decided to organize it like the Klee exhibition.

Looking at all the other books about America's quilt history in my library, I saw that none of them had imposed a similar organizational structure. Instead, they arranged quilts by type and style and/or patterns or construction, which made it difficult to see the ways in which all of the various visual languages quilters played with evolved in relation to pop culture, and most importantly, the way the cloth that was available at the time found its way into women's hands and into the legacy of the American quilt.

I should note that the general consensus back then was—and to some extent even today is—that the "end" of quiltmaking happened around the 1940s, that no good quilts were made after that. The market accepted this idea, and rarely did any quilts dated 1950 or beyond come to prominence. So, when deciding on the stopping point for *The American Quilt*, I chose 1950, with the idea that someday I might create a follow-up book that explored later quiltmaking, including the second great quilt revival of the twentieth century, which began in the 1970s.

For *The American Quilt*, I sought out quilts that had not been widely published, if they had been published at all, as well as the best examples from the designated time periods from museums and private collections. Suddenly, I felt like I was back in the Midwest tracking down what I was beginning to sense would become a major contribution to the history of a medium that delighted and ignited such curiosity inside me. As the search evolved and I began to narrow my choices, I realized I not only had the opportunity to show examples of the best of both appliqué and piecework techniques with the finest fabrics of the day and most exquisite quilting stitches, but that I also wanted to give consideration and space to the so-called everyday quilts. These are the incredible comforters (tied quilts) and exquisite quirky and improvisational quilts that, while sometimes not perfectly executed, always explode with soul and self-expression. These quilts, the ones America lived

with, had always had a place in my aesthetic but sadly, were still not widely regarded within the walls of cultural institutions and museums as worthy contributions to the narrative of quilt production in America. When *The American Quilt* was published, for the first time the everyday was shown alongside the well revered as an important part of the larger story of quiltmaking.

In the decade after *The American Quilt* was published, I became involved in other creative areas like craft, painting, and photography. I added to my sizable collection of photography and other art objects, helped to establish an arts district in Oakland, California, and learned from and connected with a variety of makers, which I realize now ignited an incredible desire in me to reengage with my own practice of creating new ideas in the larger cultural conversation. One morning, in 2004, I awoke with an intense curiosity and two questions circulating inside my head: What were the "everyday" quilts made from the 1950s to the end of the twentieth century like? And were they even made? Knowing that my friend and highly regarded quilt dealer Julie Silber was buying and selling quilts on eBay, I took my first spin through this contemporary answer to the country auction and my heart started to race. I realized something new had begun and it was time to get to work again.

I immediately told my husband, Jack Eiman, about my discovery and before long the barn behind our home in San Francisco was filling up with what I consider to be some of the most exciting creations of the second half of the twentieth century. These bold, dramatic, and unexpected quilts that were made outside of the circles of the contemporary quilt movement I had featured in *The Quilt Digest* tell a different story than the one that had been told before. These quilts are not precious; they are "real" and were made to be used. In some instances, the makers responded to and extended the visual conversations happening in the "high art" world at the time of their creation, while in other instances they captured not only the feeling and sensibility of a specific time period but also the iconography deployed throughout entire generations.

Did I bend the rules and go outside the intended time frame? Of course. I think most collectors do when they find something too wonderful not to include. Besides,

these quilts break the rules. I knew there were quilts that pushed and broke through boundaries prior to this time period and if a wonderful example came across my path, I chose to include it.

One of the most delightful experiences was opening a box of quilts and realizing that the maker had taken the two-dimensional medium and pushed it into places I had rarely seen in the quilt world. By attaching hundreds of yarn strings to the surface, the maker had effectively pushed the medium yet again and caused me to reconsider the object not as a flat, two-dimensional plane but as a more sculptural entity or three-dimensional object. These revelations would happen time and time again as quilts arrived.

In some quilts we can surmise that the maker started out with a traditional pattern and, for whatever reason, upended the route and swerved down a different path. She either had a different vision of what her quilt ought to look like or she simply allowed the creation to flow through her by happy accident. When I acquired a new quilt I always tried to find out about the maker but, to my disappointment, I was rarely given a name or provenance. Sometimes sellers even wondered why I wanted to know. I was quickly reminded of Virginia Woolf's statement "For most of history, Anonymous was a woman."

During the ten years of gathering this collection—holding, touching, looking at, and sharing quilts with friends and colleagues (in person and online)—I realized that I wanted to finish the conversation I had started in *The American Quilt*. *Unconventional and Unexpected: American Quilts Below the Radar, 1950–2000* is the beautiful result. This time I invited authors, curators, educators, historians, artists, and quiltmakers to view the collection and to contribute essays, and then I organized the quilts around their myriad perspectives. These writers investigate the history of quilts, what they bring to our lives and how they inform us about art and beauty, craft and making, color and surprise. I am incredibly grateful for their thoughtful meditations and excited about the worlds they've opened up for me and I trust will open up for you and for other readers in generations to come. Already these writers have caused me to reconsider what I thought I knew about these quilts

as well as the fantastic cross conversations that are possible between quilts and other visual objects. One of the most unexpected, or rather unconventional, essays is from the San Francisco–based artist and educator Abner Nolan. Instead of writing about an actual quilt, he wrote about a found photograph of a quilt. I've always loved found photos and many of the ones I have collected over the years were taken during the same time period as the quilts shown on these pages. Most of my photos are attributed to anonymous, as are most of the quilts in this book. It was a nice surprise when Abner's essay reminded me that anonymous quilts and anonymous photographs hold unique and similar places in our lives—they both have the ability to save and capture memories, to tell multiple stories, and to inspire the imagination.

For the past forty years, I have existed in that space between seeing quilts on beds and seeing them slowly find their way onto the walls of some of the best cultural institutions in America. Gathering and looking at the quilts in my collection—the majority of which are showcased here—has been, up until now, a personal journey. With this book, I aspire to link that journey with the ongoing story of the evolution of quiltmaking as a form of creative expression and art. I encourage you to really *look;* to allow yourself to see them in a new light. The deeper you look, the more they will reveal.

A NOTE ON QUILT
IDENTIFICATION

For the quilts in this book, I have assigned a pattern name either from Barbara Brackman's Encyclopedia of Pieced Quilt Patterns (considered the most reliable and complete source for quilt pattern names and the companies who produced them), my knowledge of patterns, or what I or the collector from whom it was borrowed chose to call it. Quotation marks (" ") around a pattern name indicate that the name is one I or the collector who lent the quilt assigned to it.

When assigning an age to a quilt I have always been a believer in giving a quilt a minimum twenty- to twenty-five-year range. By the last half of the twentieth century, a woman's scrap bag or fabric "stash" could have the range of fifty years or more of fabrics from which to choose.

If a quilt does not have a "found in" attribution, its origin is unknown. Where possible, I have indicated race and community of known quilters. All quilts are pieced by hand unless otherwise noted. All quilts are from the collection of the author unless otherwise noted. Dimensions are length x width (l x w).

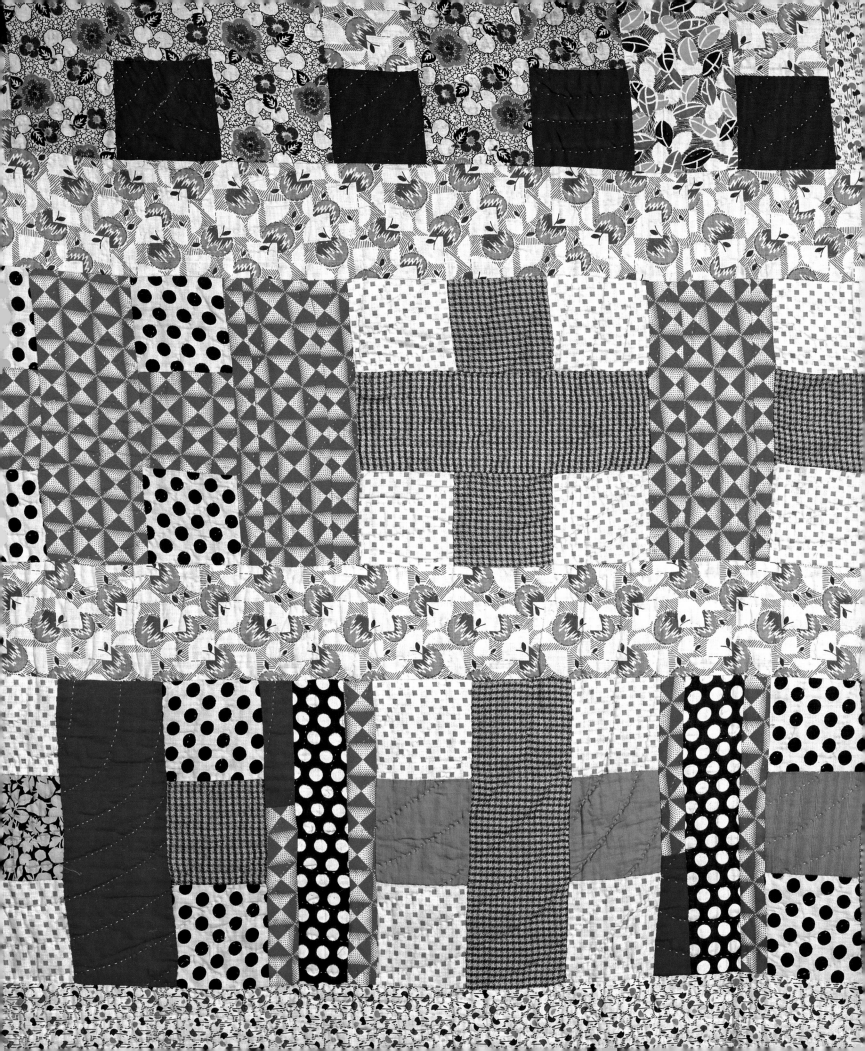

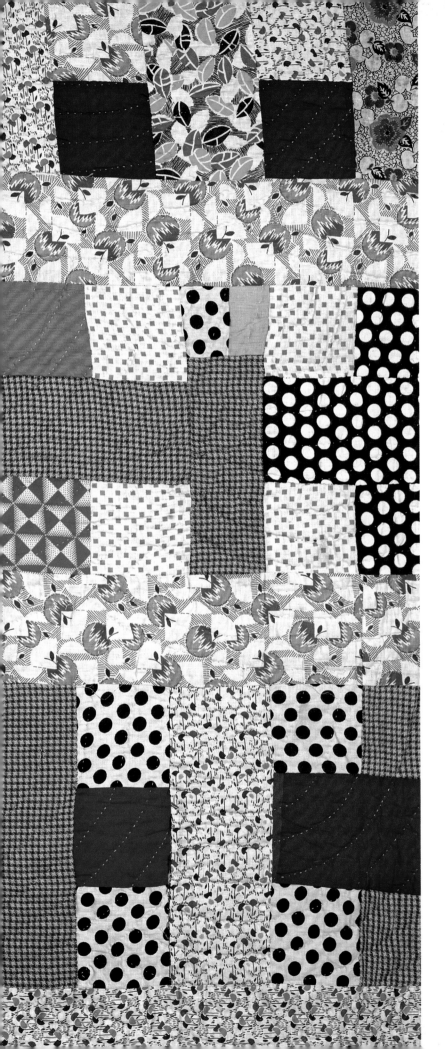

QUILTS
& ESSAYS

17

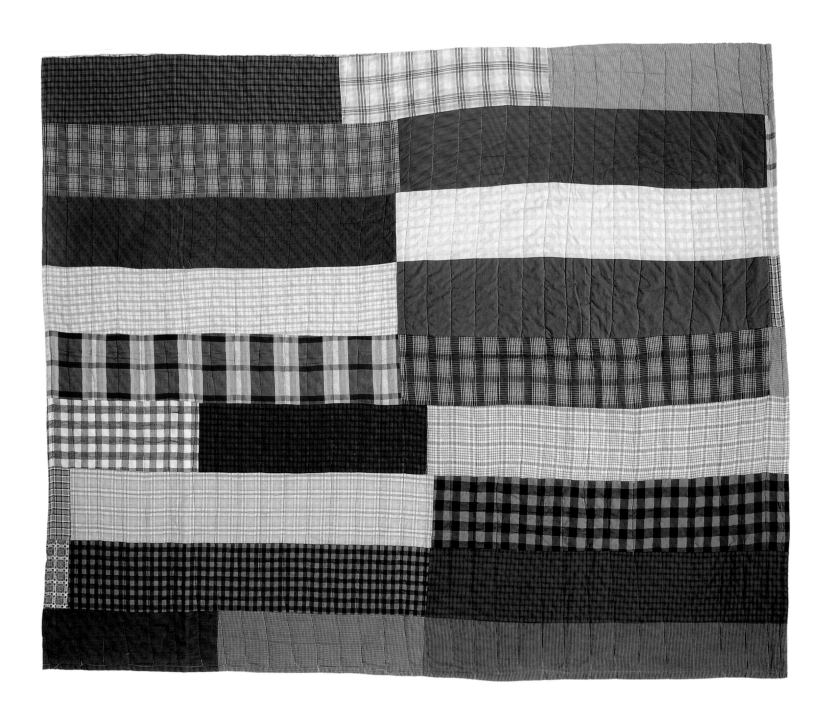

Strips

c.1950–1975

Found in Laurel Fork, Virginia

COTTON. PIECED. MACHINE-QUILTED

69 x 86 inches (175 x 218 cm)

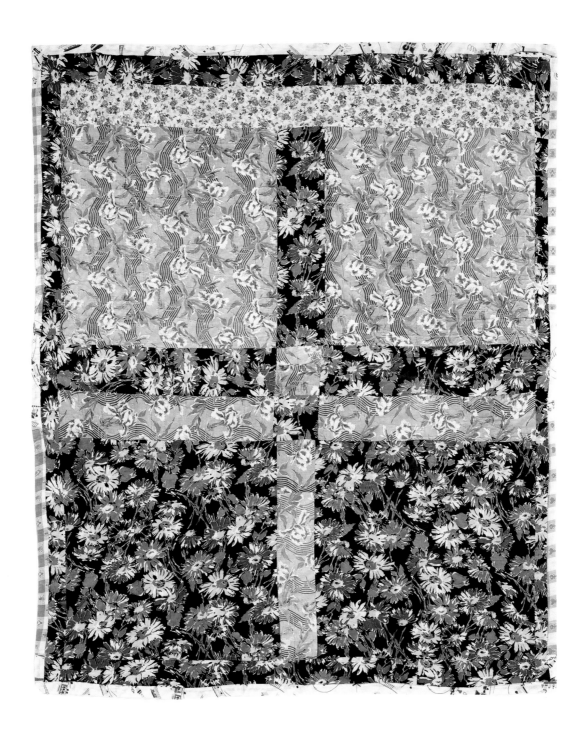

Cross (double-sided)

c.1950–1975
Found in southwestern Arkansas
COTTON
76 x 66 inches (193 x 167.5 cm)

When I first saw this quilt on eBay, I was sure the lighter fabric was sheer and appliquéd over the darker floral print, much like a window with curtains hanging at the top panes. What a surprise to discover that the entire front is pieced of different floral prints! I still see a window scene looking out to a flower garden. The reverse side has a more dominant, pieced cross on it. This motif is a feature of many of the quilts that I was drawn to as I began to form the collection.

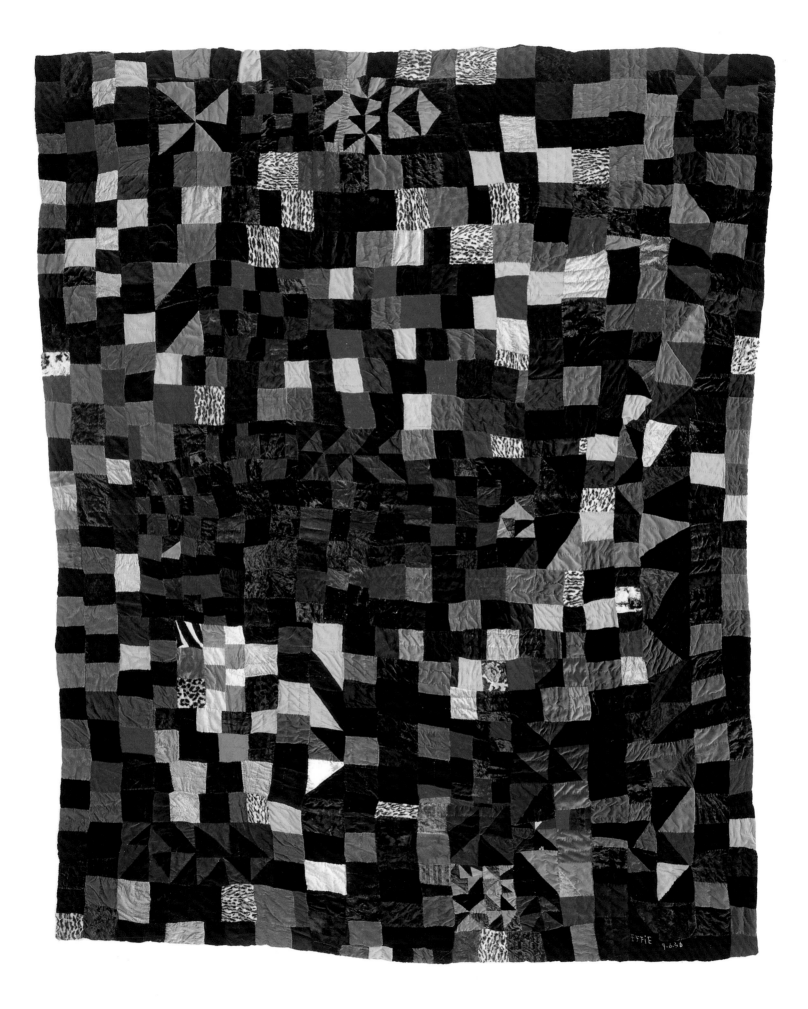

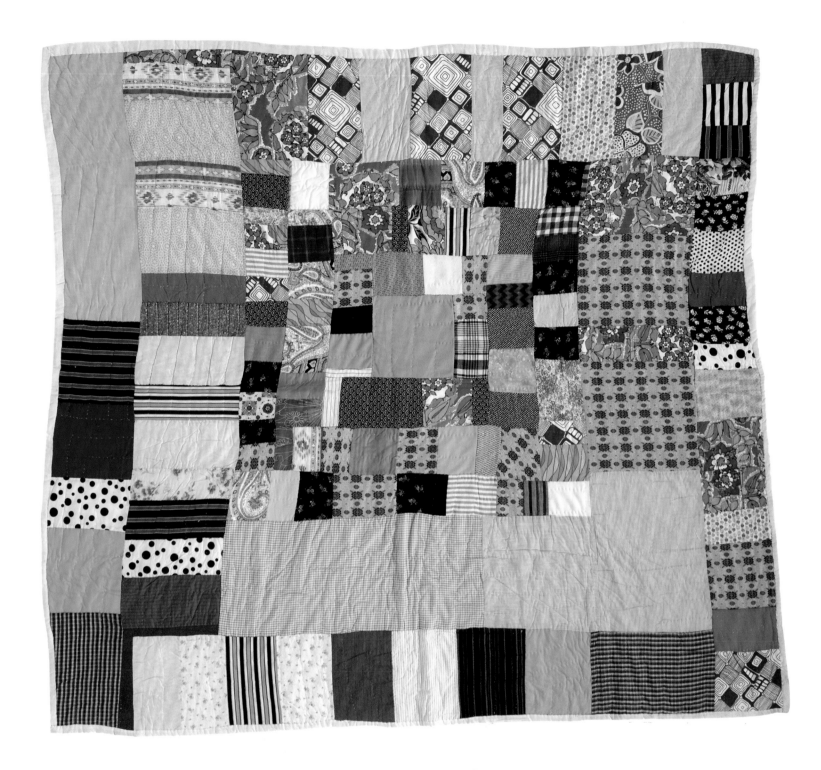

OPPOSITE

"Put-together"

1986–1997

Pieced by Rosie Lee Tompkins (née Effie Mae Howard;
1986). Quilted by Irene Bankhead (1997). African American
VELVET, VELVETEEN, PANNE VELVET, VELOUR, FAUX FUR
"EFFIE 9-6-36" embroidered in lower right corner (Effie's birth date)
95 x 113 inches (241 x 287 cm)
Collection of Eli Leon

ABOVE

Original Design

c.1975–2000

Found in Alabama
COTTON, POLYESTER
70 x 77 inches (178 x 195.5 cm)

21

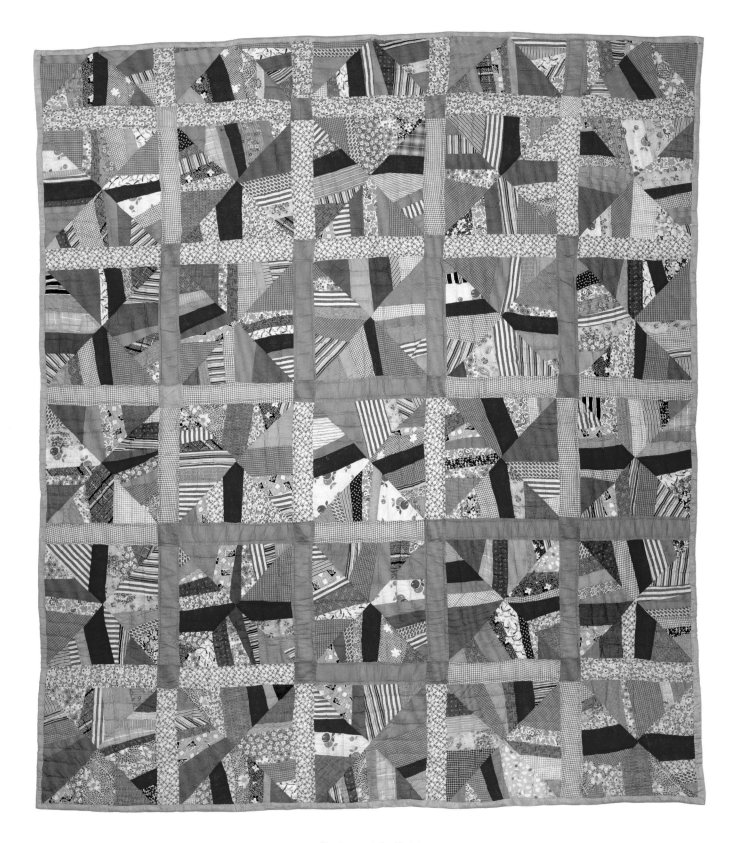

String with Grid

c.1940–1960

Attributed to Mrs. James Shirley.

Found in Fayette, Alabama

COTTON

71 x 78 inches (180 x 198 cm)

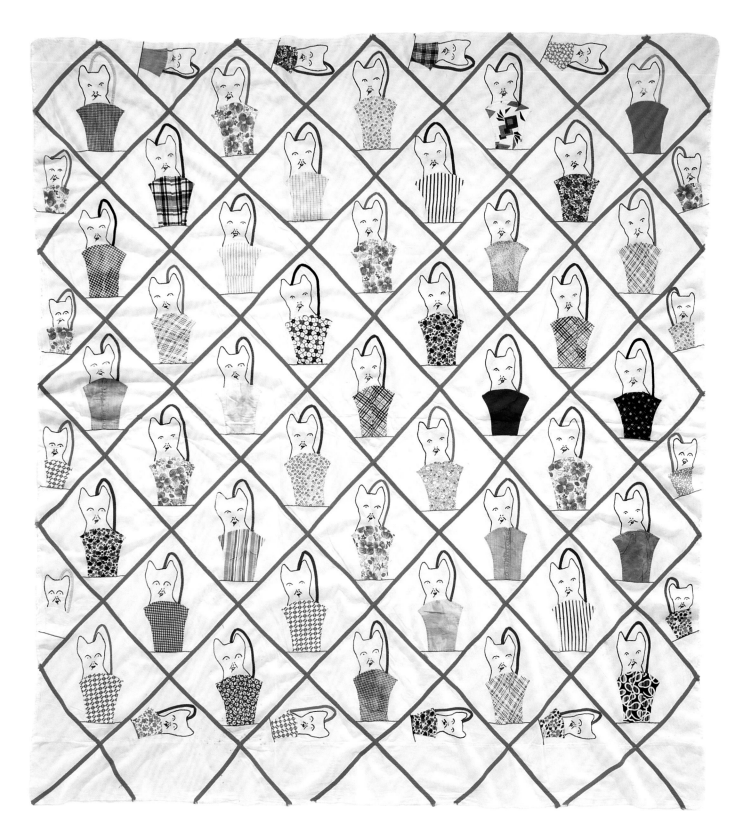

Cat in Basket (unfinished top)

c.1960–1990

Found in St. Louis, Missouri

COTTON. PIECED, APPLIQUÉD, EMBROIDERY.

PINK LATTICE MACHINE APPLIED

82 x 74 inches (208 x 188 cm)

23

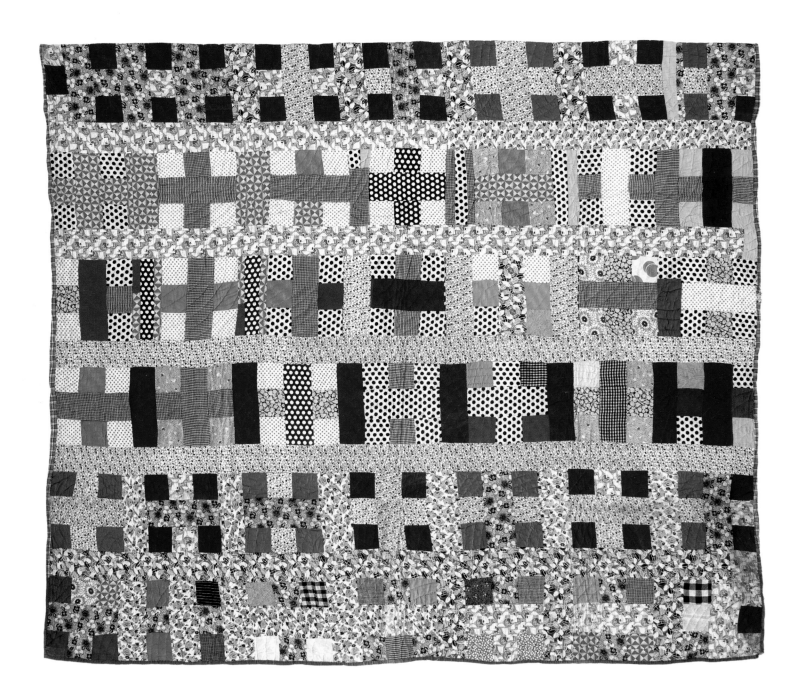

Nine Patch, variation

c.1925–1950

Found in Wingo, Kentucky

COTTON

71 x 84 inches (180 x 213 cm)

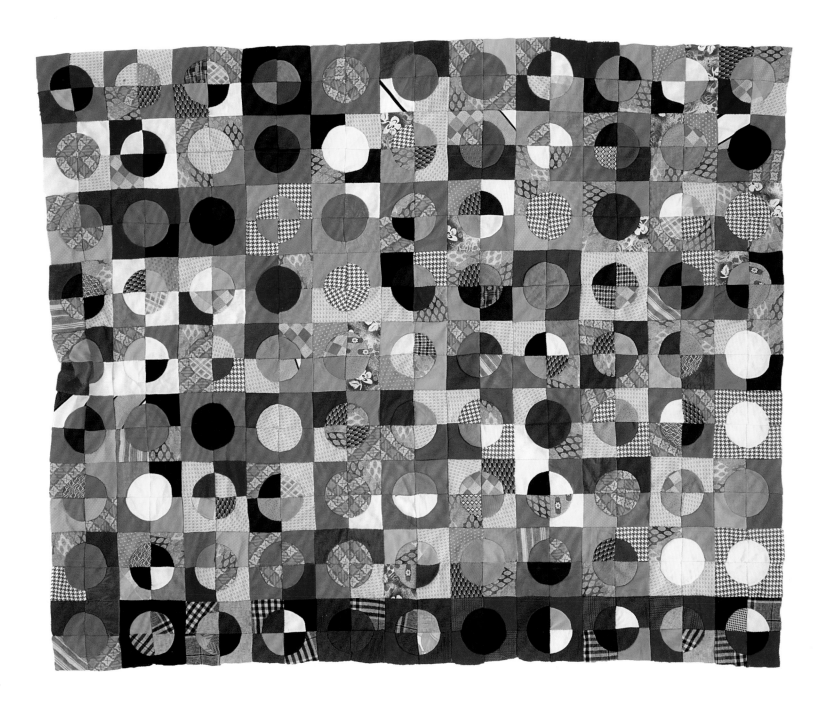

"Circles" (unfinished top)

c.1960–1980
Found in Texas
COTTON, POLYESTER
86 x 70 inches (218 x 178 cm)

The pattern may be Polka Dots, an Aunt Martha published pattern from 1958.

Never Seen a Blanket

NATALIE CHANIN

"Momma slept on the front. Our baby brother next to her. Then my older brother behind him. Me and my twin slept at the foot and our feet went up between the two of them. We had five quilts on top of us to keep us all warm and they was so heavy you couldn't turn over." —Jessie Mangrum, from Stitch: A Documentary Film from Alabama Chanin

THIS IS THE TYPE OF NARRATIVE THAT YOU COULD, and still can, hear from many rural Southern homes, from the mid-nineteenth century through the civil rights era and the Freedom Quilting Bees, until today when we listen to the stories of the Gee's Bend (and other Southern) quilters. These are the voices of people who could only afford to be sentimental if it was also practical.

In small-town northwest Alabama, where I grew up in the 1960s, generations of families and entire communities were raised to work cotton. Whether that meant picking bolls in the unforgiving sun, spinning thread, or sewing garments (by hand or by machine), everyone had some connection to the white fiber with an infamous past. My mother picked cotton in her youth; my grandmother and great-grandmother worked for a time making underwear in the Sweetwater Mills, our local textile mill. In the South, cotton is your birthright, your way of life, your punishment, and your legacy. The type of quilt that hung on your bed, or your wall, told the story of your family and your place in society.

Wealthy families could afford to make whole cloth quilts, rather than patched or blocked quilts. Displaying these quilts not only showed off the beautiful stitch work,

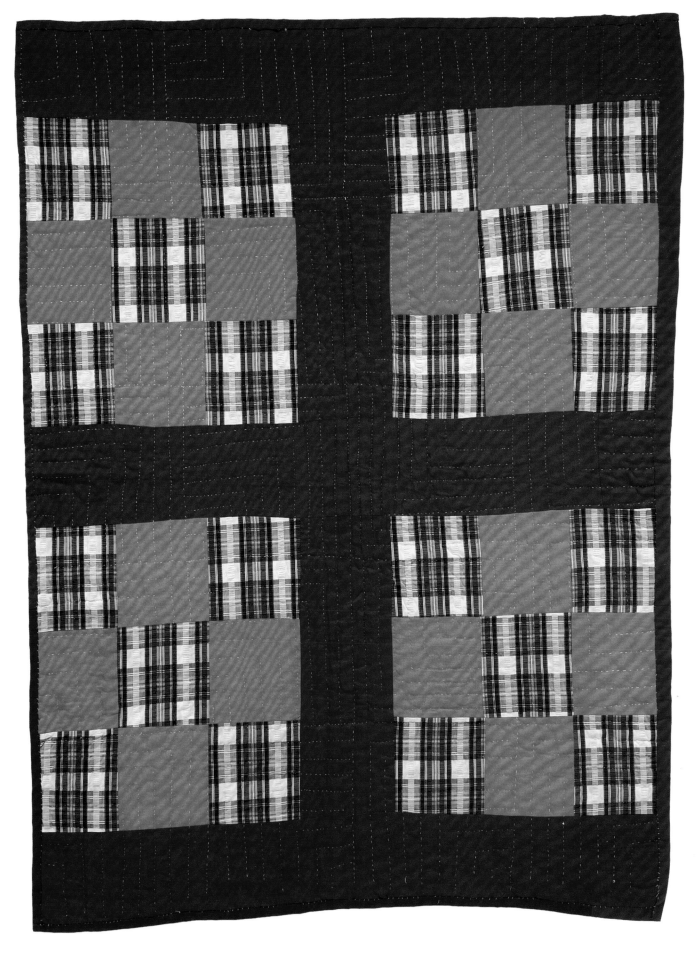

but also demonstrated that you were wealthy enough to buy entire bolts of fabric. Other, less affluent families quilted out of necessity and to demonstrate their strong ethic of frugality. The same Southerners who use "every part of the pig" also use every scrap of fabric for a quilt.

I am fascinated by the women who made the "every part" types of quilts—those who quilted for need more than for beauty, though both craft and beauty are evident in the stitching. While it is possible that a man might sew a quilt, perhaps during wintertime when there were no fields to tend, quilting was primarily a woman's task. The makers of these quilts likely gathered old coats and dresses, feed, sugar, and flour sacks, and tobacco pouches—anything that could be stitched or "scraped" together, or "scarce material" as it was called—for a quilt. These women, like everyone in the family, rose and began work with the sun. In addition to household duties, some worked the company-owned and contracted fields alongside their families or tended the family plots. Quilting was often solitary work, done after meals had been cooked, children put to bed, and cleaning done. It was a work that they looked forward to; these were rare, tranquil moments of solitude and the pieces they stitched painted a picture of what a "scraped together life" looked like. These quilts are a reflection of their love for their families, their pride in their homes, and their skill in making something beautiful out of "making do."

After summer fields were harvested, canning complete, and the work of putting up food for winter months was done, quilt tops could then be stitched together with loose cotton and a simple back during the "quilting bees." These quilting bees, the female equivalent to the all-male barn raisings, existed as a way to help a friend or neighbor complete a quilt, an urgent task if winter was looming. When not preparing a home and a pantry for winter, a working woman could take her time, make small stitches, and create a beautiful quilt that showed off her sewing skills. But, when thinking of a winter to come, that same woman would place less value on the beauty of a stitch than on the quantity of quilts needed to keep her family warm. As host of a quilting bee, a woman would first need to complete the quilt top on her own, which was no small amount of work. A group of women—her friends,

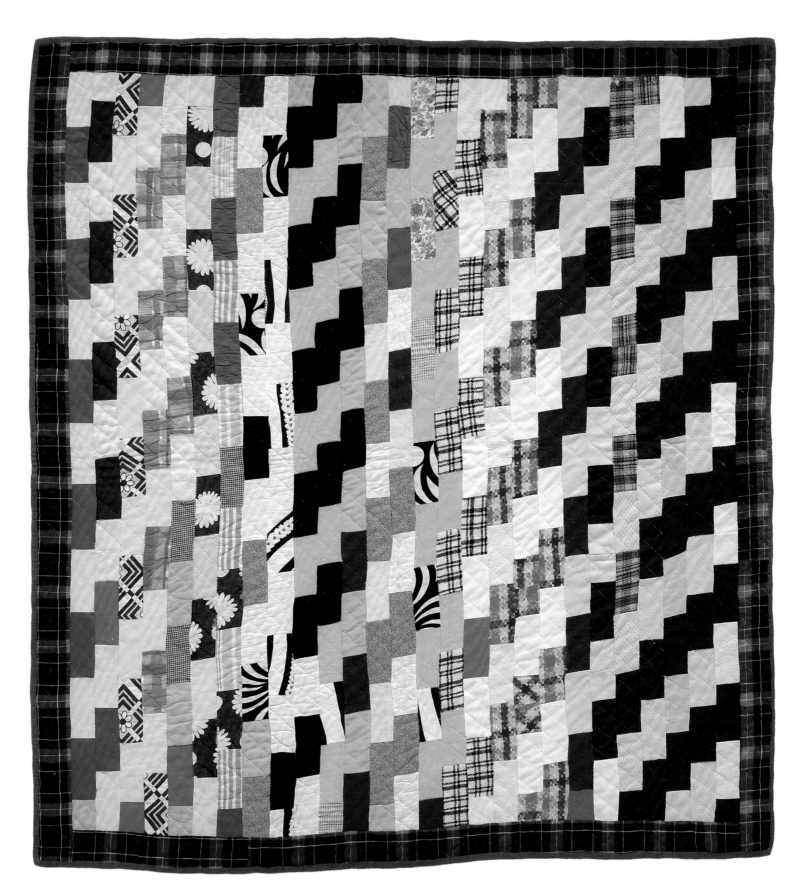

neighbors, church members (the number determined by the size of the room)—would sit around a quilting frame and help complete the quilt, stitching the pieced top to the bottom lining, layering the filling material between the two pieces. If your home and your frame could hold many women, sometimes more than one quilt could be sewn in one sitting.

Quilting bees could be held on holidays or special occasions, like weddings. More women would be on hand for tasks like cooking and arranging the events, while the quilting party would continue in another room. These were outlets for women to socialize, learn the news of the community, gossip, share recipes, and use the power of a group to get more sewing done. These were rare occasions, not frequent occurrences because of the complex lives that these women led, but they were hard-won, treasured days. In rural communities, where a woman could go for days without speaking to another adult woman, events like quilting bees were a woman's respite and a mother's relief as children could play together or help with stitching or threading needles.

The makers of these quilts might be humble at talk of beauty or brush aside compliments given to their quilts, but they were certainly trying to bring beauty and light and color into their homes with each piecing of a scrap of fabric and stitch of the needle. While practicality won the day and the quilts were pieced in such a way as to get the most use out of each scrap of fabric, there is an art of design or what I like to call "living arts." Just the right shade of blue next to a large, yellow-patterned flower tells a story of place. In other words, there is a vernacular to a community, a family, and a home that cultivates a style or skill or instinct and that can be seen when a quilter creates. Those stories are here in these quilts, some never to be deciphered.

Many women who grew up in the rural South said they'd never seen a blanket. On cold nights they would curl up under a stack of quilts, each made from what was available: large burlap sacks or tiny colorful scraps of fabric carried away and stored as a magpie would do. Each block tells a story, important or mundane, about a moment in the life of the maker.

NATALIE "ALABAMA" CHANIN *is the founder and designer behind Alabama Chanin, which focuses on sustainable design, organic materials, community revitalization, and craftsmanship. Her work has been featured in* Vogue, *the* New York Times, Style.com, Elle, *and American* Craft. *She is the author of three books,* Alabama Stitch Book *(2008),* Alabama Studio Style *(2010), and* Alabama Studio Sewing + Design *(2012). Chanin is a member of the Council of Fashion Designers of America (CFDA), which twice nominated her as a finalist for the CFDA/ Vogue Fashion Fund Award (with Project Alabama in 2005 and Alabama Chanin in 2009). The Cooper-Hewitt, National Design Museum selected Alabama Chanin as one of ten fashion companies featured in the 2010 National Design Triennial exhibition, "Why Design Now?" Chanin has made several documentary films, including* Stitch, *a documentary that has been called a "road movie through rural America where the old-fashioned quilting circle represents the road we travel."*

ABOVE

Brick Wall

c.1950–2000

Found in Akron, Ohio

COTTON, BLENDS

MACHINE-PIECED AND -QUILTED

73 x 60 inches (185.5 x 152 cm)

OPPOSITE

Strips

c.1975–2000

Found in southern Louisiana

POLYESTER, SUEDE, UPHOLSTERY FABRICS

HAND-PIECED AND APPLIQUÉD WITH CROSS-STITCHING

85 x 63 inches (216 x 160 cm)

Lattice (double-sided)

c.1920–1925

Possibly Canadian

WOOL, COTTON. MACHINE-PIECED. TIED

78 x 71 inches (198 x 180 cm)

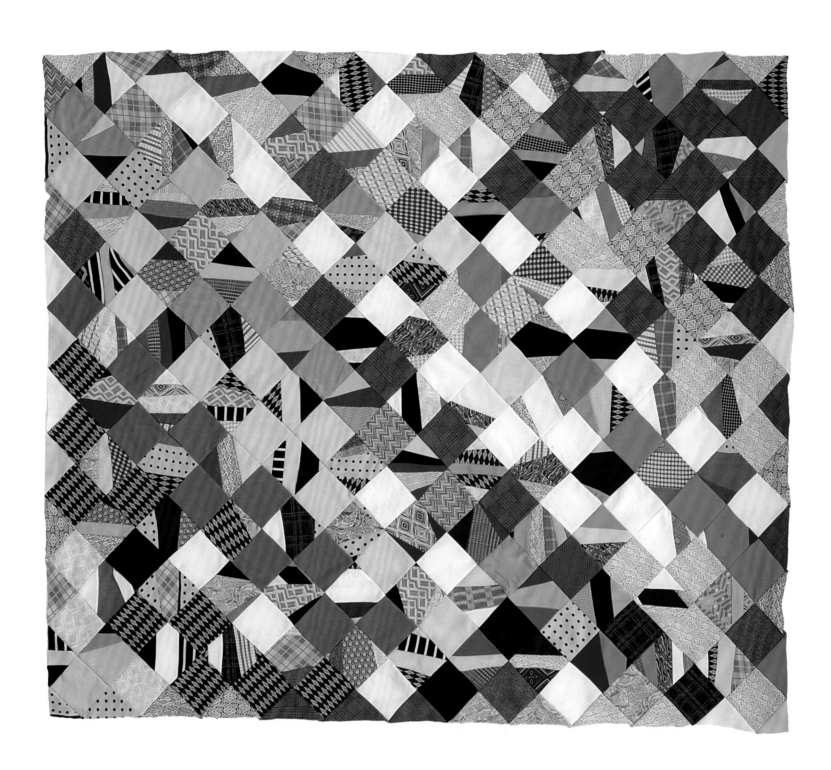

One Patch Diamond (unfinished top)

c.1980–2000

Attributed to a "Mrs. Wilson."

Found in Fayette, Alabama

POLYESTER DOUBLE-KNIT

73 x 84 inches (185.5 x 213 cm)

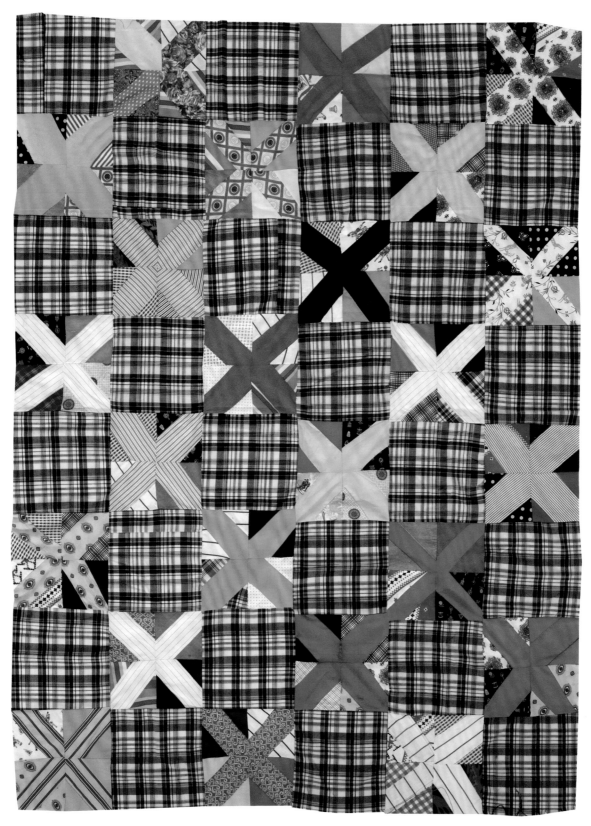

"X" (unfinished top)

c.1950–1970

Found in West Tennessee

COTTON (SHIRTING FACTORY REMNANTS)

91 x 68 inches (231 x 173 cm)

Private collection

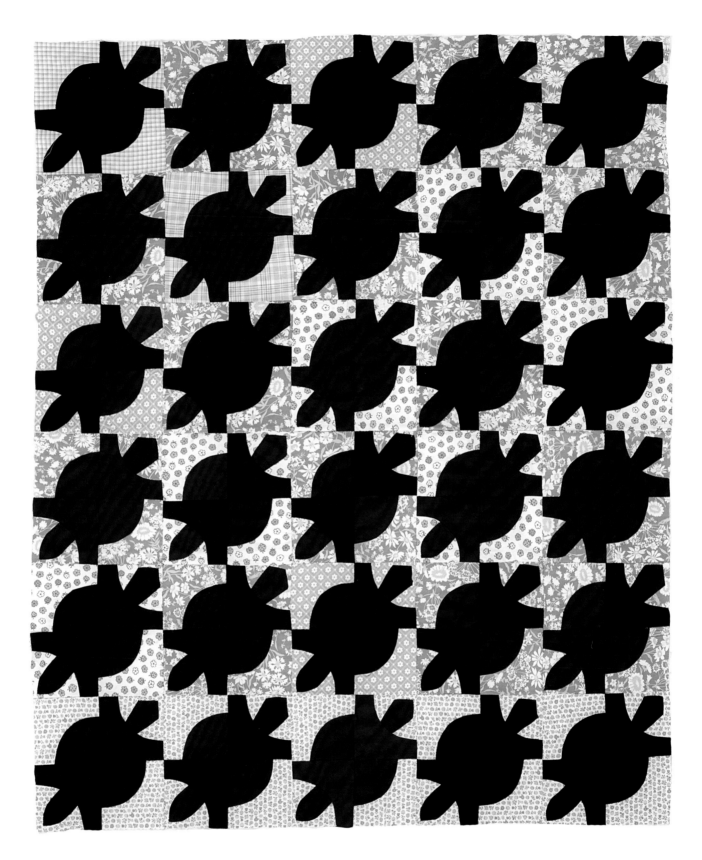

The Terrapin (unfinished top)

c.1960–1980

Found in Alabama

COTTON, BLENDS

82 x 68 inches (208 x 173 cm)

In Dialogue with an Anonymous Quilt

AMELIA PECK

OF COURSE, I KNOW I'M PREJUDICED. But I think textile curators (and especially those who work with quilts) have a harder job to do than many other museum curators.

Fine arts curators usually have the advantage of researching signed works of art. This is a clear advantage in the task of contextualizing a work. The questions they ask of the painting or sculpture that sits before them are, I imagine: "How does this work fit into the artist's oeuvre? How rare is this work? Is it one of the best works by this artist? During which part of the artist's career was it made? Is there anything unusual about it that might make me suspect it isn't really by this artist? Is it in reasonably good condition? How does this artist fit with the other artists who were working at the same time and in the same place that he/she was? How does this painting or sculpture fit into the entire history of art?"

Decorative arts objects put up more of a challenge, but there are still good clues available to silver or ceramics curators, who often have stamped makers' marks to investigate. Furniture curators deal with pieces that are sometimes signed. And furniture history has been intensively studied for at least the past century, revealing regional styles and pointing to certain materials and cabinetmaking techniques that can be used as clues to a piece of furniture's origins.

But now let's think about textiles. For the sake of our argument, and because it's the subject matter that concerns this beautiful book, let's only include handmade textiles for the home such as quilts, not factory-produced yardage. What is the first problem I face when I am presented with a quilt for the museum's consideration? Nine times out of ten (or perhaps ninety-nine times out of a hundred), it is anonymous—there is

no maker's name to associate with the quilt. With no maker's name, and her (or his) accompanying birth and death dates, the date the quilt was made can only be guessed at, using clues such as the fabric with which it was made, or stylistic features. The next question might be: "Where was it made?" In most cases, that too must be guessed at, by searching out other quilts that show distinctive regional characteristics, and hoping that the quilt in question fits into a particular regional group. This is often easier said than done. And to add to the puzzle, in the past quiltmakers rarely had long-term "careers" as quiltmakers, and known bodies of work. In all likelihood, the quilt being examined is a singular artwork, making it still harder to contextualize. On the plus side, questions of a quilt's authenticity rarely arise—it will be a sad day when people decide to forge a valuable quilt.

So when I am offered a quilt to purchase, or as a gift to the Metropolitan Museum's American Wing, what are the questions I ask about it in order to ascertain whether it would be an important addition to our collection? Some are similar to those that might be asked of a painting. "How rare is this work?" is certainly important to me, as the curator of a large and diverse collection of quilts in an art museum. Any quilt I acquire must add something new to the established collection, and be visually interesting as a work of art. Condition is also very important to me. I don't want to bring a quilt into the collection that is too fragile to be exhibited, or in such poor condition that the piece's original appearance is severely compromised.

Assuming I figure out some basics like the approximate date the quilt was made, what it's made of, and maybe even its region of manufacture, what else am I looking for? Looking through the collection of quilts in this book made mostly by makers whose names we don't know, I felt more attracted to some of the quilts than to others. So I decided to use the experience to help define what I look for when thinking about acquiring a quilt. Here are some of the categories I came up with, from perhaps the most obvious to probably the least.

COLOR

Original Design (page 41). It really isn't just the color that makes this quilt so compelling, but it's a place to start. The faded indigo blue dye that colors the work clothes with

which this quilt was made is itself part of the quilt's story. The pieced-together bits of work clothes speak of years of hard physical labor, and though the clothes are now too worn to wear, surely the labor goes on. The leftover scraps of repurposed clothes used to construct the quilt, rather than new colorful fabric, speaks of the poverty of the family who needed this quilt to stay warm at night. And the indigo with which the clothes were dyed was produced in the Americas on large plantations fueled in the seventeenth and eighteenth centuries by African slave labor, bringing further levels of meaning to this quilt made by an African American woman.

PATTERN

The Terrapin (page 37). I've never seen this pattern before, though apparently it was a published, yet rarely used design. I greatly admire the dark silhouettes of the terrapins gliding silently through the flowery green, blue, and yellow water. The strength of these almost threatening black silhouettes—there is something about them that I instinctively associate with bombs or landmines—all swimming in the same direction on patches of light-hearted flowered calico makes for a very interesting dualism.

UNUSUAL FABRICS OR OTHER MATERIALS

String with Grid (pages 193–194). This unfinished quilt top has a spectacular, brightly colored, and well-pieced top, but what may intrigue the viewer more is the back of it, where the pieced squares were worked over cut out pieces of paper from a Sears catalog. The vivid quilt top, with its oranges, fuchsias, and deep greens, is such a contrast from the Sears illustrations of smiling ladies in pastel dresses, their hair curled into fashionable "flips." Although, of course, these papers were meant to be cut out of the completed quilt, the fact they have survived to tell something about the world the quiltmaker lived in, or may have aspired to, add to this quilt top's resonance as a work of art.

HUMOR

Bow Tie, variation (page 42). Maybe it's the tan and white ground fabrics, or the contrast between the center and wings of ties, but these bow ties also remind me of Band-Aids. This was surely not intended, but it still makes me chuckle. Why not

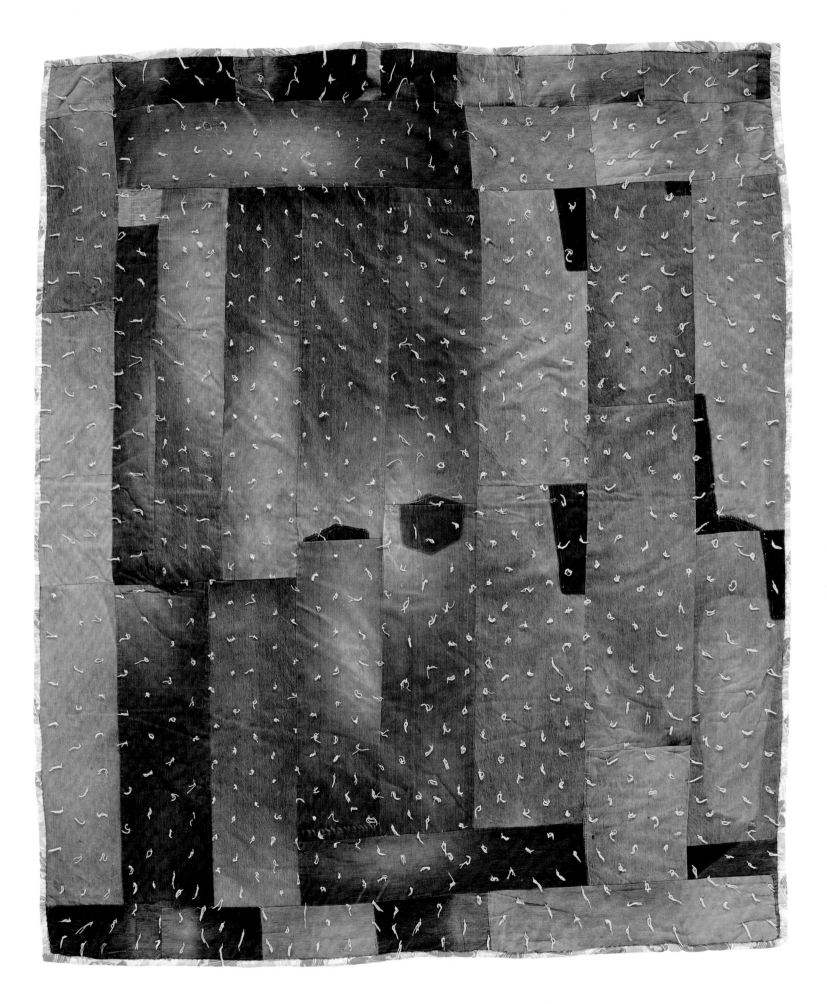

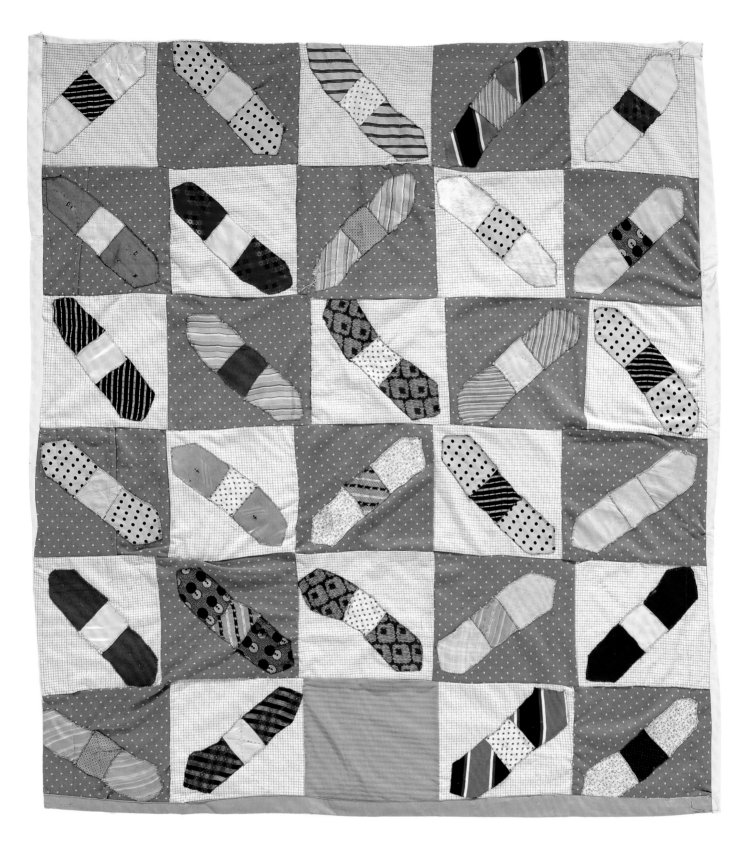

Bow Tie, variation

c.1960–2000

Found in Ohio

POLYESTER, BLENDS, SATEEN, OLD
NECKTIES. PIECED AND APPLIQUÉD

70 x 65 inches (178 x 165 cm)

make a quilt memorializing these everyday objects that patched up many a scrapped knee or cut finger? And what's going on with the mysteriously empty patch at the center of the bottom row?

SURPRISE

String "X" (pages 48–49). At first glance this quilt looks pretty regular, with its repeating motif of diamonds with light centers surrounded by the light and dark blue striped edging. To me it reads more like a diamond patterned quilt than an "X" patterned quilt. Then to break up all that regularity, there is the blue and white striped "X" in the second row that demands the eye's attention with such force that one has to look at the quilt again, beyond the seemingly regular pattern, to all of its delightful irregularity of fabrics and piecing.

Grandmother's Flower Garden, variation (page 181). Like the *String "X"* quilt, this quilt leads us to have expectations of a regular hexagonal "flower" pattern repeat. And then the quiltmaker, Donna Settles, defies our expectations and breaks free of the rigid pattern, making an overall composition that is far more interesting than if the "flowers" simply marched across the quilt in an orderly fashion. I love quilts that speak of creativity, and perhaps even rebellion, rather than just follow the assumed route.

UNIQUE VISION

"Flag" (pages 46–47). Was this quilt really meant to look like an American flag? Or are we just reading that into it? Looking at it makes me wonder if the quiltmaker started by piecing together all those small brightly colored and patterned pieces at the center, and then either ran out of fabric or patience, and decided to just finish it up with the strips of green and white fabric. What was her vision, and what is ours? How uncomfortable are we with abstraction, with no firm pattern name to assign to a quilt?

Oversized Courthouse Steps / Log Cabin, variation (page 56). There is something monumental about this quilt. Though perhaps technically related to a traditional Log Cabin quilt, it has traveled into different realms from those highly belabored quilts. Instead of cozily glowing red hearths at the center of tightly ordered log cabin blocks, in this quilt I see a landscape of two soaring mountains made up of the solid-colored rectangles of brown and black cotton, surrounded by a glowing sky of multicolored prints.

AMELIA PECK *is the Marica F. Vilcek Curator in the Department of American Decorative Arts and Manager of the Henry R. Luce Center for the Study of American Art at the Metropolitan Museum of Art. She is a graduate of Brown University and received her M.S. in Historic Preservation from Columbia University. Her areas of expertise include American textiles and interiors. She has curated numerous exhibitions at the Metropolitan, and is the author/general editor of many books and exhibition catalogs, including* American Quilts and Coverlets in the Metropolitan Museum *(1990, revised ed. 2007) and* Interwoven Globe: The Worldwide Textile Trade, 1500–1800 *(2013).*

INTANGIBLES (I.E., "I DON'T KNOW— IT JUST SPEAKS TO ME")

"Circles" (opposite). I struggled with which category to place this quilt in. It speaks to so many of my interrogations: color, pattern, surprise, unique vision, and intangibles. The fact that the quiltmaker marched boldly ahead with this quilt, despite not having enough of any one color fabric, so used two shades of purple and three shades of green, and finalized the bottom border with a band of yellow paisley printed calico, all just adds to its overall composition. If one imagines this quilt made with fabrics in all one color purple, and all one color green, how much less interesting it becomes.

Nine Patch, variation (page 169). I love this quilt because it reminds me of my childhood. It's as simple as that. I'm sure I had a blouse made of that orange and blue fabric printed with hexagons when I was in the fifth grade. The whole quilt, its color palette and psychedelically distorted nine patch blocks, looks very "Mod" to me—the height of fashion in the late 1960s and early 1970s. That was the era when I first became aware of style and fashion. I would have loved this quilt then and I still love it now.

OPPOSITE

"Circles"

c.1950–1970
Found in Alabama
COTTON. QUILTED
WITH PURPLE THREAD
71 x 62 inches
(180 x 157.5 cm)

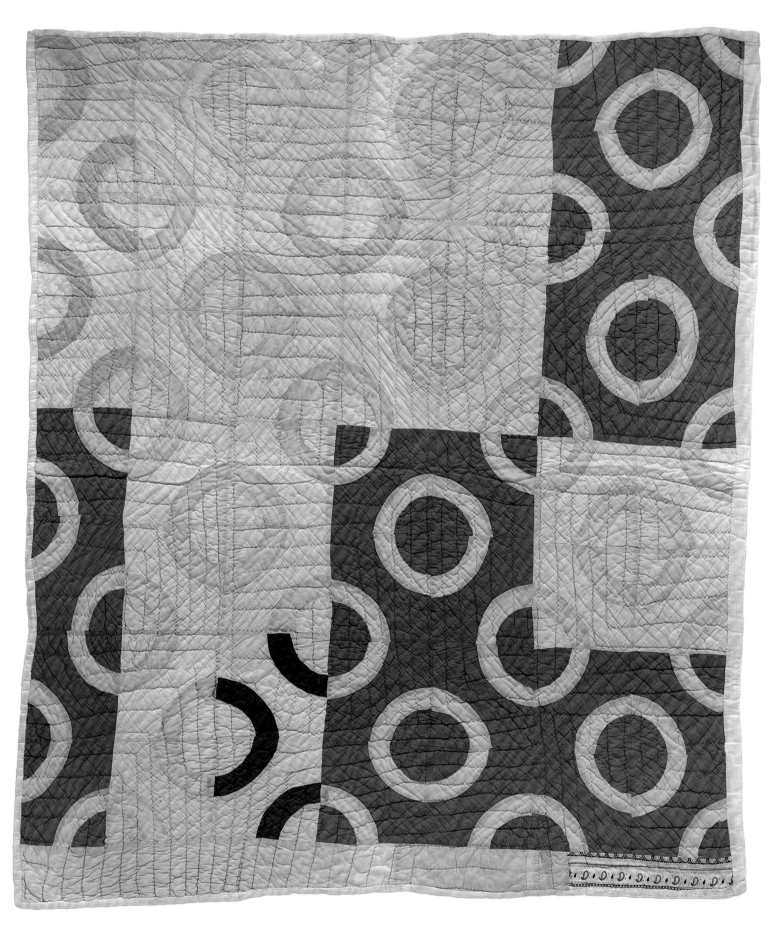

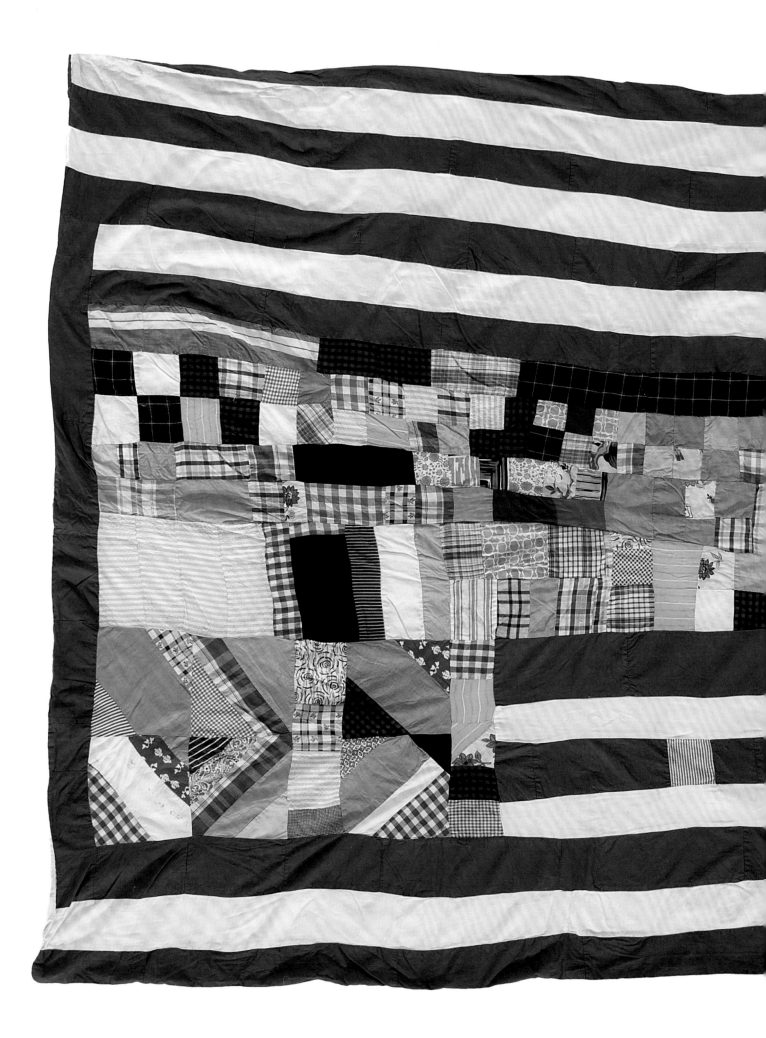

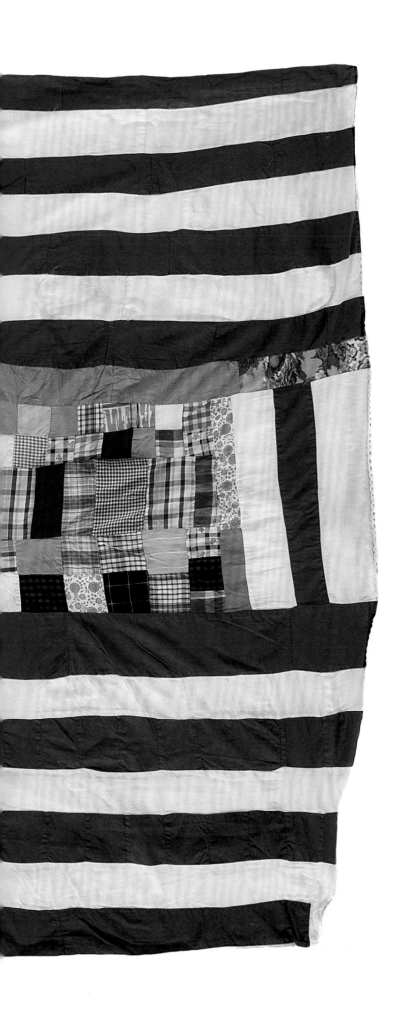

"Flag"

c.1960–1990
COTTON, BLENDS. MACHINE-
AND HAND-PIECED
82 x 67 inches (208 x 170 cm)

Depending on how this quilt (and Stripes by Virgie Walton, pages 70-71) is placed, we get different readings. Presented horizontally and on a wall, it very much has a flag motif quality. Placed vertically, we see it how it might have been seen on the bed if approached from the foot. We will never know the maker's original intentions.

47

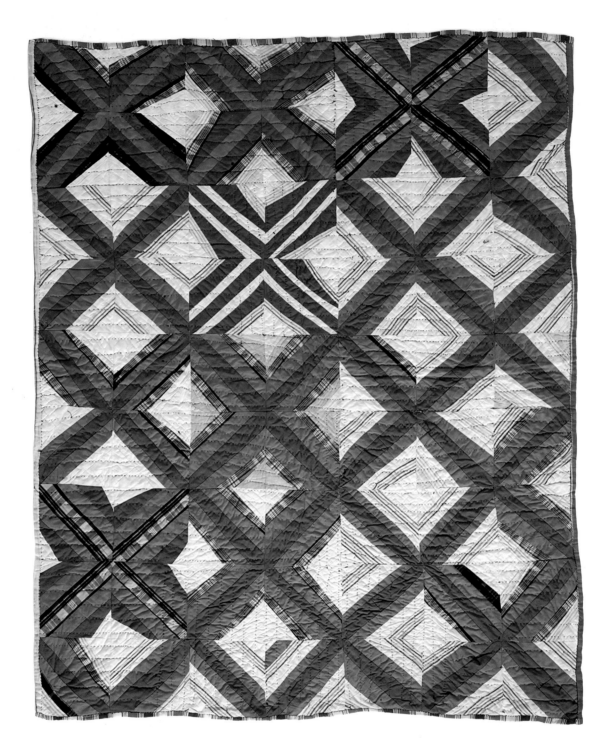

String "X"

c.1950–1975
Attributed to Maggie Townsend.
Found in Goodsprings, Alabama
COTTON. QUILTED WITH BLACK STRING
80.5 x 65.5 inches (204.5 x 166 cm)

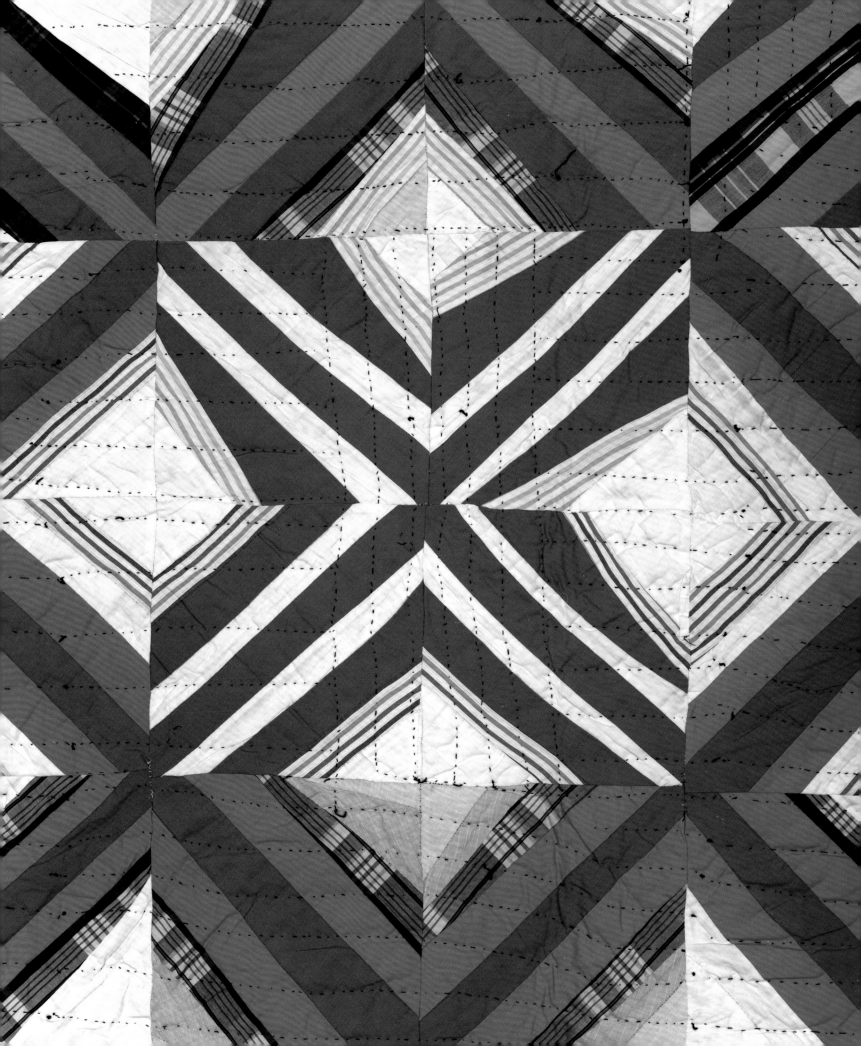

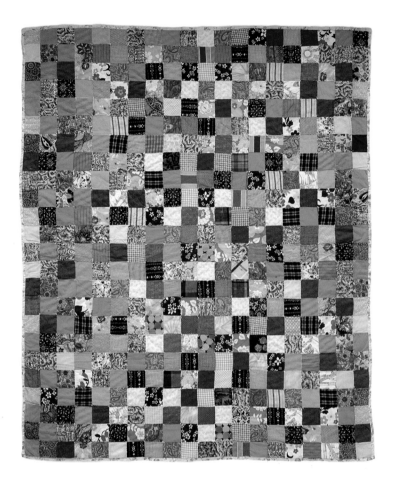

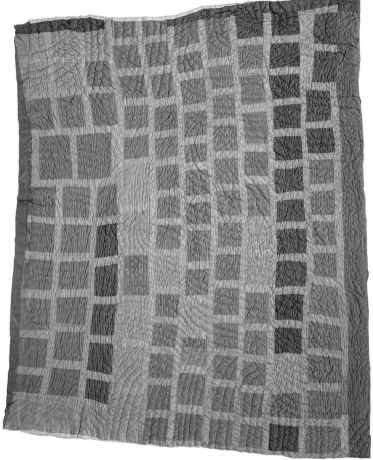

One Patch

c.1975–2000
Found in Texas
COTTON, POLYESTER
MACHINE PIECED. TIED
83 x 99 inches (211 x 251 cm)

"Four-Corner Block"

1987
Florine Taylor. Ozan, Arkansas
African American
COTTON, BLENDS
84 x 68 inches (213 x 173 cm)
Collection of Eli Leon

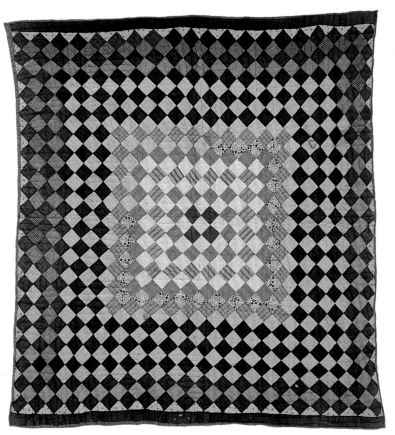

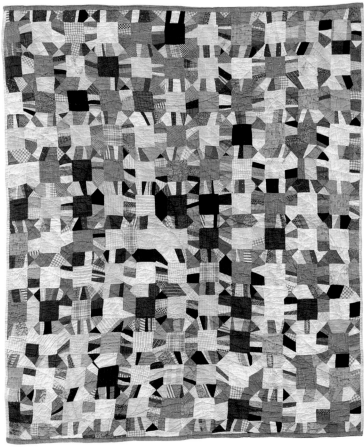

One Patch, variation

c.1920–1950
Attributed to Ina Lois Posey.
Found in Fayette, Alabama
COTTON
79 x 72 inches (201 x 183 cm)

Unknown Pattern

c.1910–1940
Found in Coal City, Alabama
COTTON, FLANNEL
ANOTHER QUILT OR HEAVY
BLANKET USED AS BATTING
77 x 66 inches (195.5 x 167.5 cm)

A Texas Quiltmaker's Life:
An Interview with Sherry Ann Byrd

RODERICK KIRACOFE & SHERRY ANN BYRD

SHERRY ANN BYRD IS A SIXTH-GENERATION QUILTMAKER and storyteller from Freestone Country, Texas. She tells stories through her quilts and on her blog, *Quilts and Stories by Sherry Ann*. Her quilts and those of her family members have been included in numerous museum exhibitions and are an integral part of the renowned Eli Leon Collection. I was delighted when she agreed to take part in an interview for this book.

RODERICK KIRACOFE: *Can you explain the terms* precision quilt, M-provisational quilt, *and* throw together quilt *as they relate to the way you, your family, and your community use them?*

SHERRY ANN BYRD: The precision quilt had the very best and most precise piecing and hand-quilting. These items, which took a lot more time to create, would usually be sold to make income for the family. Precision-made quilts always got the best batting and lining, mostly store-bought in my time, but I have heard stories where relatives who picked cotton or grew cotton would allow the ladies to glean the leftover cotton still sticking to the stalks in the fields after harvest time. This would then be processed to be used as batting in the quilts.

As far as M-provisational goes, I created this word. It is a brainchild of my own imagination plus conversations with my musically inclined husband, Curtis Byrd, Sr. I came up with it when people were deep into categorizing the differences between precise and improvisational quilts and quiltmaking in the 1980s and early 1990s. I was trying to find a way to describe the offbeat, asymmetrical uniqueness of the artworks that we made in my family. I fell in love with the word "improvisation." I loved the sound of it but I felt that the spelling needed to be doctored up a bit since

OPPOSITE

Grid with Prairie Points
c.1960–1985
*Found near Harrisburg,
Pennsylvania*
COTTONS, BLENDS
MACHINE-PIECED
73 x 78 inches (185 x 198 cm)
Collection of Marjorie Childress

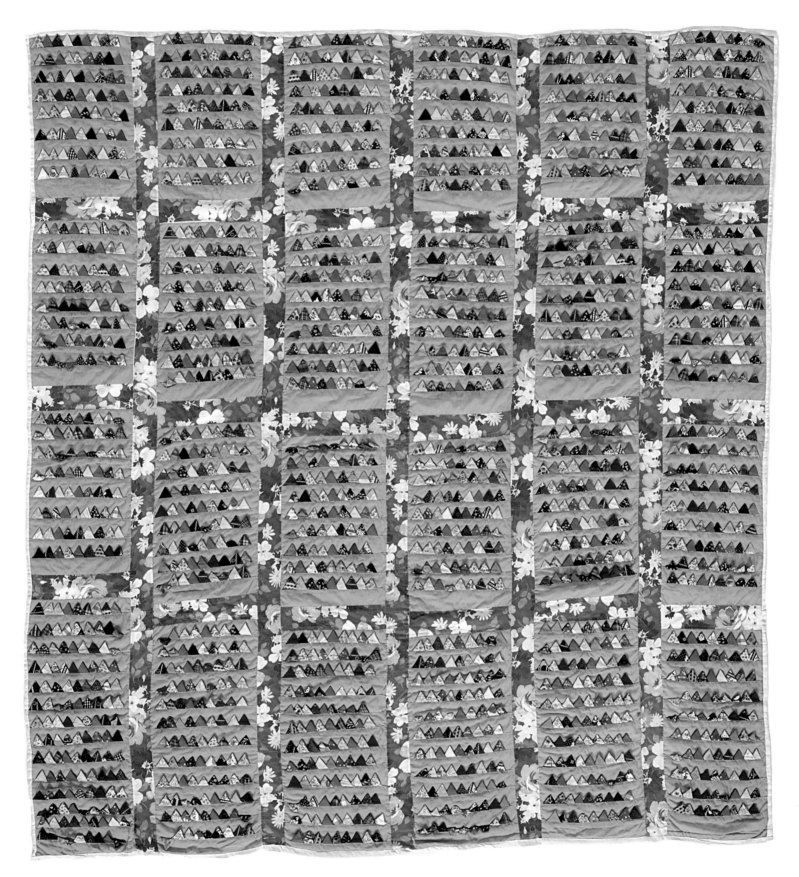

53

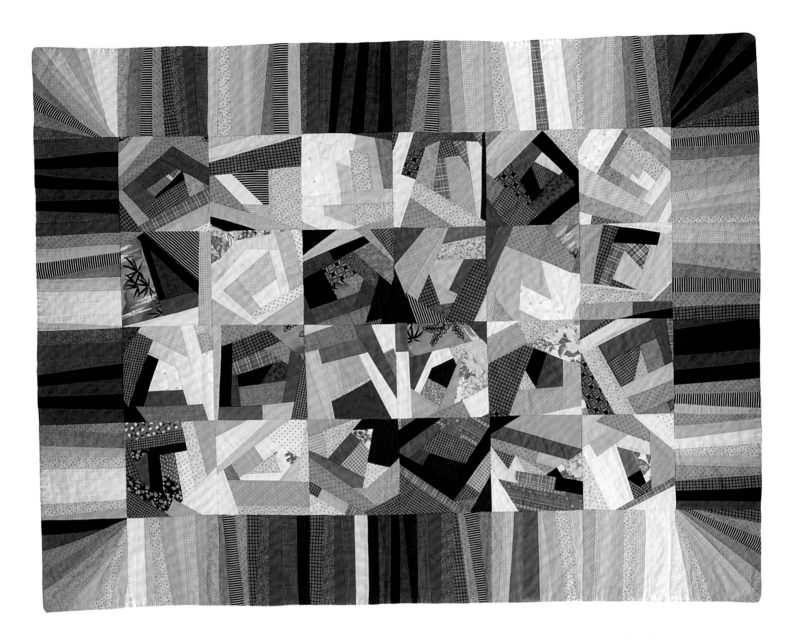

it seemed too stiff, proper, prim, and politically correct to describe quilts that were spicy and off the beaten path. I wanted the word to convey more swagger, colorfulness, and a bit of jazzy bling and slang. I played around with different spellings until I found one that I felt I could embrace as my own.

M-provisational quilts were mostly for family use and on the whole were considered nothing special, but could turn out to be very pleasing to the eye because of the combinations of colors, prints, and types of textiles incorporated into them. Sometimes particularly fancy M-provisational quilts would be given store-bought batting and lining. They were rarely sold, but might instead be given away to a neighbor or someone in need.

Log Cabin, variation
2000
Becky Jacobsen.
Ramona, California
COTTON (CLOTHING PATTERN
SCRAPS)
82 x 62 inches (208 x 157.5 cm)
Collection of Colter Jacobsen

Throw together quilts are the same as put together quilts. The two terms signify a quilt that is created in a relaxed but fast-paced manner, without a lot of fuss or precision. For the most part these are everyday utility-type quilts and are mostly hand-tied to save time. Most of our local families had one to six or more children, so lots of quilts had to be ready to keep them all warm in the winter. Usually two or three quilts, depending on the thickness, were used on one bed. The houses were not insulated. There were lots of drafts and when the wood fires went out at night or the propane was low, everyone hunkered down under the quilts till the morning light. Hand-quilting on them was definitely kept at a minimum, if at all possible. If quilts survived one winter season to the next they were doing well, considering that they were created from textiles and materials that were already quite worn. Roderick,

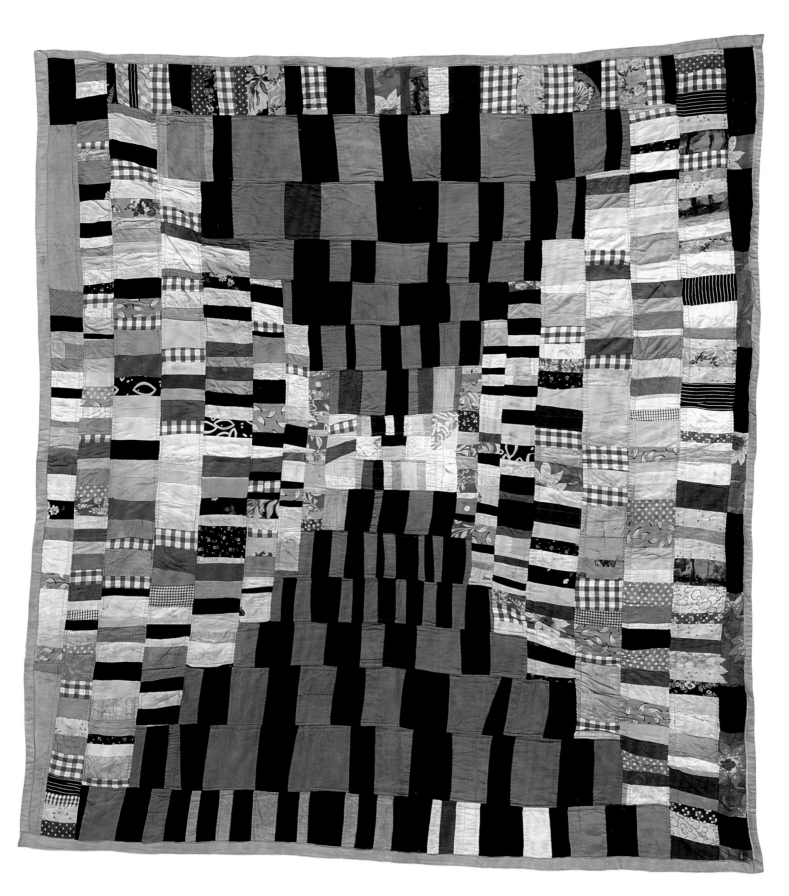

you have quite an extensive array of this type of utility quilt in your collection. These are mostly the types that filled my everyday life when growing up on South Bateman Road in Freestone County, Texas.

RK: *Do you have a favorite quilt among the ones your grandmother made?*

SB: My grandmother, Gladys C. Durham-Henry, or "Big Mama," made more M-provisational quilts than precision quilts. My favorites are her old blue-jean quilts. She would take the old pants that the men and boys wore and turn them into very heavy tied quilts. Big Mama substituted old clothes, linens, and other leftover textiles of various sorts—including other old quilts—for the batting in quilts used by the family. As a child I was fascinated by these types of quilts. Sometimes the seams would pull loose and the insides would start to poke out. I usually made the hole worse because I couldn't resist investigating to see what might be trying to escape from confinement.

The linings (or backings, as they are also called) might also be an old worn spread or bedsheet or a combination of articles sewn together to create a large enough piece to serve as a lining, again as a matter of economics. Reversible quilts might have started from these utility quilts that happened to get a lining that was composed of several articles sewn together to make a whole. The jeans quilt tops were usually constructed with the strip-piecing method. Long and short pieces of pants were sewn together to make a long strip that measured from the headboard to the foot of the bed, maybe with a tuck under the pillows, or all the way to the floor. Then several of these strips would be sewn together to complete a top. Another way to create a jeans quilt top would be the house-top method or log-cabin method that is popular with the quilters of Gee's Bend. But ours were usually straight strips because they were quicker to make. Both patterns produce nice looking tops because the beauty of jeans or work-clothes quilt tops usually lies in the varying shades of coloration where the pants have faded or not. The pockets are just a little extra-spicy and neat treat. My mother, Laverne Brackens, a 2011 NEA (National Endowment for the Arts) Folk-Art Award recipient, still creates stunning blue-jeans and work-pants quilts.

Another one of my favorite Big Mama quilts is a small one-patch square, crib-sized lap quilt top that I retrieved from her estate after she passed away. It is part precision, part M-provisational. She created a small top of regular precision-pieced squares, cut it into two large triangles, and then sewed another piece featuring M-provisational squares right down the middle between them at an angle. I'm pretty sure she was going to do more to this top because at one corner a block was missing, as if she had run out of material to work on it. I later filled in the block and hand-quilted the piece. It was exhibited with other family quilts at the Quilts of Color exhibit at Texas Folk Life Resources in Austin, Texas, in 1999. The pattern is a simple one-patch square. But, oh what a wonderful folk-art piece to behold!

My grandmother is the reason why I chose to make story quilts. When I was preparing to go off to college in 1969, Big Mama was working on a Bible story quilt where you use transfer patterns and paint to apply pictures or drawings of Bible characters to cotton cloth blocks. She had a subscription to *Workbasket* magazine and often ordered craft projects from it or followed instructions from its pages. I wanted to follow in her footsteps. They are very large and eye-popping showpieces.

RK: *You wrote about the Titus family (your maternal family ancestry) speaking "two quiltmaking languages fluently." I'd like to know more about that.*

SB: Only the older quiltmakers in our family lineage did precision piecing. My mother and I are M-provisational quiltmakers. My grandmother, her sisters Katie Mae and Clara, a cousin Amanda Marie (Sweet) Hunter-Titus, and their sister-in-law (and best lifelong friend of Katie Mae) Juanita Louise Henry-Durham could all switch back and forth between the two styles easily. My grandmother, whose extended family of children and grandchildren was rather large, chose to do a lot of M-provisation and tied quilts, because she had to make more quilts in a short period of time, as compared to her younger sister, Katie Mae Tatum, who had no children and no grandchildren. Aunt Katie Mae was free to hand-quilt with leisure and sometimes even took on projects brought to Big Mama, so as to help her out with the heavy demand for her quiltmaking services.

Most of the quilts and tops I own by my grandmother are M-provisational, but quilt collector Eli Leon has a few of her wonderful precision pieces in his collection, including one based upon a crossword puzzle pattern taken from a daily newspaper.

RK: *You grew up during the time period that most of the quilts I have collected were made, but you didn't start making quilts yourself until the 1980s. You've written about the personal tragedy that brought this about. How did the act of making quilts help you through that terrible time?*

SB: I always had this inner desire to be like Big Mama and create beautiful quilts. I was determined to do so, but just hadn't found time to do it. In 1984 our son Micah was stillborn. Everything happened so fast—the pregnancy, delivery, birth, and death—that I could not quite compose myself and get back to my daily routine of taking care of the six children I already had at home. I prayed to Jehovah God to help me find "peace of mind that excelled all the stressful thoughts." Quilting was the answer to this prayer. My thoughts were guided and directed back to Big Mama and how she always seemed to be so calm, peaceful, and composed while sewing and quilting. Her health was not the greatest, and yet she was able to maintain a household (cooking, cleaning, washing, canning, gardening, quilting) and also provide babysitting for her twenty-plus grandchildren on an almost daily basis. I could picture her quietly making quilts and it gradually dawned on me that somehow she took a vacation, organized daily life, and maintained peace of mind, all at the same time—while quilting. I started off with a crib-sized quilt since it seemed less intimidating. Next I moved on to twin-sized quilts for my six children, and finally I created my first full-sized quilt, which I thought was terrible. But my husband, Curtis, fell in love with it and claimed it as his very own. It's now over 30 years old and it still adorns our bed every winter. I have never turned back and now I look for every possible opportunity to create a quilt.

RK: *Your mother learned to quilt from her mother, but she reports in an oral history recording for the* Masters of Traditional Arts Education Guide *that she did not particularly like making them and stopped. She credits you for inspiring her to start making them again.*

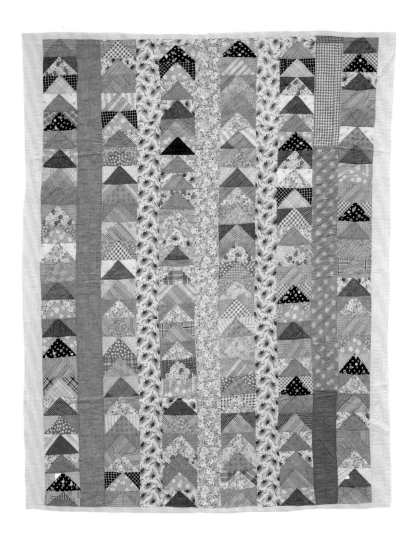

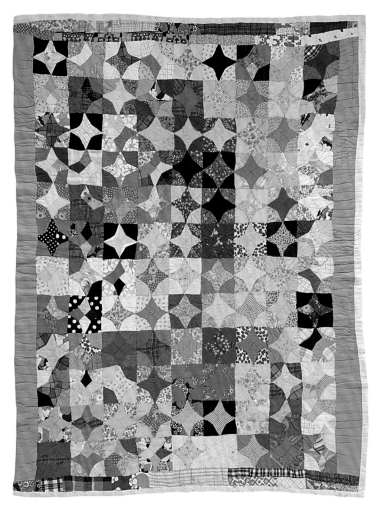

ABOVE LEFT

Flying Geese

c.1930–1950
Found in Illinois
COTTON
66 x 84 inches (167.5 x 213 cm)

ABOVE RIGHT

Hummingbird

c.1950–1975
Found in Arkansas
COTTON
84 x 63 inches (213 x 160 cm)

sb: Mom was among the generation of young women who felt that quiltmaking was outdated. She chose not to practice the craft but instead chose to bring in a paycheck and buy the new store-bought options, such as polyester blankets, to keep her family warm. When my father died in 1964 she was eight months pregnant with six other children to support. She became almost a workaholic, sometimes holding down two or three jobs at a time. Around the late 1980s she was in an accident and was forced to retire. Since then she has been unable to stand for long periods of time. Retirement did not sit well with a woman who was used to being so physically active. She was looking for something to keep her mind and hands busy plus create some income, if at all possible. Quiltmaking filled the slot.

A short time before her accident, I came across a newspaper ad placed by the collector Eli Leon in the *Classified Flea Market*, a supermarket tabloid in the San Francisco Bay

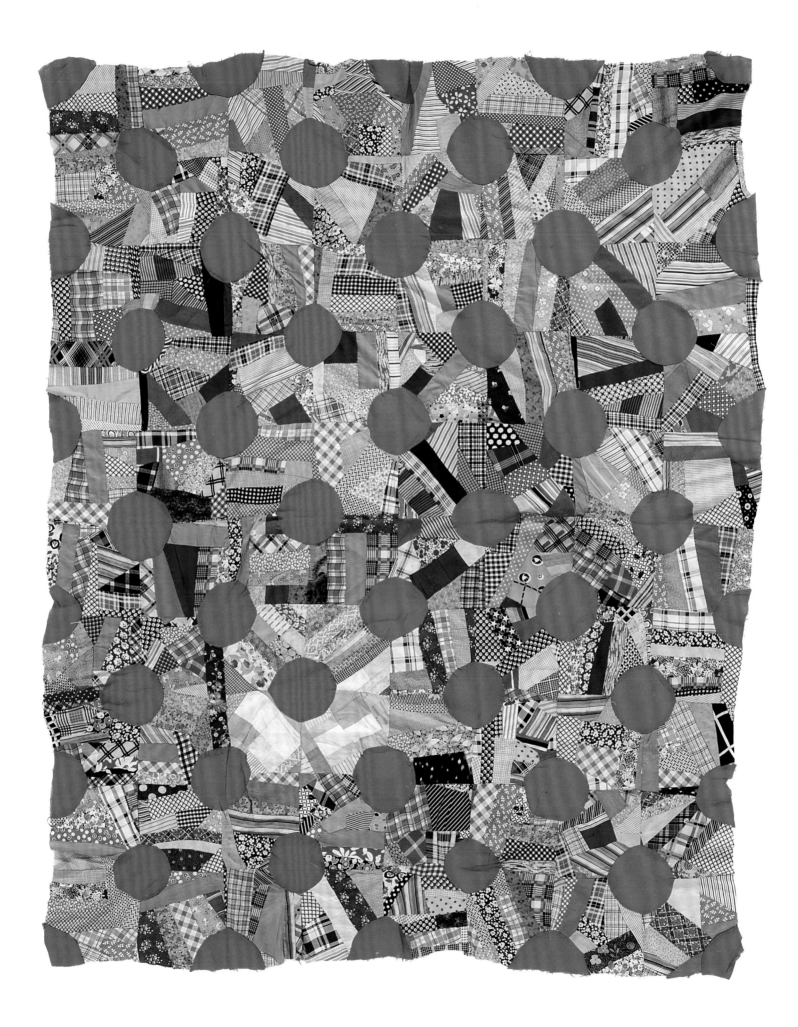

Area (where I was living at the time). The ad simply read "I Buy Old Quilts." I called and the man seemed elated to hear about my quilts and wanted to come by my apartment to view them. He purchased just about everything I had, asked if I would make more, and inquired as to whether I knew other people who still created quilts in the African American community. I did not know of anyone except for my grandmother. The next thing I knew Big Mama and mom were sending quilt tops for Eli to purchase. Once she became convinced that she could sell her quilts and tops for income, there was no stopping her. Eli even made a trip to Texas to meet them personally, and he and my mom still communicate today. A few years ago I did a count on the quilt tops he had purchased from her and the number was approaching the three hundred mark. Since he nominated her for the 2011 NEA Folk-Art Award and she actually received it, she is more dedicated than ever.

RK: *I have used the term* comforter *to describe quilts that have been tied, but I know there are other names used. What did your family call them?*

SB: I truly cannot ever remember even hearing the word comforter while growing up. It wasn't introduced into my vocabulary until I was over eighteen years old and then only in connection with store-bought bed clothing. The covers I was exposed to were referred to as quilts or tied quilts.

RK: *You have lived to see quilts from your family made for and used on beds and then also being hung on the walls of museums. How do you feel about that? What might your grandmother have said if she had lived to see this happen?*

SB: At about the age of eleven or twelve I had picked up information about people who were called collectors who gathered art, quilts, and all kinds of wonderful items for their personal collections. I wondered to myself (never out loud) why quilts were not considered art. They were just as beautiful and fascinating. I think it is a fantastic and wonderful turn of events to have these beautiful folk-art creations accepted for what they really are—art. My older relatives never dreamed that something so fascinating could happen to their humble utility quilts. And though Big Mama never experienced the joy of seeing hers in a museum or gallery, her sister Katie Mae did and she was

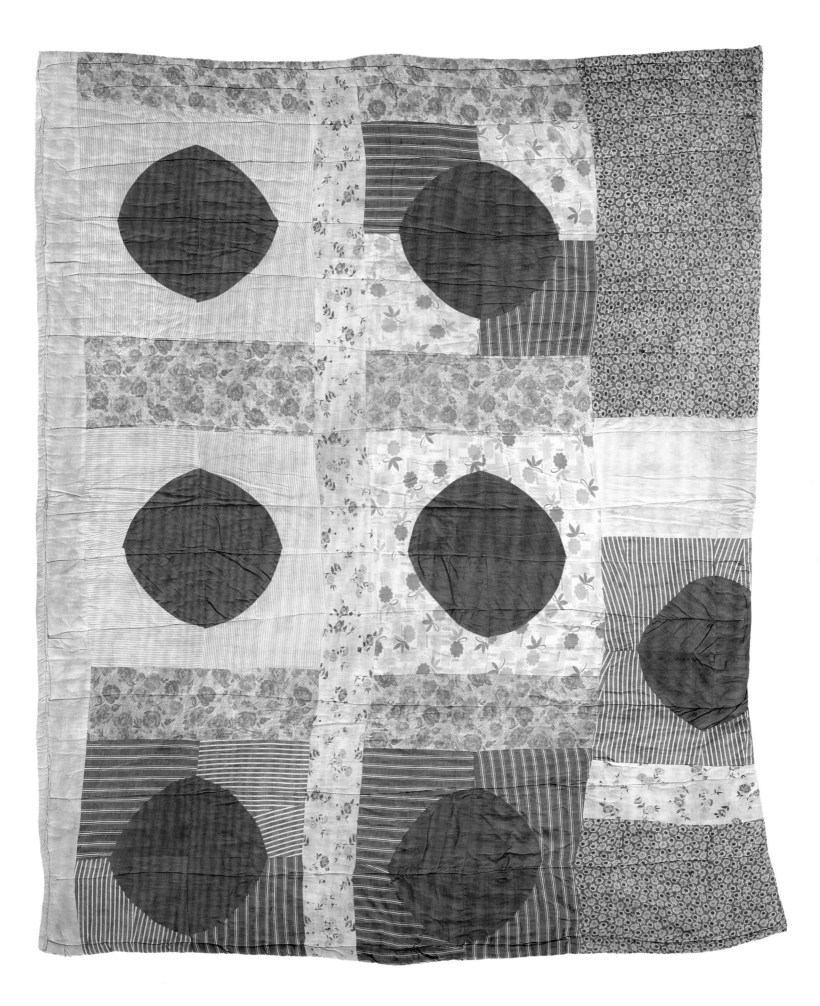

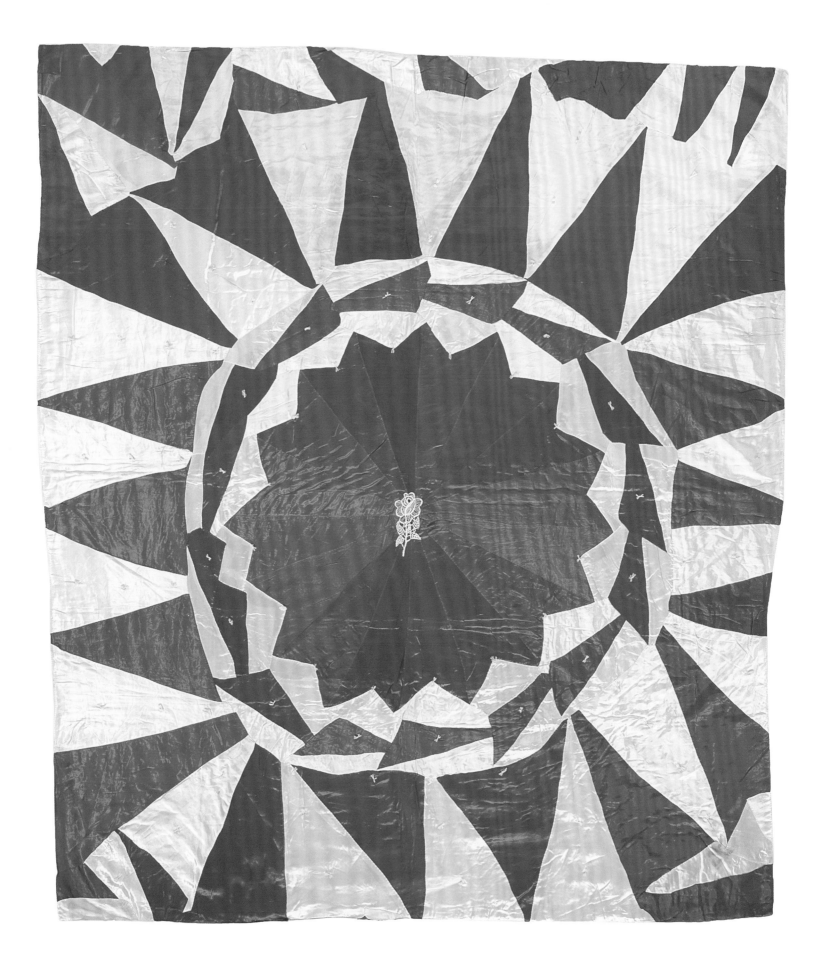

overjoyed. So I feel I can speak for my grandmother and say, I think she would have been exceptionally pleased.

RK: *Where do you get fabric for the quilts you make?*

SB: Anywhere fabric exists. I do not limit myself. But I have always embraced the thought of recycling and the old adage "waste not, want not," so I am particularly drawn to old clothes, linens, and textiles. There is such a variety of textures and colors suited to anyone's palette, discarded for new stuff every day, mountains of it going to waste. Don't get me wrong though: If there is, for some reason, a particular print, color, or texture that hasn't come my way in the recycling piles and I feel I simply must have it to finish the composition of my top, I will mosey on down to the fabric store. Right now I'm looking for pieces with lovely snowflakes on them and also Mexican sombreros, dancers, and anything with a Spanish/Mexican theme. Textiles featuring French explorers of the Americas and an image of an older French flag design on cloth used by these early explorers are also on the bucket list. If I don't find them among the recyclables by the time I'm ready to complete that section of my quilt, I'll be forced to look for them among the new stuff or try my hand at drawing them.

RK: *You have spoken of quilts being aired on the clothesline to "clean" them, and sometimes even being left out in the rain to give them a cleaning. Is this how you and your family have always taken care of your quilts?*

SB: The first eighteen years of my life were mostly filled with utilitarian quilts. In the spring the quilts were sunned and aired out. Sometimes the quilts were left out in the rain to receive a good soaking, then kept out to dry. They were then folded and put away for next year in a cedar chest, or a closet, or stored neatly between the mattress and bedsprings or any other convenient place of storage until needed in the fall and winter. If the quilts were badly damaged they might receive a new top, be rolled over as batting in the following fall's quilts, or thrown onto the trash pile if they were simply too dilapidated or soiled to keep.

Quilts didn't get frequent washings because they could be super thick, heavy, and awkward to handle. Also, we did not have inside plumbing or an outside water

OPPOSITE

Sunburst, variation
C.1950–2000
Found in Hartford, Connecticut
SATIN, APPLIQUÉD CROCHETED
ROSE IN CENTER, TIED
84 x 75 inches (213 x 190.5 cm)

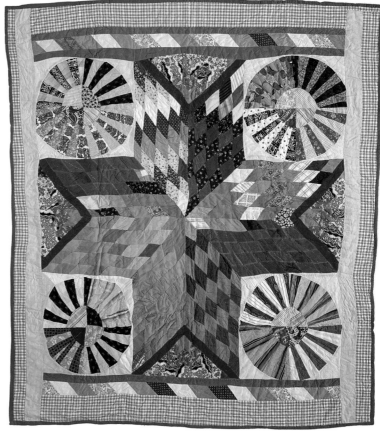

faucet. We drew water from a well with a rope, bucket, and pulley, and for quite a period of time, as I remember, we still washed laundry in a #10 galvanized tin washtub with a scrub board. Sometimes an extra-large cast-iron pot was placed over a wood fire to boil water for cleaning and washing the white clothing and linen bed sheets. It wasn't until the late 1950s or early 1960s that families were able to afford a luxury like a wringer-type washing machine. But even then the quilts were too thick to go through efficiently. Lastly, there were just too many quilts to always be washing continuously.

RK: *Are there particular quilts in my collection that stand out for you?*

SB: I am drawn to many of the quilts in your collection, mostly because a lot of them resemble quilts I grew up around and slept under in my youth. Some also inspire me with new ideas for my future creations. It is very hard to pick just one as the best overall. Each one has its own unique syncopated compositional appeal and arrangement that invites one to sit down and visit for a while and enjoy the view, so to speak.

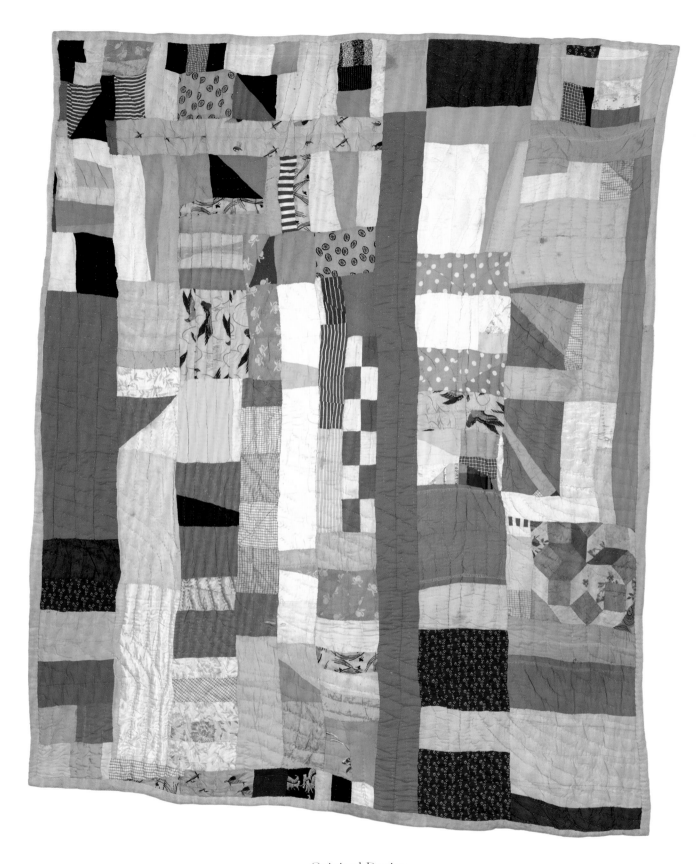

Original Design

c.1975–2000

Found in Alabama

COTTON, BLENDS, SATIN

83 x 68 inches (211 x 173 cm)

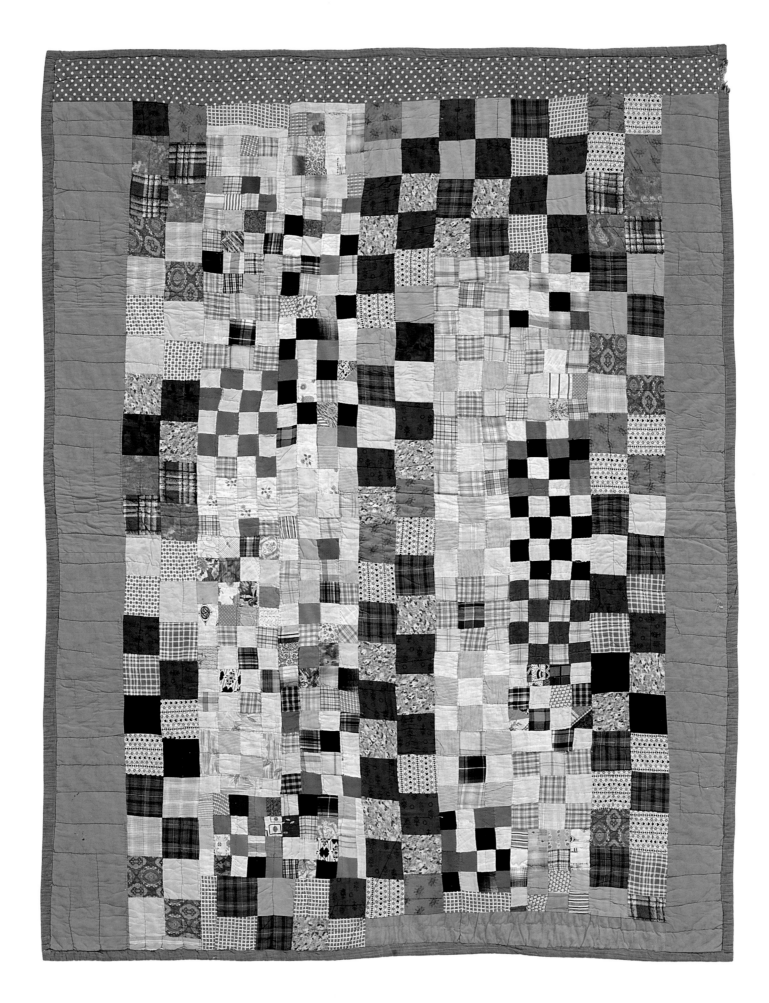

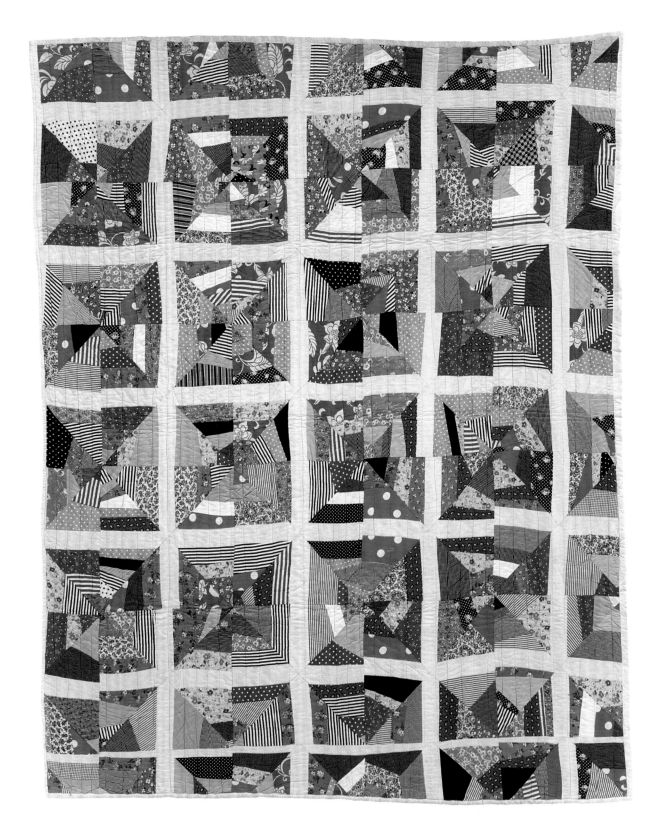

OPPOSITE

Original Design

c.1960–1990
Found in Alabama
COTTON, BLENDS
81 x 63 inches (206 x 160 cm)

ABOVE

String with Broken Grid

c.1930–1960
Found in Kentucky
COTTON, MACHINE-QUILTED
83 x 66.5 inches (211 x 169 cm)

69

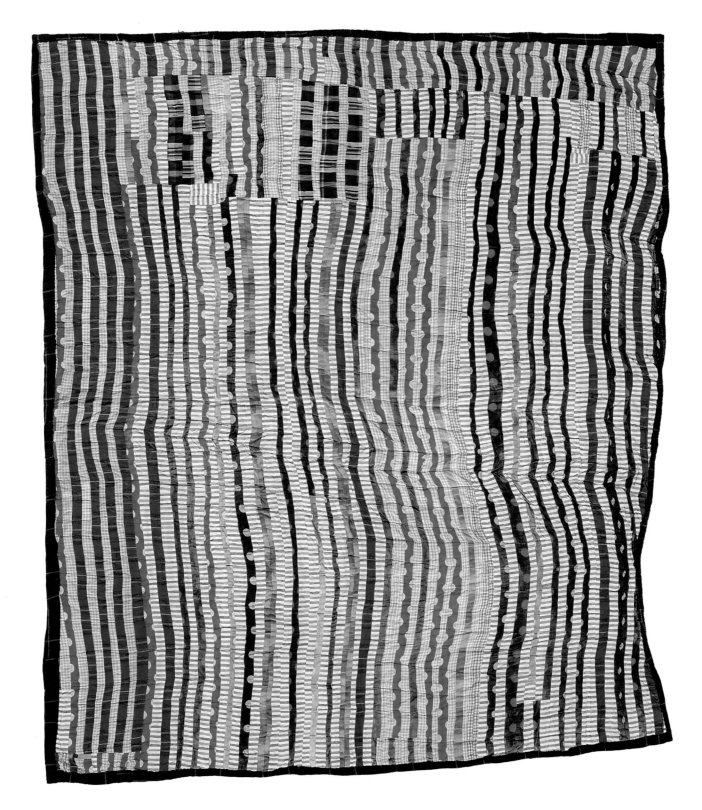

Stripes

c.1950–1975
Virgie (née Pickett) Walton. Mississippi or Missouri
African American
COTTON. MACHINE-QUILTED
71 x 62 inches (180 x 157.5 cm)

This is one of the few quilts in the collection for which the maker is known. Virgie Walton lived in Mississippi and then Missouri, where she did custom sewing for a living and made quilts. She said that she enjoyed using strips of material to make her quilts and preferred to create her own patterns. The whereabouts of her other pieces are unknown. This masterpiece of Virgie Walton's stands alongside the other great contemporary works of art of the last half of the twentieth century.

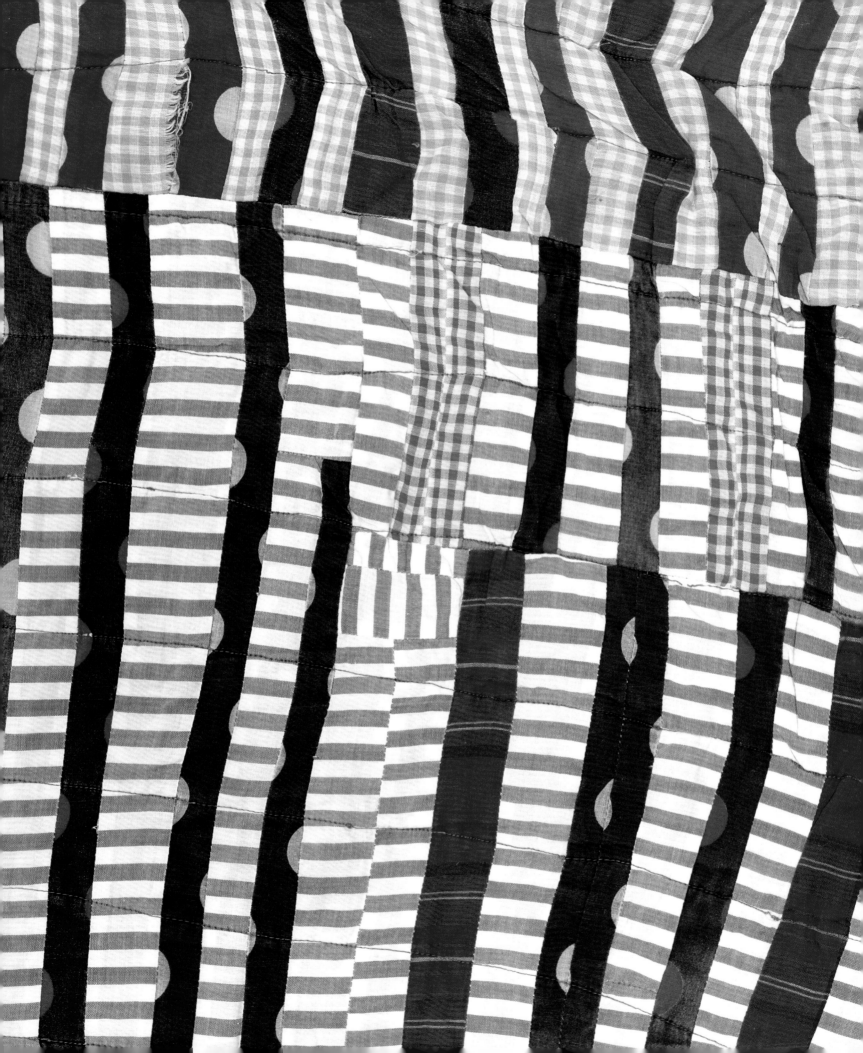

Cross (double-sided)

c.1975–2000
Found in Texas
COTTON, CORDUROY, VELVET,
SATIN. MACHINE-PIECED. TIED
58 x 41 inches (147 x 104 cm)

OPPOSITE

Original Design

c.1950–1975
Found in South Carolina
COTTON
79 x 72 inches (201 x 183 cm)

*The collaging of these prints and
solids is masterfully executed. The
alignment of the blue and yellow
grid fabric as well as the bold bar
of maroon draws the eye in. The
use of the floral prints gives it a
painterly, landscape quality that
is balanced by the two light fabric
pillars on each side.*

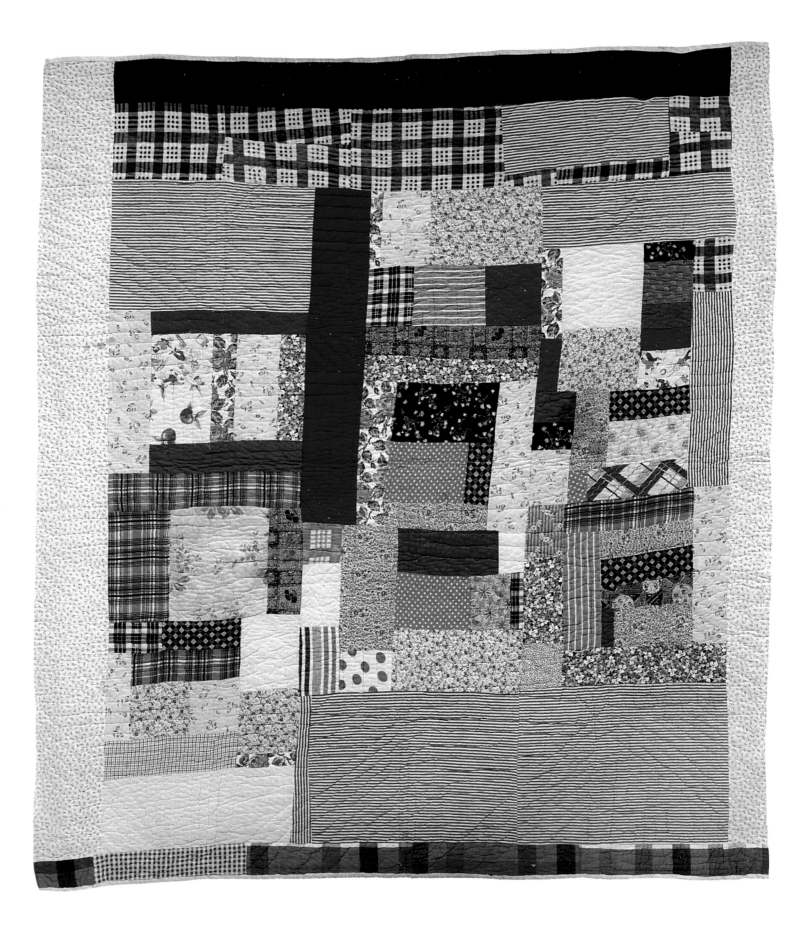

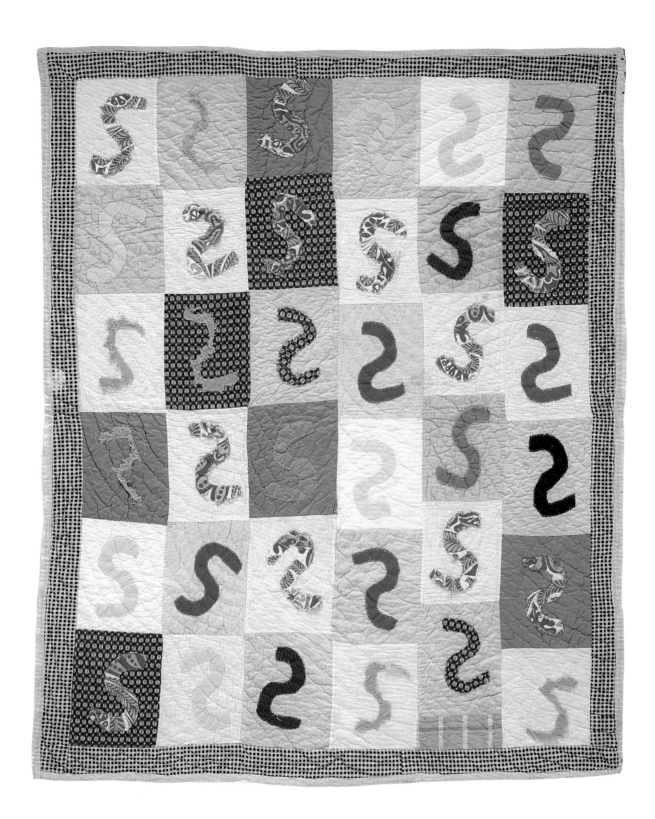

Boots (unfinished top)

c.1975–2000
Found in Alabama
COTTON. HAND-APPLIQUÉD
92 x 76 inches (234 x 193 cm)

A stunning example of Pop Art.

"S"

c.1960–1980
Found in Ohio
COTTON
80 x 65 inches (203 x 165 cm)

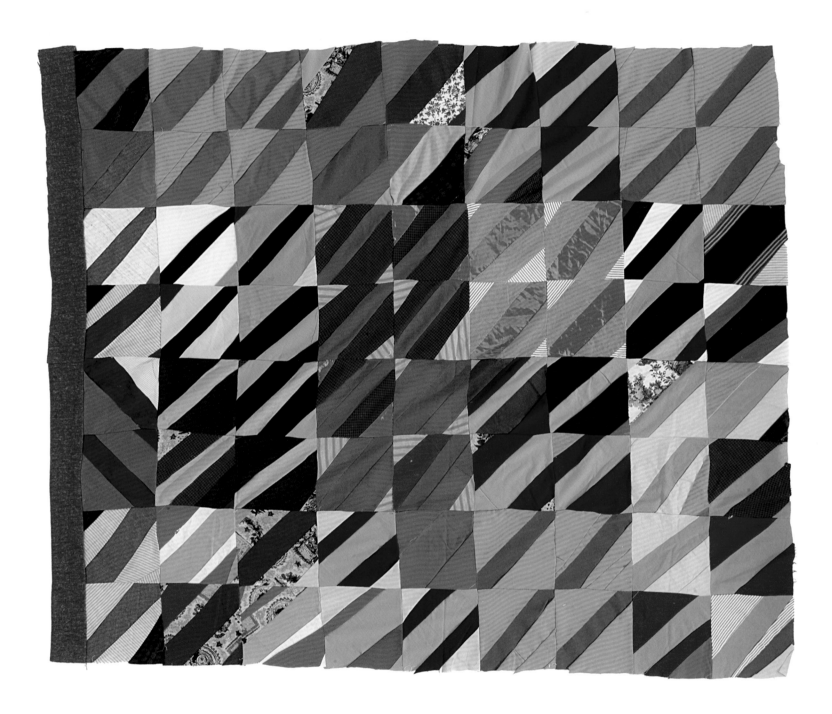

String (unfinished top)

c.1960–1990

Found in Alabama

COTTON, POLYESTER

84 x 72 inches (213 x 183 cm)

This dramatic top contains few printed fabrics. The diagonal movement of color darting across the surface from left to right is particularly animated. This diagonal movement also brings to mind a more modern, streamlined version of Unknown Pattern, an earlier, unfinished top (page 101).

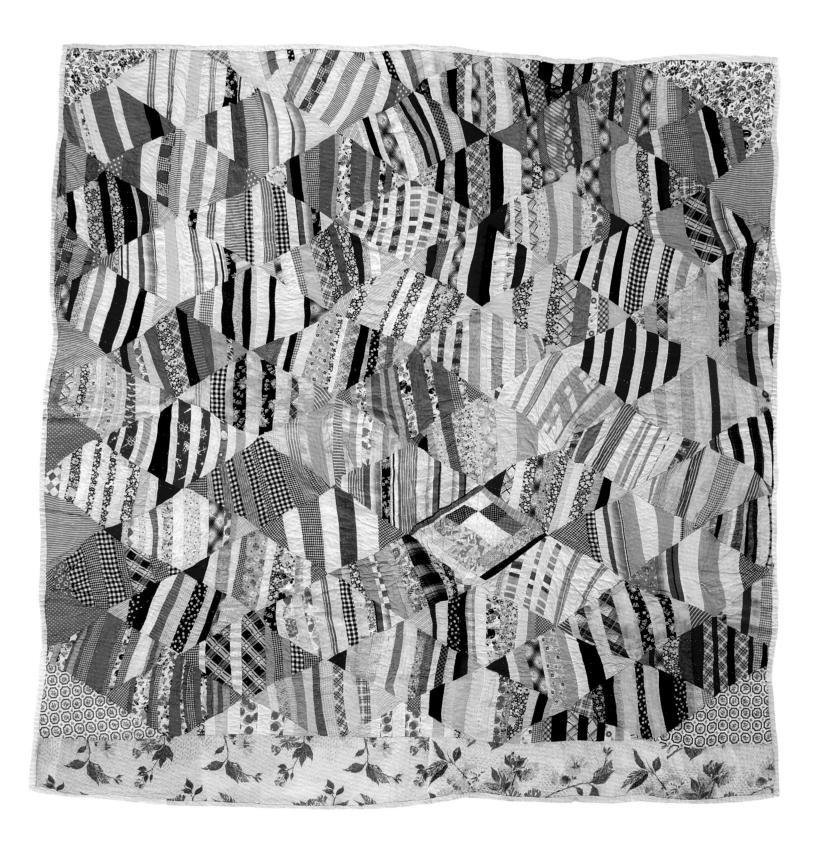

String Diamond

c.1930–1960

Found in Alabama

COTTON, BLENDS, BACKING OF UNBLEACHED

100 LBS. CUBAN SUGAR SACKS

79 x 79 inches (201 x 201 cm)

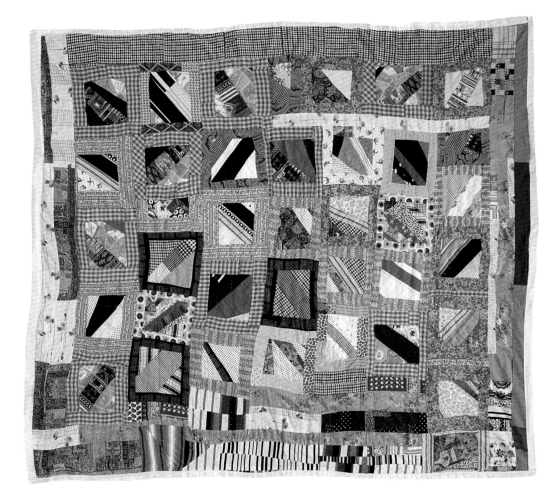

"Framed String"

c.1960–1980
COTTON, BLENDS
ANOTHER QUILT OR HEAVY
BLANKET USED AS BATTING
79 x 90 inches (193 x 229 cm)
Collection of Bonnie Grossman/
The Ames Gallery

Sixteen Patch

c.1960–2000
Found in Tuskegee, Alabama
African American
POLYESTER, DOUBLE-KNITS
67.5 x 81 inches (171.5 x 206 cm)

Housetop

c.1960–2000
Attributed to Preston Whitehead.
Found in Sipsey, Alabama
POLYESTER, FURNISHING FABRICS
84 x 64 inches (213 x 162.5 cm)

This is the only piece in the
collection attributed to a male
maker, although documentation
has not been verified.

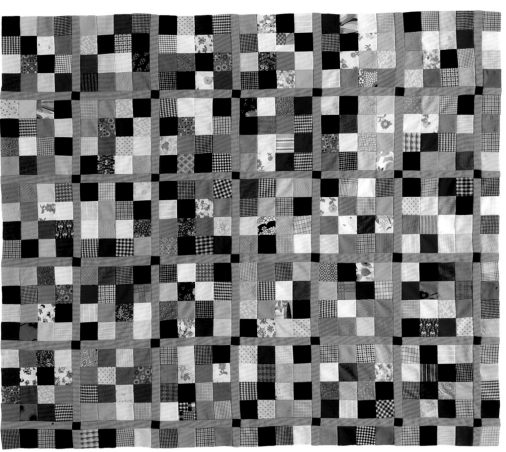

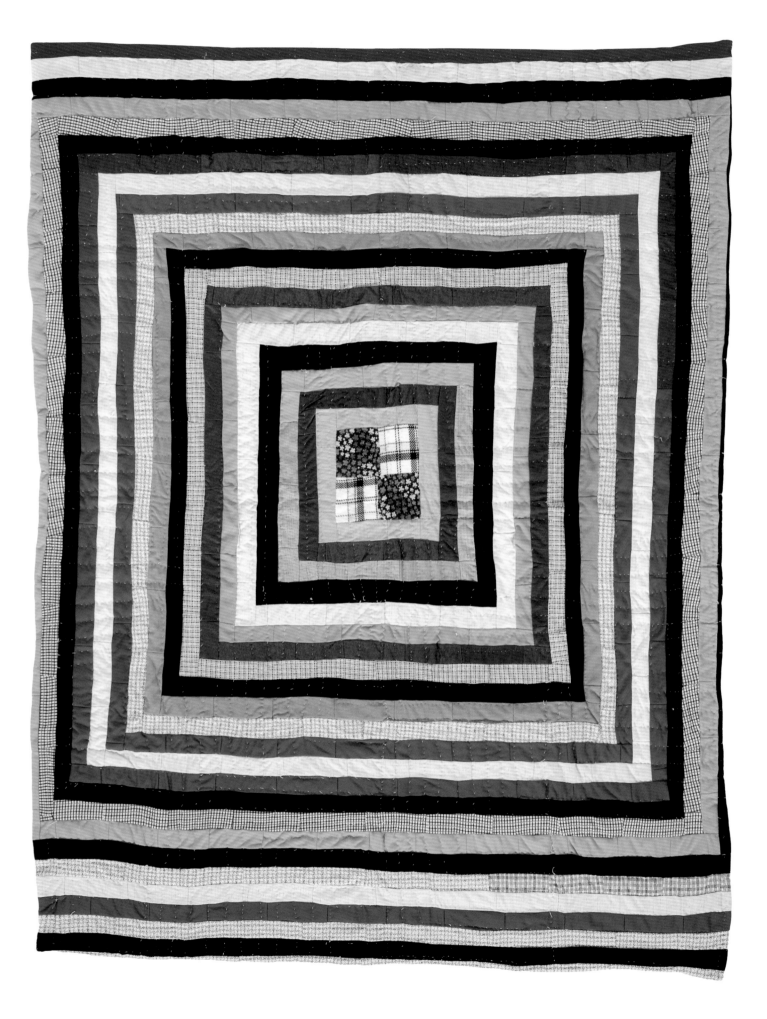

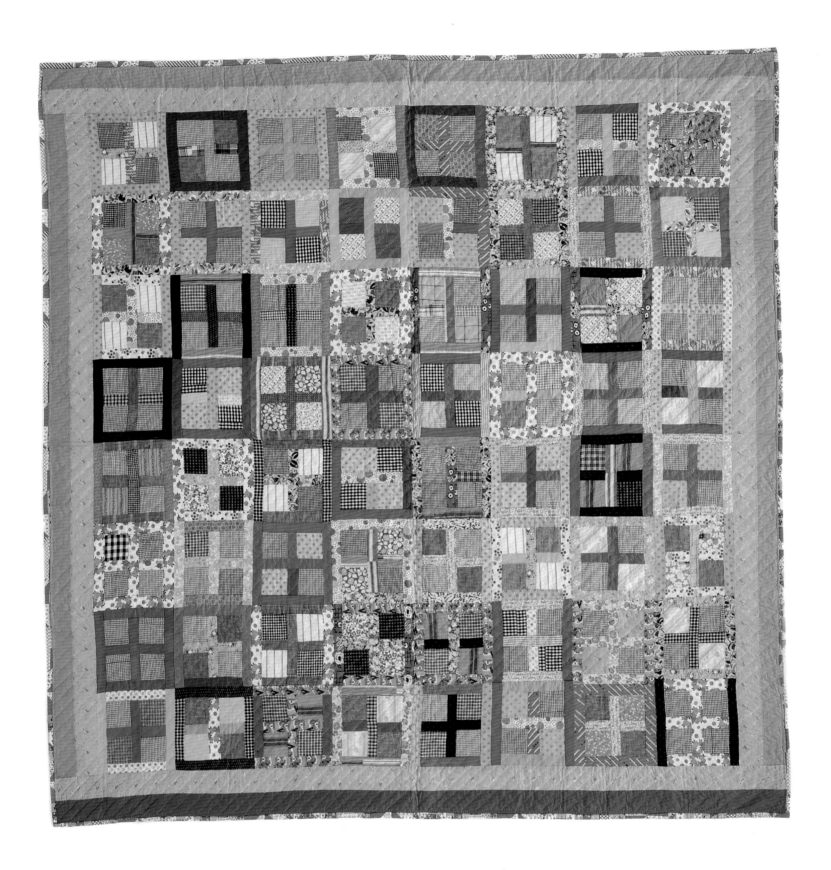

"Cross" / Four Patch

c.1950–1975

Found in Pennsylvania

COTTON, BLENDS

87 x 87 inches (221 x 221 cm)

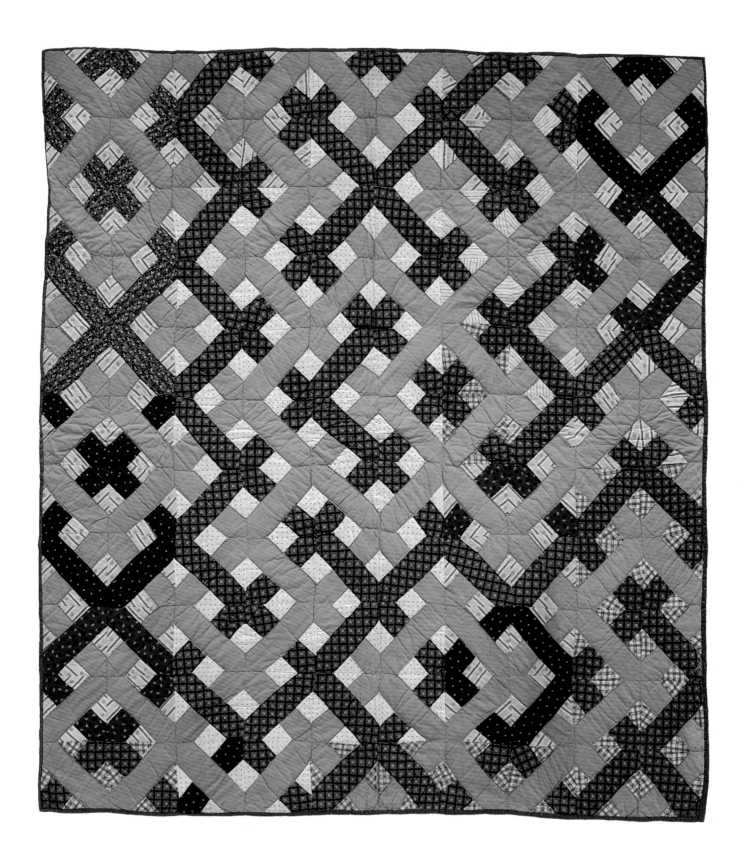

Lattice

c.1925–1950

• COTTON

93 x 72 inches (236 x 183 cm)

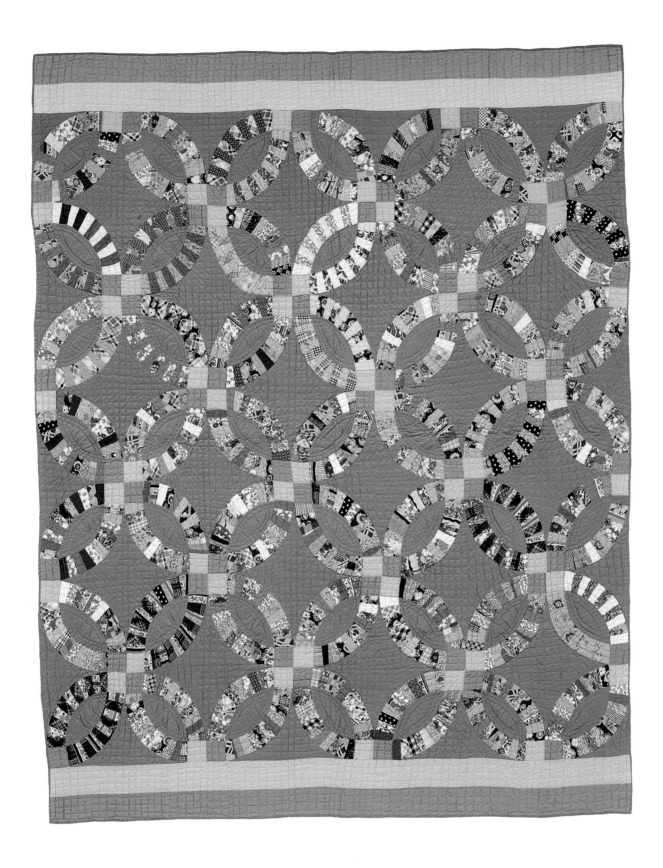

Double Wedding Ring

c.1940–1960
Found in Pennsylvania
COTTON

82 x 66 inches (208 x 167.5 cm)

This is the pattern most people would expect to see from the mid-twentieth century. It is included here as an homage to the traditional patterns made by the hundreds of thousands at this time. This example is unusual in its use of a colored background instead of traditional white. Contemporary quiltmakers like Nancy Crow and Victoria Findlay Wolfe have been inspired to explore new and exciting concepts based on this pattern.

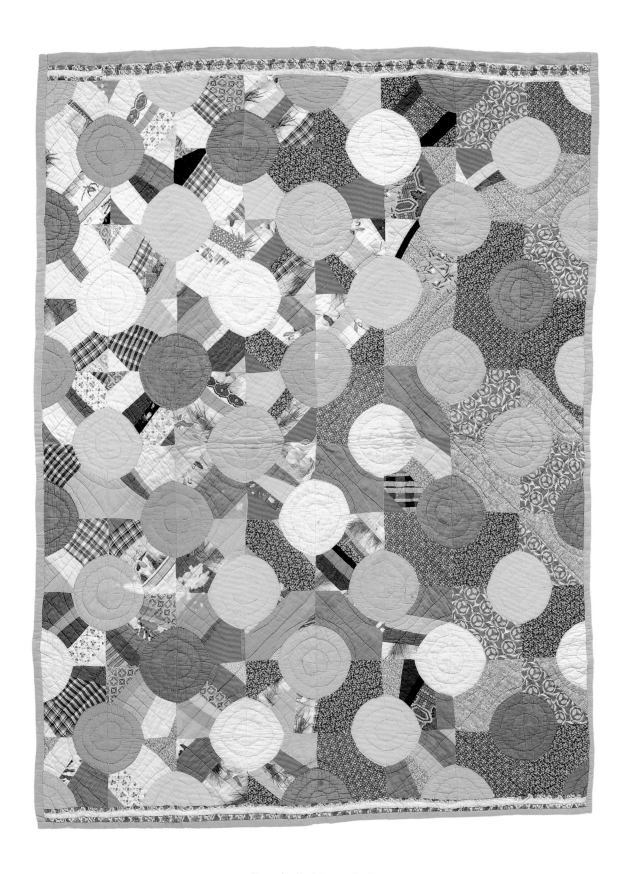

Baseball / Snowball

c.1975–2000
Found in Alabama
COTTON, BLENDS
87 x 65 inches (221 x 165 cm)

Unconventional Wisdom: *The Myths and Quilts That Came Before*

JANNEKEN SMUCKER

AS A QUILT HISTORIAN I'VE REFUTED MANY TIMES THE MYTH of the scrap bag quilt, insisting that historical quilts typically were high-style objects of the middle and upper classes, rather than utilitarian ones crafted with an economy of means. And then I see the collection of quilts Roderick Kiracofe has assembled over the last decade of the twentieth century, quilts that can hardly be called "high-style," exhibiting creative reuse, unconventional design, and both an awareness of quiltmaking traditions and a willingness to break those rules. Kiracofe's oldest quilts date to the early twentieth century, and seem to foreshadow a new sensibility within a corner of American quiltmaking that embraced the aesthetic potential of thrift and an abandonment of order and predictability. These quilts do not adhere to the conformity of quilts from 1900 to 1940, which makers typically based on commercially available patterns printed in newspapers and magazines or kits purchased through mail-order companies. These quilts are not harking back to simpler times of an imagined past, like so many Colonial Revival–inspired patterns of this time period. These quiltmakers used recycled bits and pieces of fabric, repurposed from scrap bags and worn clothing. These quilts make me think I know nothing about quilts. These quilts break the rules.

In the past forty years, during the so-called quilt revival of the late twentieth century, one of the many facets of revivalists' enthusiasm—along with collecting, preserving, and making quilts—has been studying the history of quilts. Collectively we've discovered much about the sources and styles of quilt fabrics, the circulation and evolution of quilt patterns, and the ways women found meaning through making, using, and sharing quilts. And like any good historians, we've debunked a few myths

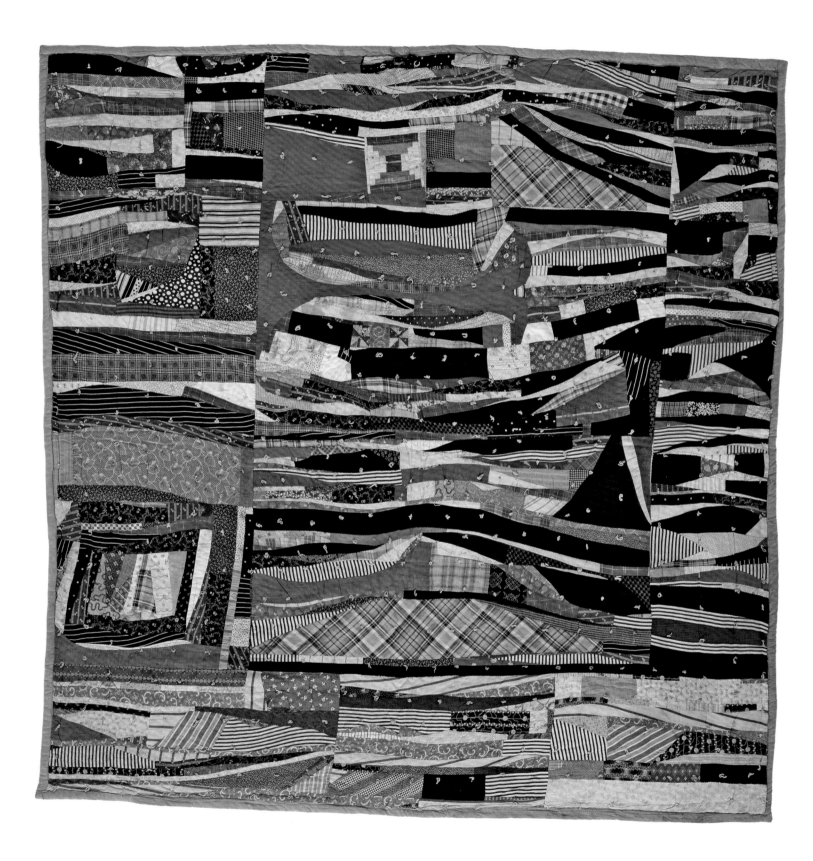

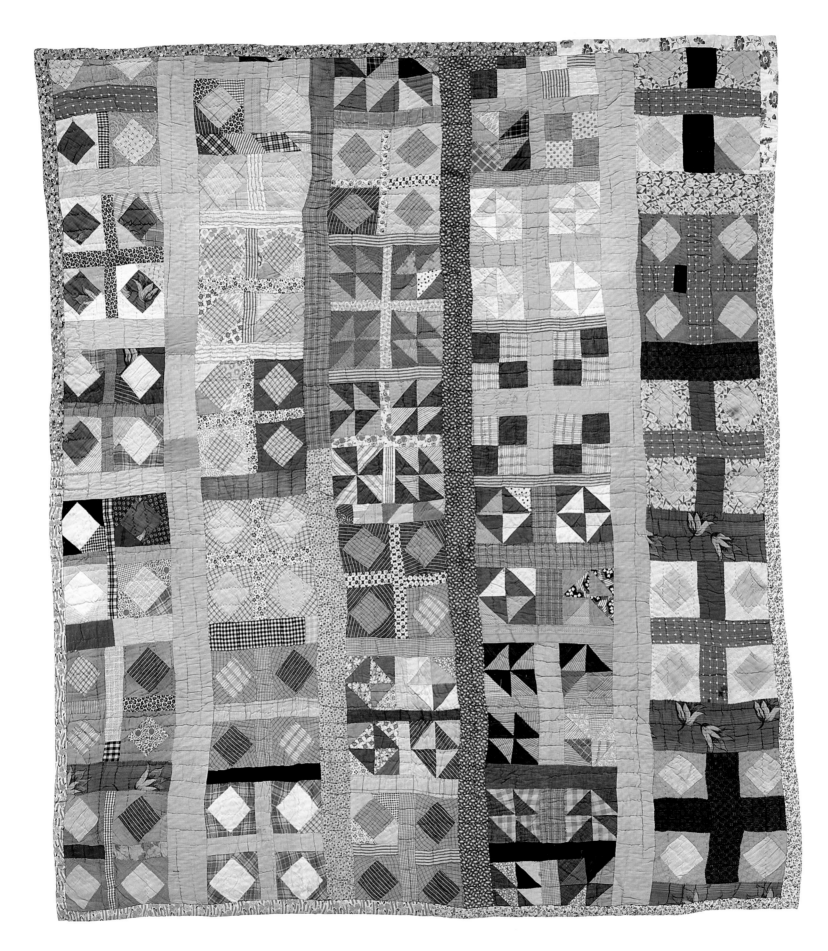

along the way, as we've established theories for what we think happened in the past. Yet quilts like the ones in this collection make me reassess what I know about quilts and lead me once again to contemplate the role of the scrap bag in American quiltmaking and mythmaking.

THE SCRAP BAG IN MYTH

One of the prominent myths of quiltmaking has long been that industrious homemakers saved up their scraps to lovingly stitch together bedcovers to keep their family members warm.[1] What we've learned about early American quilts—particularly during the colonial era and in the early nineteenth century prior to the technological advances of the Industrial Revolution—suggests that few American women at this time made quilts because fabric typically was among the most expensive items within a household. Not until New England factories began spitting out an abundance of affordable cotton fabrics did women begin to cut it up in order to stitch it back together again, typically using new rather than used fabric. But during this mid-nineteenth-century era of abundant cloth, the belief about quilts as thrifty products of a culture of reuse and salvage emerged, fueled by displays in nineteenth-century World's Fair "colonial kitchens" and imagined notions of colonial days prompted by the American Centennial.[2]

Such beliefs gained credence in the early twentieth century's Colonial Revival, when the first enthusiasts began writing about old quilts. In *Old Patchwork Quilts and the Women Who Made Them*, Ruth Finley declared, "In mansion house and frontier cabin, from the Cavaliers of Jamestown to the Puritans of Plymouth, scraps of linen, cotton, silk, and wool were jealously saved and pieced into patchwork quilts."[3] Delineating the evolution of quiltmaking styles in a way that made sense to the Progressive-Era writers familiar with Darwin's theory of evolution, Finley and other authors promulgated the notion that American quilts progressed from early colonial haphazard crazy-pieced scrap quilts to the more orderly patterns of the nineteenth and twentieth centuries.[4]

Americans widely understood the fortitude of these imaginary early American quiltmakers as something to admire. Prominent quilt author and designer Marie

OPPOSITE

Original Design
c.1910–1930
Found in Georgia
COTTON
74 x 64 inches (188 x 162.5 cm)

An early twentieth-century quilt that foreshadows many of the quilts in this collection. Note the long sashings running vertically from end to end and the utilization of pieces left over from the maker's other quiltmaking projects. It shares a sensibility with "Blue Bars and Crosses" (page 189) and more abstractly with the Original Design quilts on pages 67 and 142.

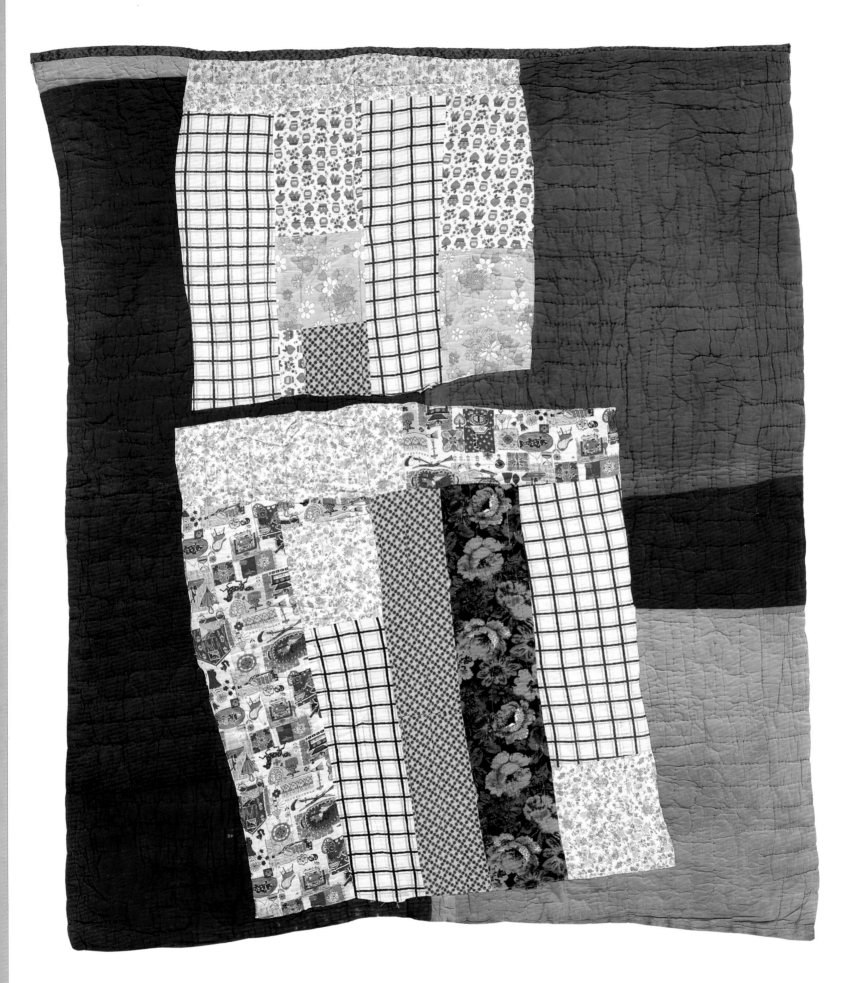

The early twentieth-century makers of the particularly idiosyncratic scrap quilts in Kiracofe's collection—while likely far from the cosmopolitan upper class who imported high-style European fabrics in colonial America—understood the language of quiltmaking: the rhythms of repeated block patterns, the impact of contrasting light and dark fabrics, the way a quilt looks like one thing up close and quite another from a distance. These quiltmakers understood the conventions of quiltmaking—even if they chose to ignore some of them. And perhaps they also adopted the popular myth of the colonial scrap bag circulating within popular culture at this time: quilts as symbolic of a thrifty attitude of making do. If contemporary culture celebrated the frugality of colonial quiltmakers, why not adopt it in one's own quiltmaking? And for those of limited economic means, such thrift—even if inspired by American culture's romanticizing of the craft of quiltmaking—made good sense.

When the maker of the quilt on page 86 had leftover quilt blocks—an assortment of Broken Dishes, Four Patch, and One Patch—she creatively assembled them into five distinct rows, separated by bars of sashing, running vertically. Even if she wasn't on the forefront of Colonial Revival discussions of the thrifty ingenuity of American foremothers, she may have understood that blocks such as those she, or perhaps someone else, had left from other projects could be "used up" in frugal fashion.

A few pieced pinwheels were similarly inserted into the tied comforter on page 85, perhaps remnants from a scrap bag, now reused alongside an askew Log Cabin block and the leftovers from cutting out trouser legs. The quilt's appearance resembles an archeological dig and, just as one might discover the layers of generations buried in an outdated privy, here we see what are likely several generations of scraps, reused remnants, leftovers from sewing, and unfinished quilt projects. Many of these scrap quilts are challenging to date because scraps live on through generations.

Another intergenerational quilt, opposite, clearly features layers, perhaps first assembled in the 1920s by Sarah Patric out of solid-colored cottons, hand-quilted together with parallel lines. Her daughter, Mary Meed, or perhaps Mary's daughter-in-law Mattie, added a layer of appliquéd printed fabrics featuring the sorts of cheery prints common to 1950s and 1960s curtains and housedresses. Whether the addition

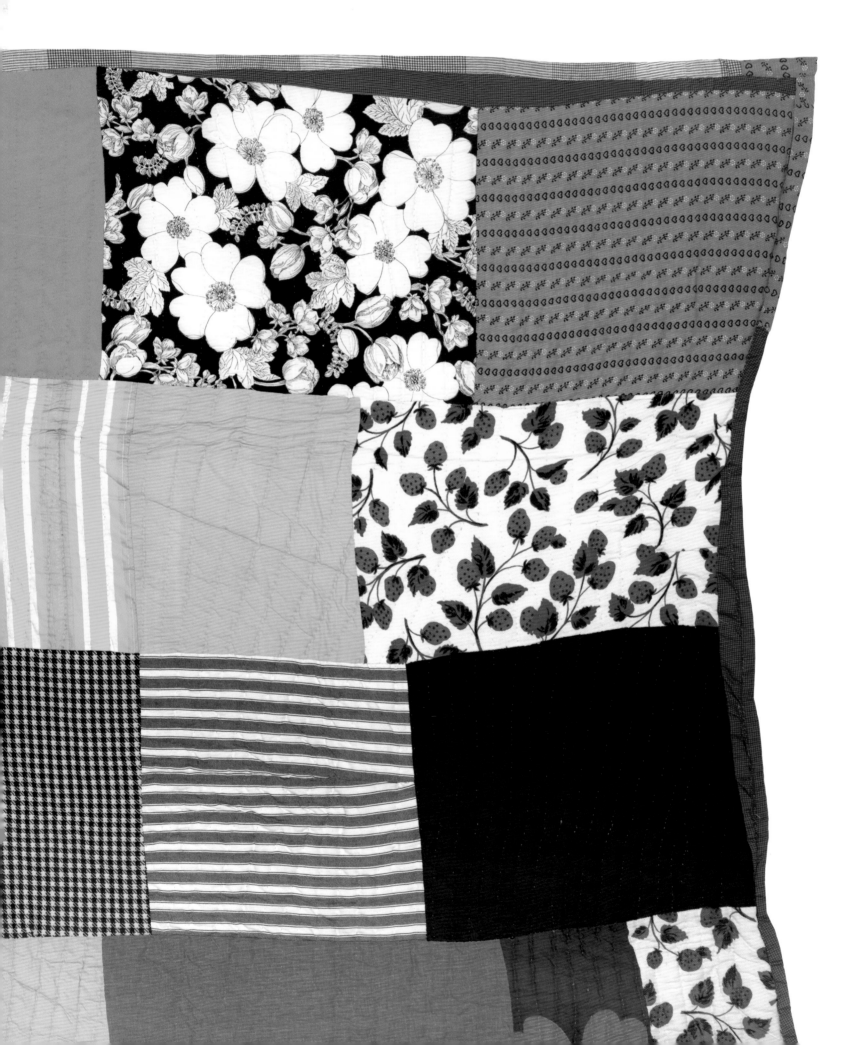

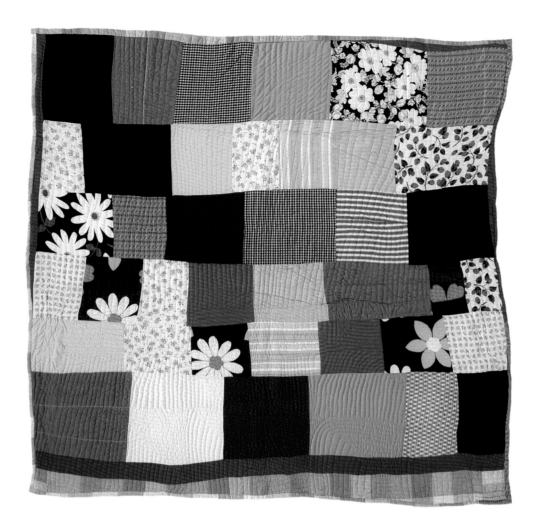

was solely aesthetic, or a utilitarian patch to a worn section of the quilt, we can't determine without undoing the later contribution. The contrast between the appliquéd printed fabrics and the plainer original quilt depicts a vivid generation gap as well as the way women creatively drew on their scrap bags to enliven quilts.

Early twentieth-century quilts that fly under the radar aren't, however, all haphazard amalgams of scraps and leftovers. Like an inchworm looping its way across the quilt top's surface, the pattern on page 101 leads the viewer's eyes from the lower left corner to the upper right, with a wiggly finish due to the directional change of the far right column. The maker's use of turn-of-the-century scraps—simple shirtings, gray and black mourning prints, indigo discharge prints, ginghams, and yarn-dyed plaids—lends a busy feel to the quilt top. Like others, this quilt breaks rules. We'd expect such use of scraps to result in a utilitarian bedcovering, yet this piece remains an unfinished top, rather than a completed quilt. Its exposed back reveals the foundation piecing method common among "string quilts," in which the strings of fabric are stitched to a foundation ground. This technique gained

OPPOSITE (DETAIL OF FRONT) & ABOVE (FRONT)

One Patch
c.1975-2000
Found in Alabama
COTTON AND POLYESTER
75 x 79 inches (190.5 x 201 cm)

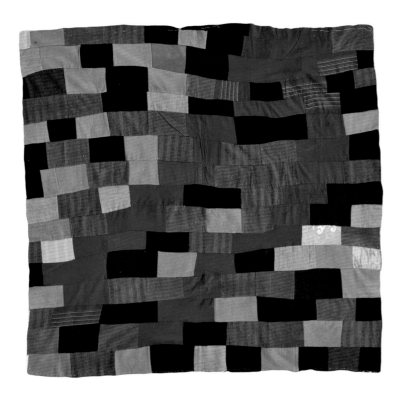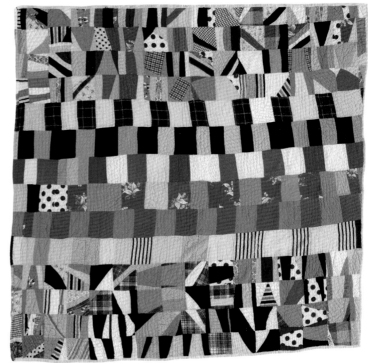

ABOVE LEFT

Brick Wall (unfinished top)

c.1920–1940
Found in Pennsylvania
WOOLS
73 x 68 inches (185.5 x 173 cm)

ABOVE RIGHT

Strip and String

c.1955–1975
Possibly made in North Carolina
COTTON, RAYON, TAFFETA,
CORDUROY
70 x 68.5 inches (178 x 174 cm)

*This is a stunning marriage
of the One Patch strips in the
center and string blocks in the top
and bottom bands. The red and
white dividing line through the
middle is a bold focus point. The
simpler, less busy center bands
stand in contrast to the more
complex upper and lower bands
and the busy string blocks.*

popularity among late nineteenth-century quiltmakers with trendy styles including Log Cabins, crazy quilts, and string quilts like some of those pictured here.[9] This string piecing technique does not seem to have been isolated to a specific geographic area, and likely was a method that complemented the piecing of more traditional pieced patterns. The scraps left from cutting the patches for more orderly blocks (or tailored clothing) were perfect for integrating into string quilts. String quilts are well documented in New England and New Mexico, and parts in between.[10]

Attributed to Ina Lois Posey, of Fayette, Alabama, the One-Patch, variation quilt (page 51) also exhibits deliberate care in its design, with alternating light and dark squares winding out from the quilt's center. Like many rural women working since the introduction of plain, coarsely woven sacks as packaging for feed, flour, and sugar in the 1850s, Posey backed her quilt in reused sacking, perhaps hand-dyeing it first. Such dual-use packaging had great appeal to women in the early twentieth century, and companies promoted their sacks as a way for women to thriftily create decorative and useful items for the home. Some companies and organizations published instructions for reusing sacks; during the Great Depression advertisers promoted the versatility of sacks as a selling point for products, and many women during those penny-pinching days embraced them as a staple for home use.[11] Here, the bag itself serves as the scraps for reuse, providing its maker with cloth she wouldn't need to buy new.

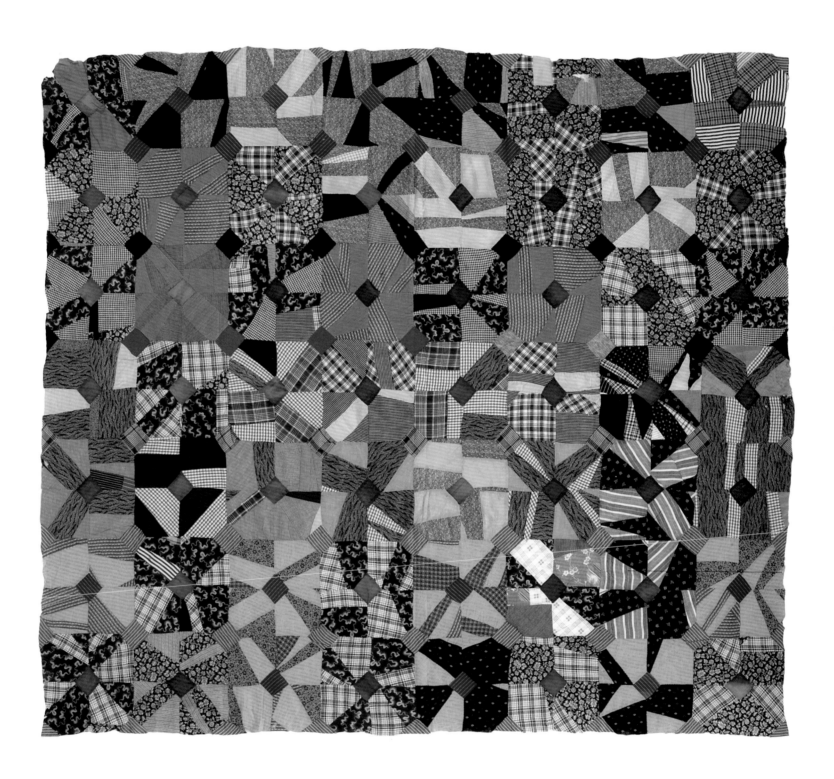

Unknown Pattern (unfinished top)

c.1900–1940

Found in Alabama

COTTON

86 x 77 inches (218 x 195.5 cm)

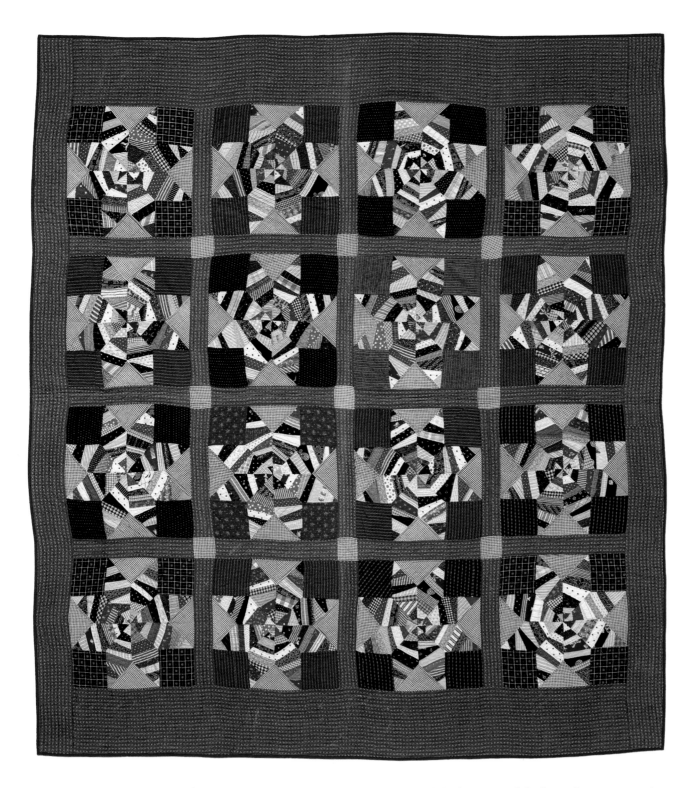

String Star

c.1910–1940
Found in Ohio
COTTON
86 x 77 inches
(218 x 195.5 cm)

The women's magazine Hearth and Home *published a version of the String Star pattern under the name "Helena," as part of its state capital quilt block series, which ran from 1907 to 1916. The Quilt Index (the online database documenting over fifty thousand quilts in public and private collections) has records of more than fifty finished quilts in a variation of this repeated block pattern, most with estimated dates ranging from the 1890s to the 1940s (with most circa 1930). This popular pattern, with documented examples from southern states including Tennessee, North Carolina, and West Virginia, as well as from New England and the Midwest, serves as a perfect canvas for scraps strung together into an orderly yet playful pattern, ideal for drawing on the leftovers from home sewing and usable bits from worn clothing.*

WHAT WE LEARN FROM THESE QUILTS

What can these extraordinary quilts tell us? We, unfortunately, do not know enough about their makers' circumstances to make generalizations about class or race or geography. Poor women and those on the frontier may have been the most likely to use sacking or scraps and leftovers from dressmaking, rather than new cloth, in their quilts, yet middle-class women may have found joy in reuse and, conversely, impoverished women may have relished the opportunity to use a piece of brand-new cloth.[12] Some of the makers of these quilts might have also crafted more typical fare, like the Grandmother's Flower Gardens and Dresden Plates of the 1920s and 1930s. We just don't know. We do know that the growing consumer culture of the early twentieth century reached even isolated rural communities, particularly through mail order.[13] The quilts may look "coarse" or "primitive," but they are made from commercially available fabrics, sometimes in commercially published patterns.

The most important thing these quilts teach us is to check our assumptions at the door. Marie Webster and Ruth Finley seemed pretty sure they knew all there was to know about quilts. But some of their ideas were tinted a bit much with the nostalgia for an imagined past characteristic of Colonial Revival thinking. These authors based their assumptions on their worldview and the sources they had access to, making excuses about the mythical scrap quilts that colonial families "used to shreds." The late twentieth century's quilt scholarship has also been largely filtered by the quilts that have been preserved by both private and public collections: the ones a family or antiques dealer or museum deemed worth saving. No one outside of family members (and likely sometimes not even family members) paid attention to these quilts. For that reason alone, many of these objects have indeed flown under the radar, unearthed only in recent years thanks to the curiosity and aesthetic intuition of collectors like Roderick Kiracofe, the accessibility of buying quilts on eBay, and a dwindling market for expensive show quilts. These surprising quilts create a new body of evidence as we reexamine our quilt myths and perhaps debunk a few more.

JANNEKEN SMUCKER, *a fifth-generation Mennonite quiltmaker, is author of* Amish Quilts: Crafting an American Icon *(Johns Hopkins University Press, 2013). As assistant professor of history at West Chester University, she specializes in digital history and American material culture. She has served as a board member for the national nonprofit Quilt Alliance since 2005. Her previous publications include contributions to* "Workt by Hand": Hidden Labor and Historical Quilts *(2013),* Amish Abstractions: Quilts from the Collection of Faith and Stephen Brown *(2009), and* Amish Crib Quilts from the Midwest: The Sara Miller Collection *(2003). Learn more about Janneken at www.janneken.org.*

FOLLOWING SPREAD

Bow Tie / Original Design
(double-sided,
detail on pages 218–219)

c.1950–1970
Possibly made in Gee's Bend, Alabama
COTTON, BLENDS
75 x 58 inches (191 x 147 cm)

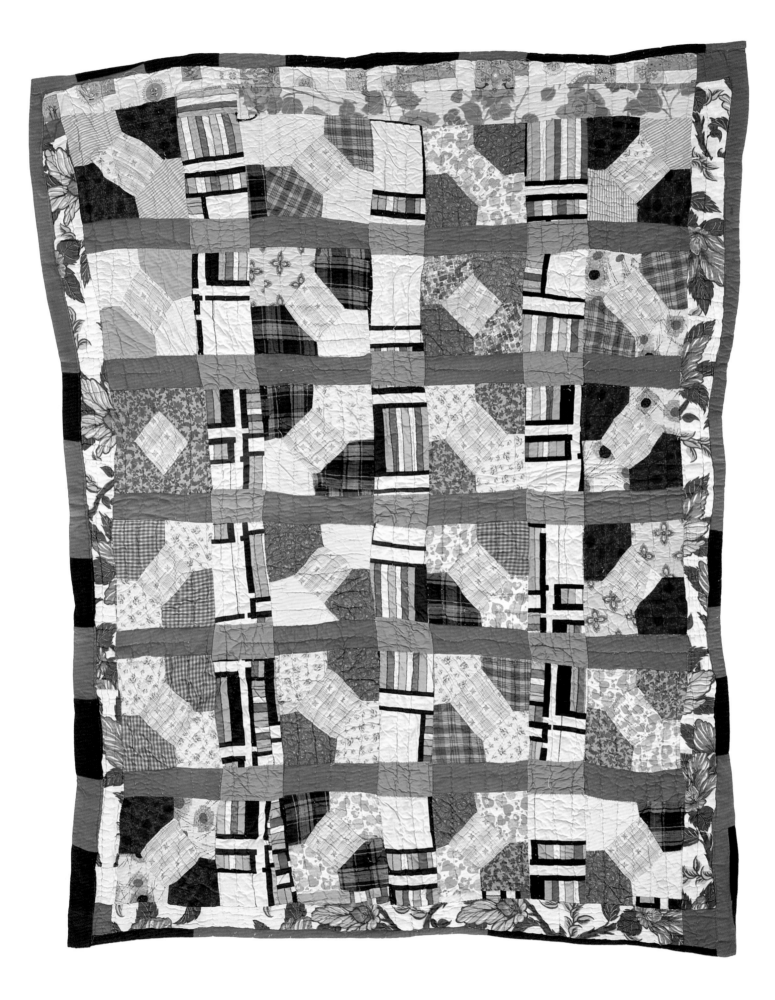

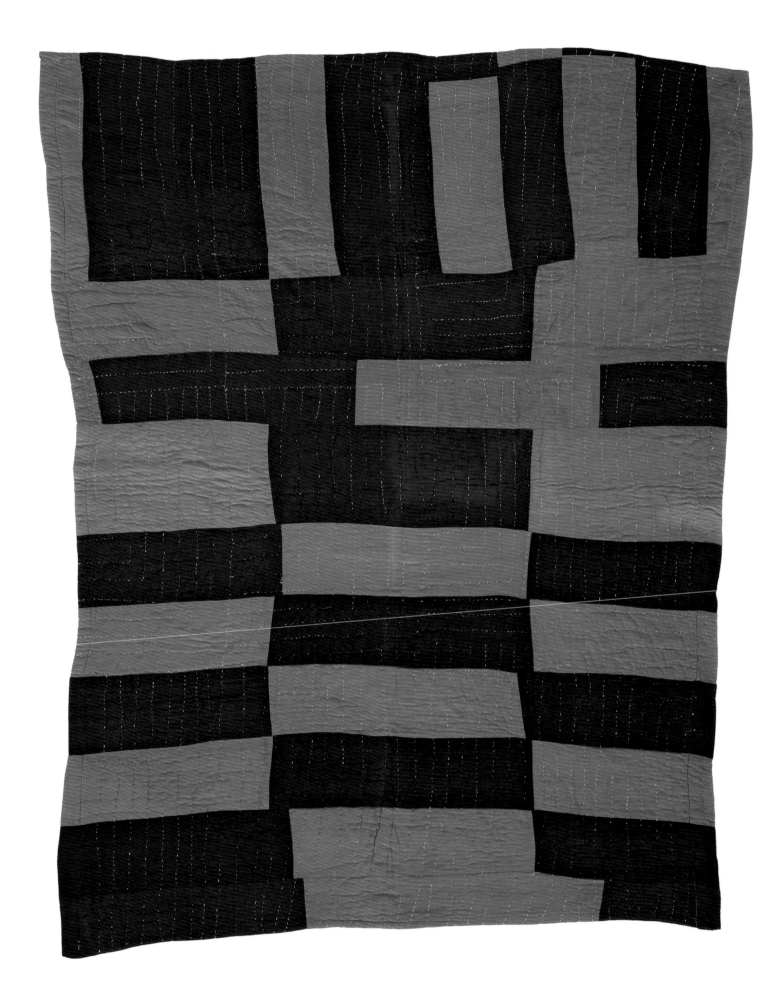

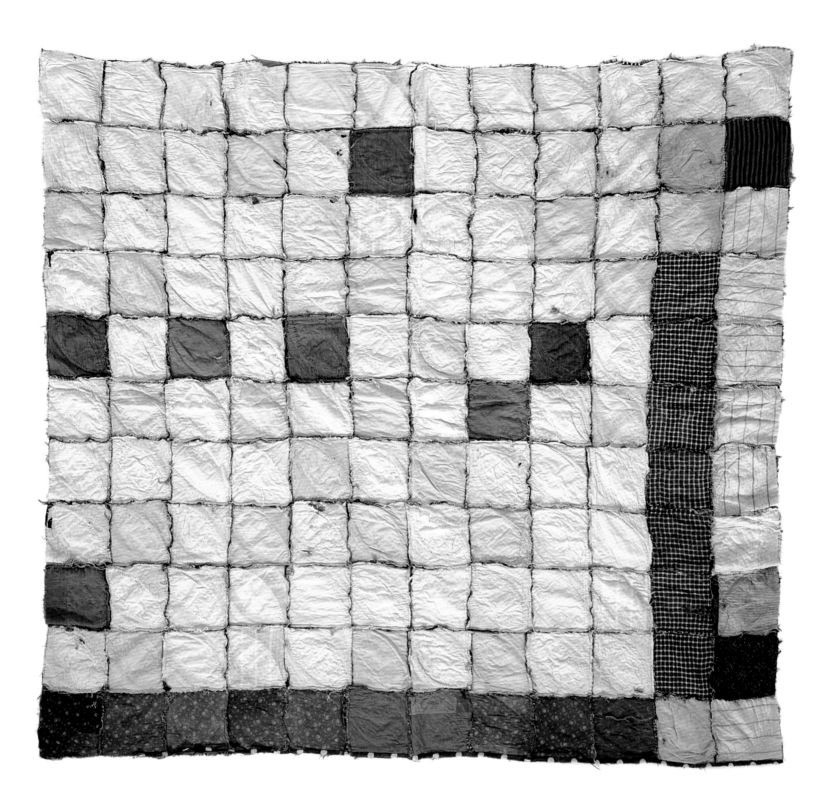

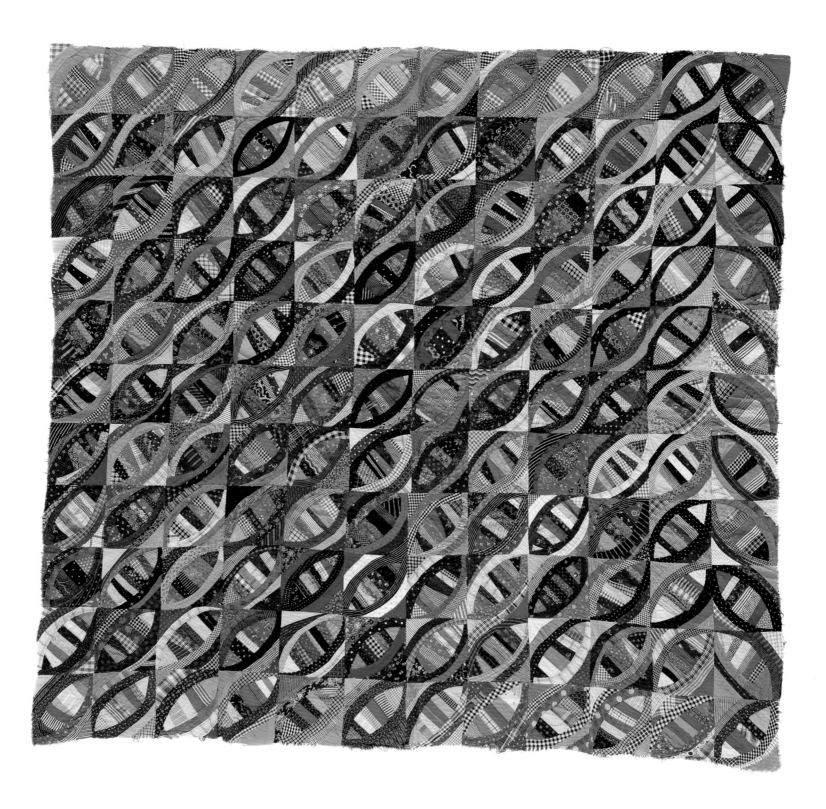

Unknown Pattern (unfinished top)

c.1890–1920

Found in Richland County, Ohio

COTTON

FOUNDATION-PIECED

73 x 79 inches (185.5 x 201 cm)

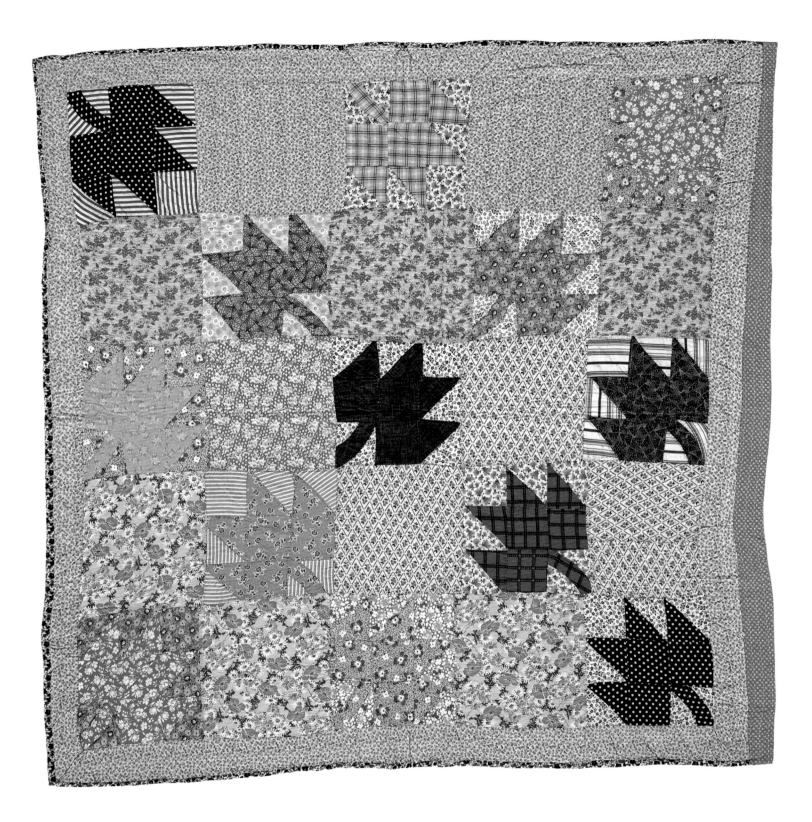

Maple Leaf

c.1930–1960
Found in Pennsylvania
COTTON
65 x 68 inches (165 x 173 cm)
Private Collection

The compelling use of printed cotton next to printed cotton creates the appearance of new patterns and textures in an almost Op Art effect. The punctum is the irregular strip of red polka dot fabric running down the right side.

Crazy, variation

c.1950–1975
COTTON, CORDUROY, TIED
77.5 x 64 inches (197 x 162.5 cm)

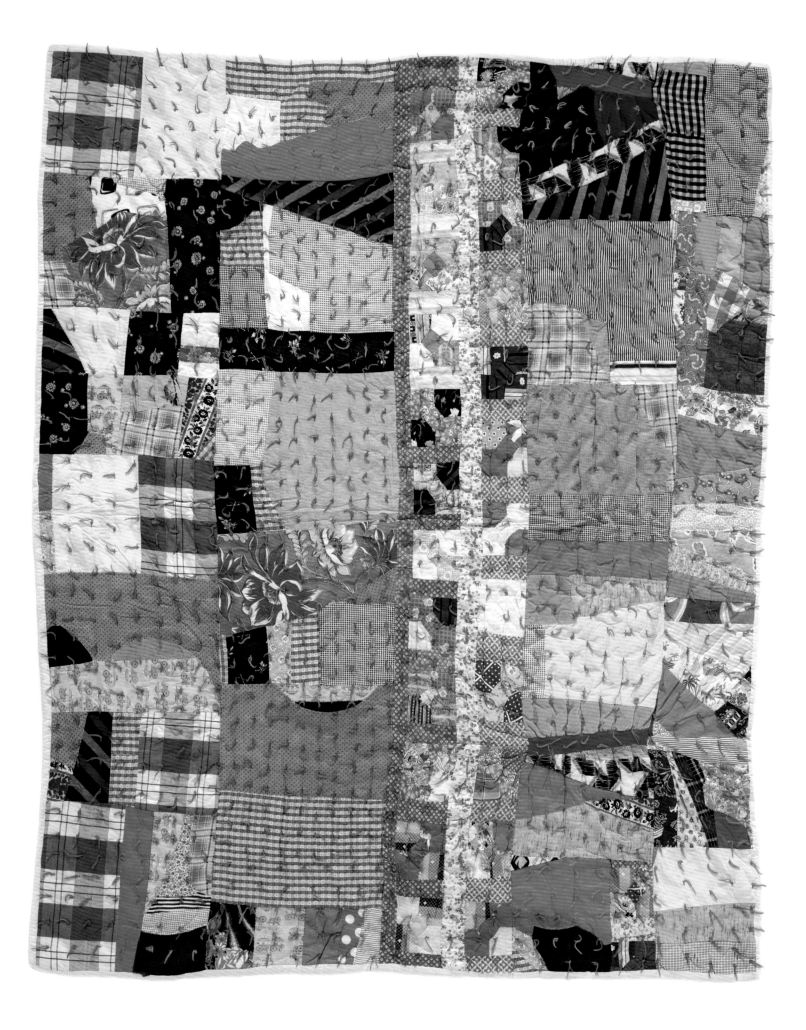

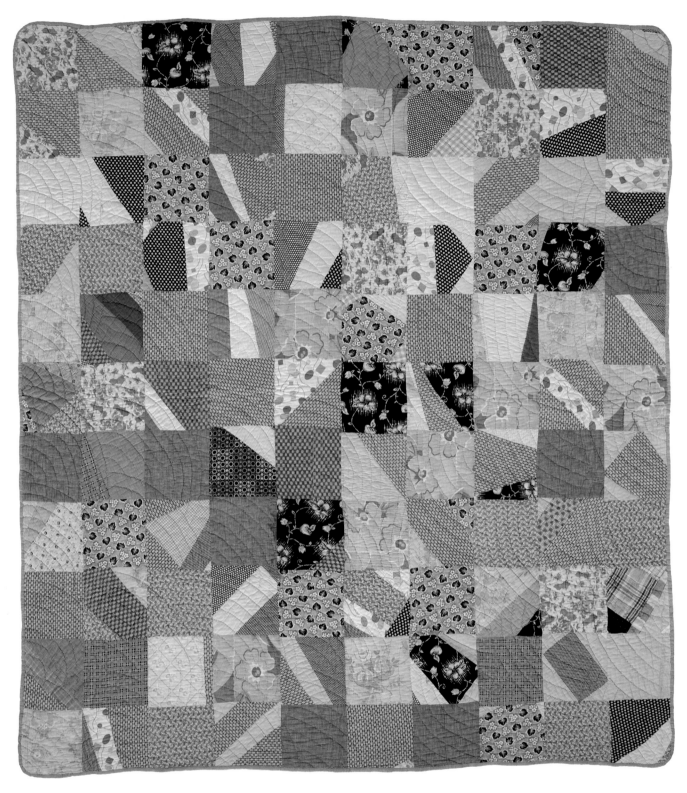

One Patch / String

c.1925–1950

Found in Kentucky

COTTON

79.5 x 71 inches (202 x 180 cm)

Log Cabin, variation

c.1950–1975

Attributed to Deborah Pettway Young.

Gee's Bend, Alabama

COTTON

83 x 71 inches (211 x 180 cm)

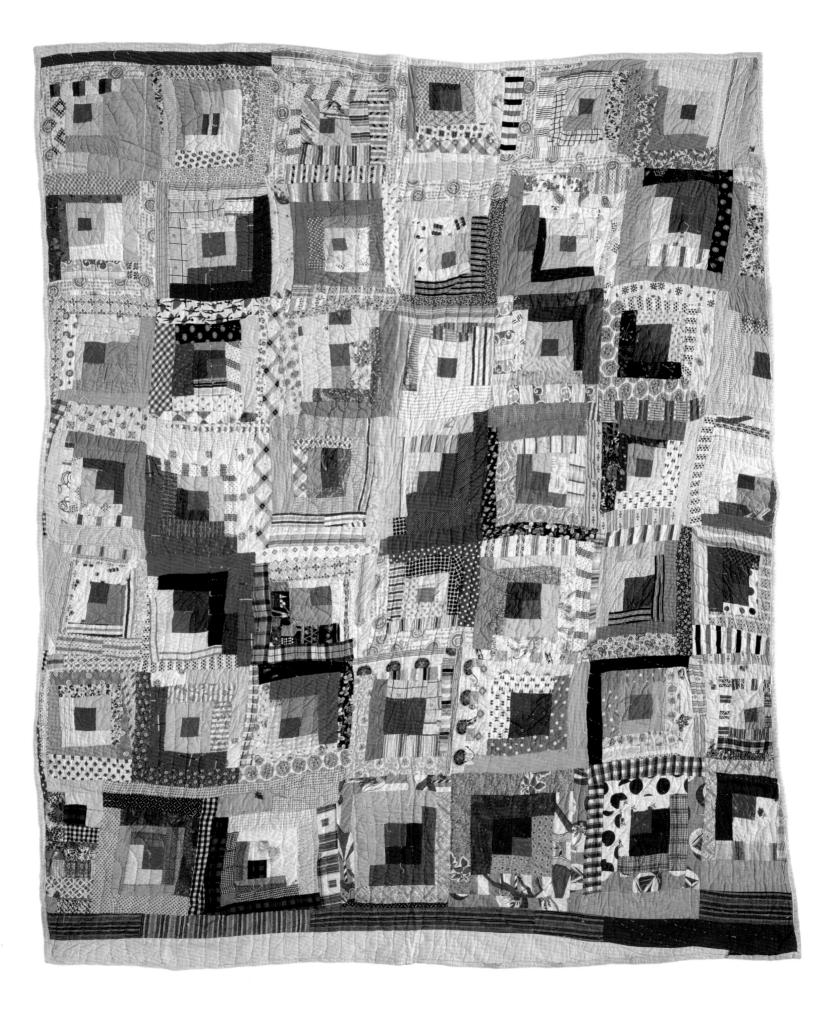

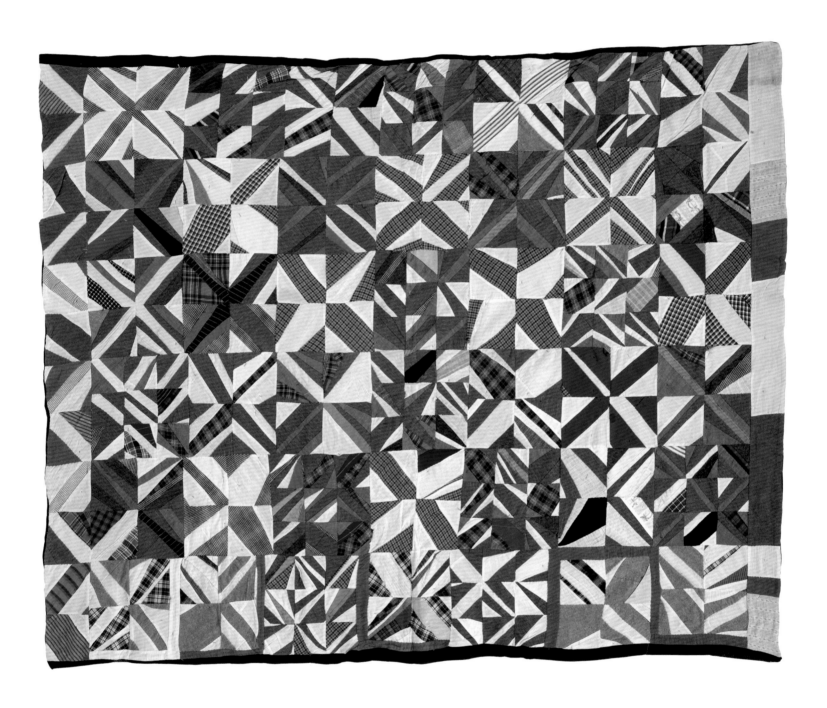

String "X"

c.1940–1960

Found in Natchez, Mississippi

COTTON, FLANNEL, WOOL

80 x 67 inches (203 x 170 cm)

Collection of Allison Smith

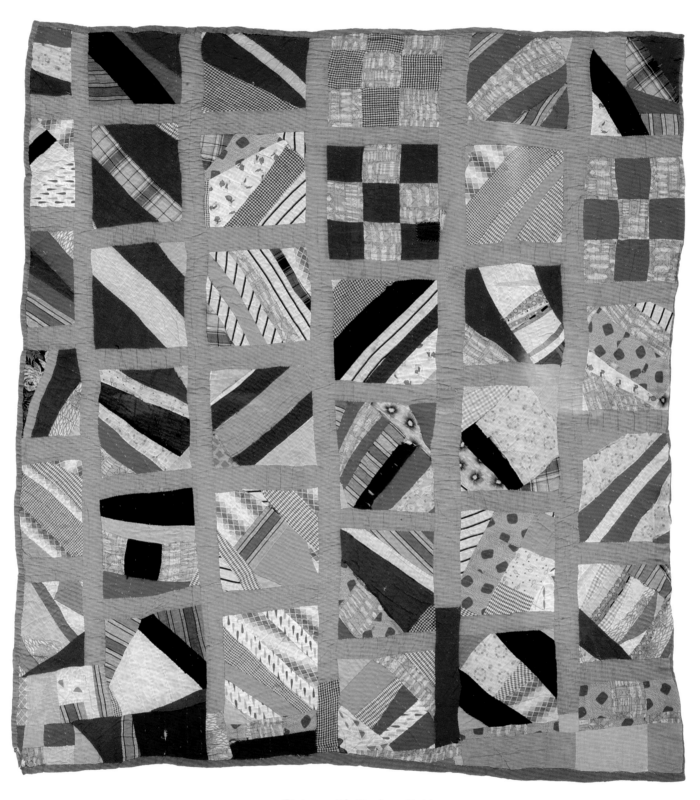

String with Broken Grid

c.1970–1980
Aileen Pearson.
Oxford, Mississippi
African American
COTTONS, BLENDS
72 x 70 inches (183 x 178 cm)
Collection of Jasmine Moorhead

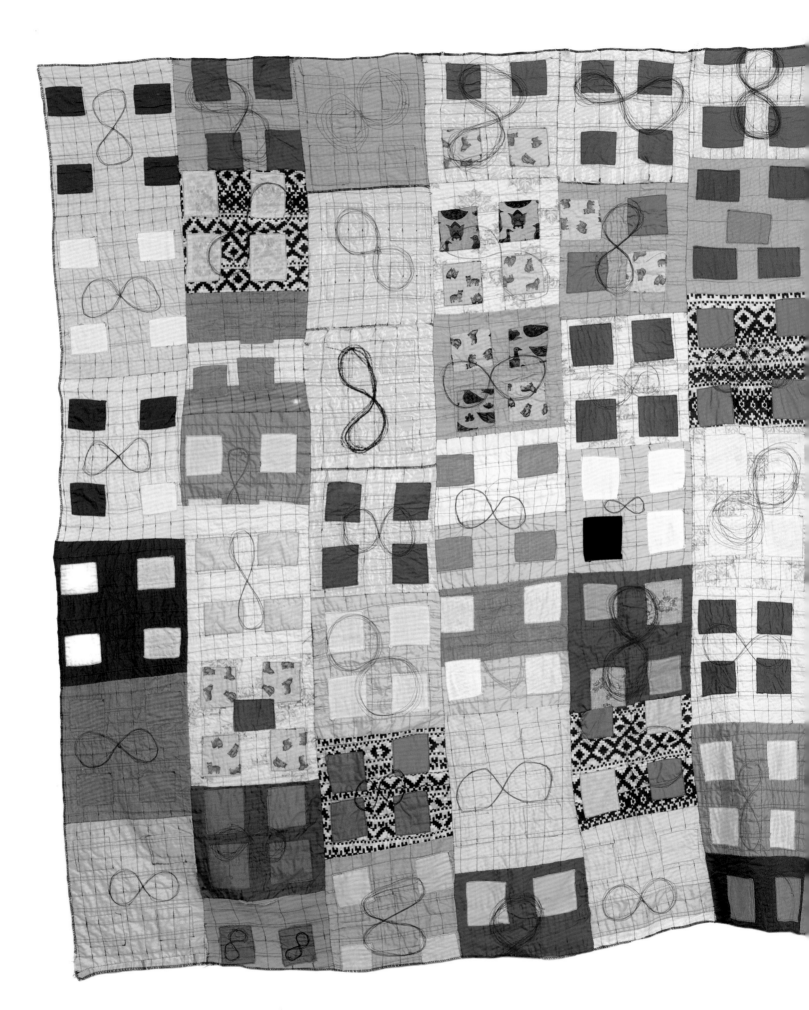

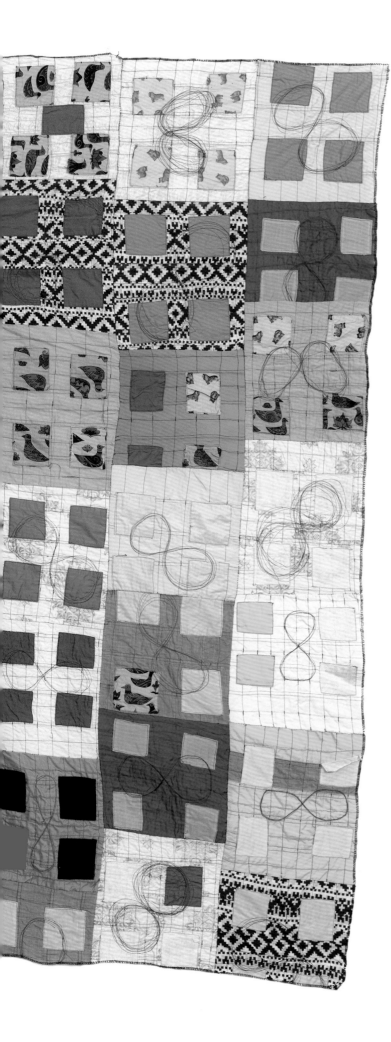

"8"

c.1960–1970
Attributed to Regina "Reggie" Jarvis (or Jervis).
Made in Wilkes-Barre, Pennsylvania
RAYON, COTTON, SYNTHETICS, FURNISHING
FABRICS. 8s AND GRID PATTERN ON EACH
BLOCK ARE MACHINE-STITCHED. FOUR-BLOCK
PATTERN IS MACHINE-APPLIQUÉD. EACH
BLOCK IS WHIP-STITCHED ON ALL FOUR SIDES
BY MACHINE. BLOCKS ARE JOINED BY HAND
80 x 62 inches (201 x 157 cm)
Ex. coll. Sandra McPherson

This is only the second example that I know of with
this pattern; the other is in a collection in Kansas
City, Missouri. Interestingly, both share the same
construction method, the distinctive motif of the
number eight, and the machine-stitched grids.
The scarcity of this pattern indicates perhaps the
same maker, a friendship, or a mysterious and very
particular shared idea. What did the number eight,
or possibly the infinity symbol, mean to the maker,
and why does it only appear in some of the blocks?
These questions add to this quilt's strange magic.

A Brief History of Quilts in Contemporary Art

ELISSA AUTHER

THE PLACE OF THE AMERICAN PIECED QUILT in the history of modern and contemporary art typically begins with Robert Rauschenberg's *Bed* (1955), one of his early "combines," as the artist called his assemblages constructed of found objects. *Bed* consists of a worn pillow, sheets, and a Log Cabin quilt, an ensemble that was framed and hung on the wall like a conventional painting. On these textiles, Rauschenberg slathered and dripped paint in a way that referenced the gestural style of the Abstract Expressionist painters of the period. On the other end of this history is The NAMES Project *AIDS Memorial Quilt*, initiated in 1987 in San Francisco by the activist Cleve Jones. From the quilt's beginnings as a humble, grassroots memorial to those lost to the AIDS/HIV pandemic, it has grown to be one of the largest public art projects in the world. Whereas the actual quilt incorporated into Rauschenberg's *Bed* posed a challenge to modernist hierarchies of the high and low, among other sacrosanct conventions of fine art, the *AIDS Memorial Quilt* tapped into (and continues to draw from) a politics of textile craft that highlights quiltmaking's powerful emotional and cultural associations, especially the sentimental, affective quality of its handmadeness.

After Rauschenberg, the pieced quilt continued to serve as a point of departure and inspiration for artists questioning the historical conventions, definitions, and material limits of art. This was certainly the case with painters in the 1970s, a period in which every aspect of painting—from its privileged status within the hierarchy of genres to the nature of its physical support—was challenged and reinvented. Several artists stand out in this story, including Faith Ringgold, Miriam Schapiro, Al Loving, and Alan Shields.

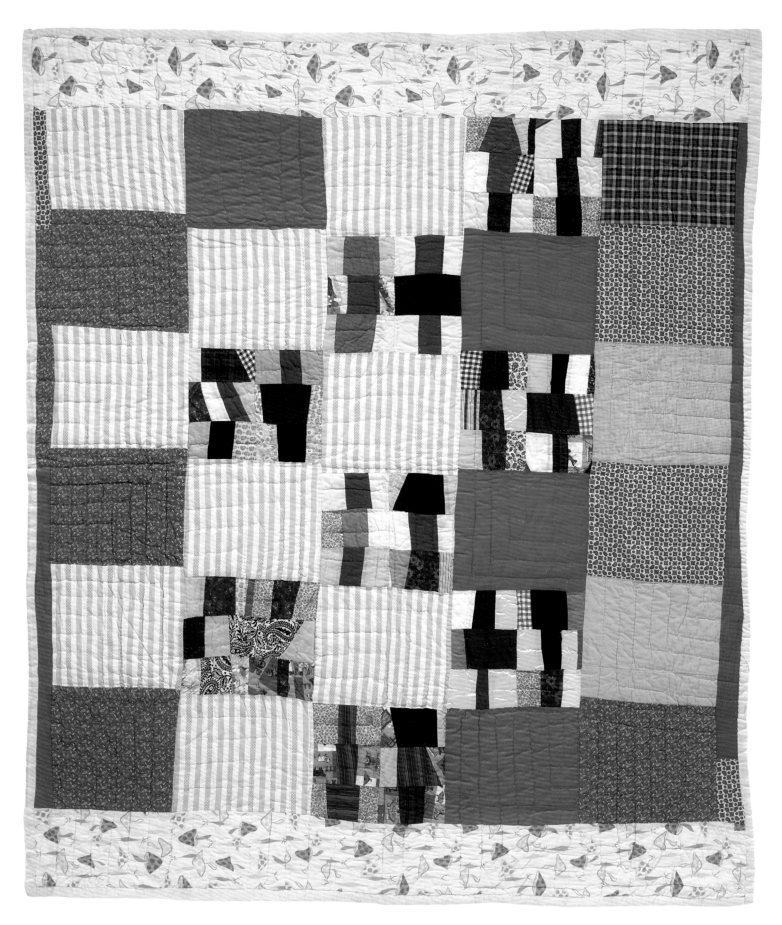

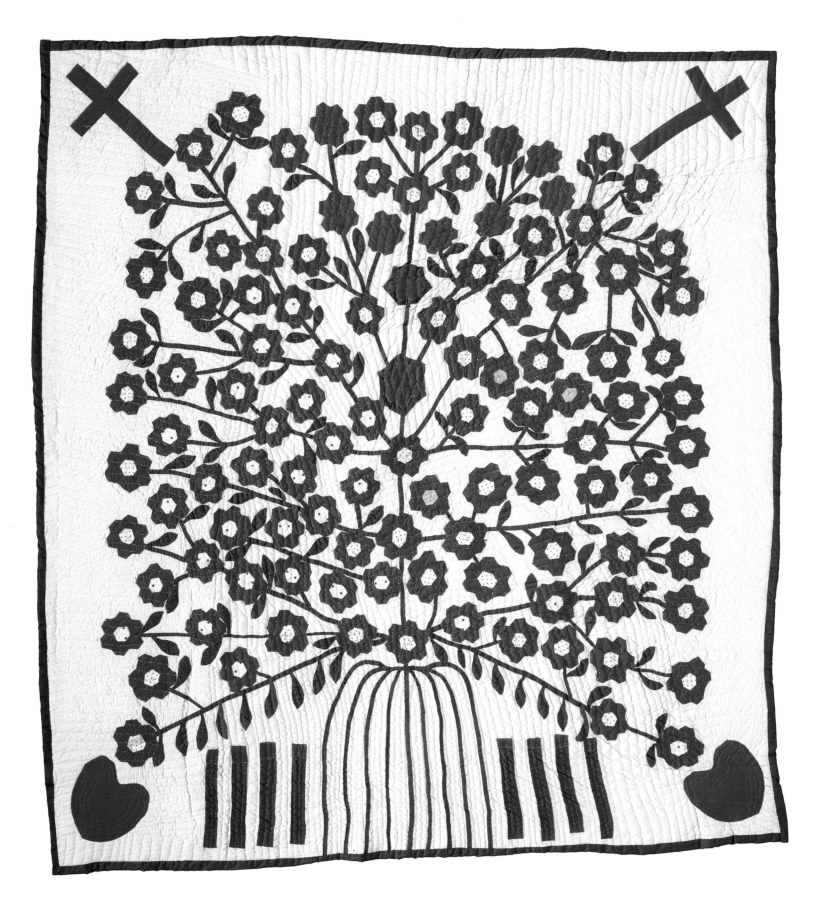

As leaders of the feminist art movement, Ringgold's and Schapiro's interest in the quilt form was motivated, in part, by the objective to recover and reevaluate women's craft traditions as legitimate art forms. By elevating these traditions, quiltmaking among them, feminist artists sought to expose the gender and racial biases that fed into the view of craft as an inherently lesser form of creative expression and thus naturally subordinate to fine art. For Ringgold and Schapiro, both of whom were painters, the quilt also helped them negotiate the vexed relationship of painting to politics at a time when their peers viewed the genre as a tool of the white male art establishment. For Schapiro, who was painting in the current, hard-edge geometric style of the day, the quilt offered a new stylistic direction that was anchored by the grid but home to a form of patterning associated with an opposing, more painterly abstract tradition historically described as feminine and decorative. Schapiro applied the term *femmage* to her new works that combined painted grounds with collaged bits of densely patterned fabric composed to recall the geometry of the female tradition of quiltmaking. For Ringgold, whose mother was a quiltmaker who worked in an improvisational style characteristic of African American quilt traditions, the quilt form was adopted as the ground for narrative painting. Prior to her invention of the genre she called the "story quilt," Ringgold had experimented with the conventions of the Buddhist *thangka*, a form of painting on an unstretched silk ground surrounded by a sewn fabric border. For Ringgold, the adoption of the quilt melded her search for an alternative to the large-scale stretched canvas (particularly its expense and macho associations) and, crucially, an aesthetic tradition that spoke directly to her history as an African American woman.

For another African American artist, Al Loving, quilts were also the vehicle for the radical reinvention of his work that skirted the constraints of formalist abstraction and the demands of the black art movement for a directly political art that took race as its subject. In 1971 Loving saw the Whitney Museum of American Art's exhibition Abstract Design in American Quilts, the first of its kind to make a case for the pieced quilt as fine art based on what was viewed as its uncanny resemblance to contemporary geometric abstraction in painting. Loving was working in just

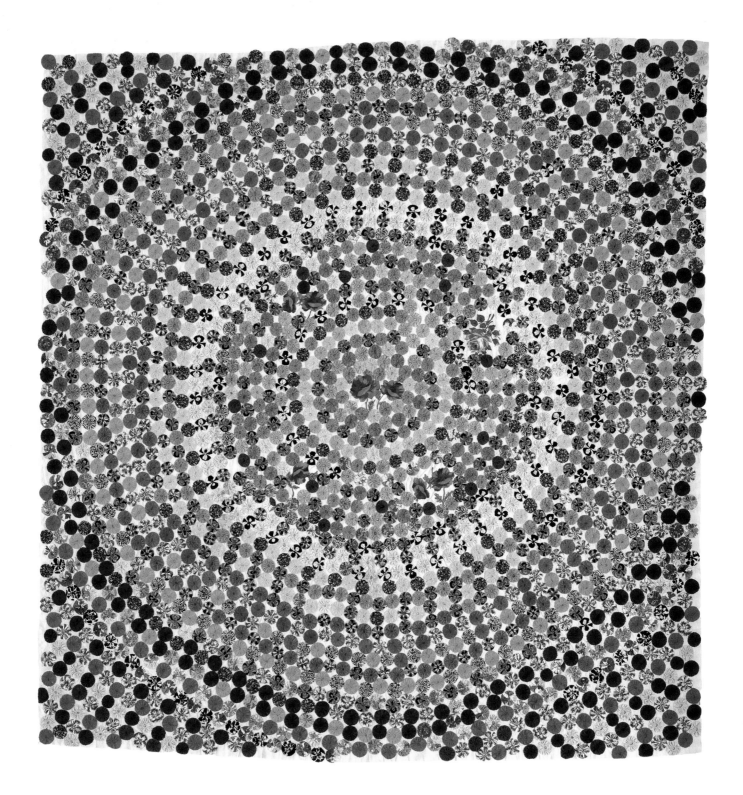

Unique Yo Yo

1964
Laura Otto.
Fairview Park, Ohio
COTTON. APPLIQUÉD
89 x 85 inches (226 x 216 cm)

This Yo Yo quilt is appliquéd to its backing.
It calls to mind Jim Hodges' floral fabric
sculptures, or Yayoi Kusama at her most
polka-dot-obsessed.

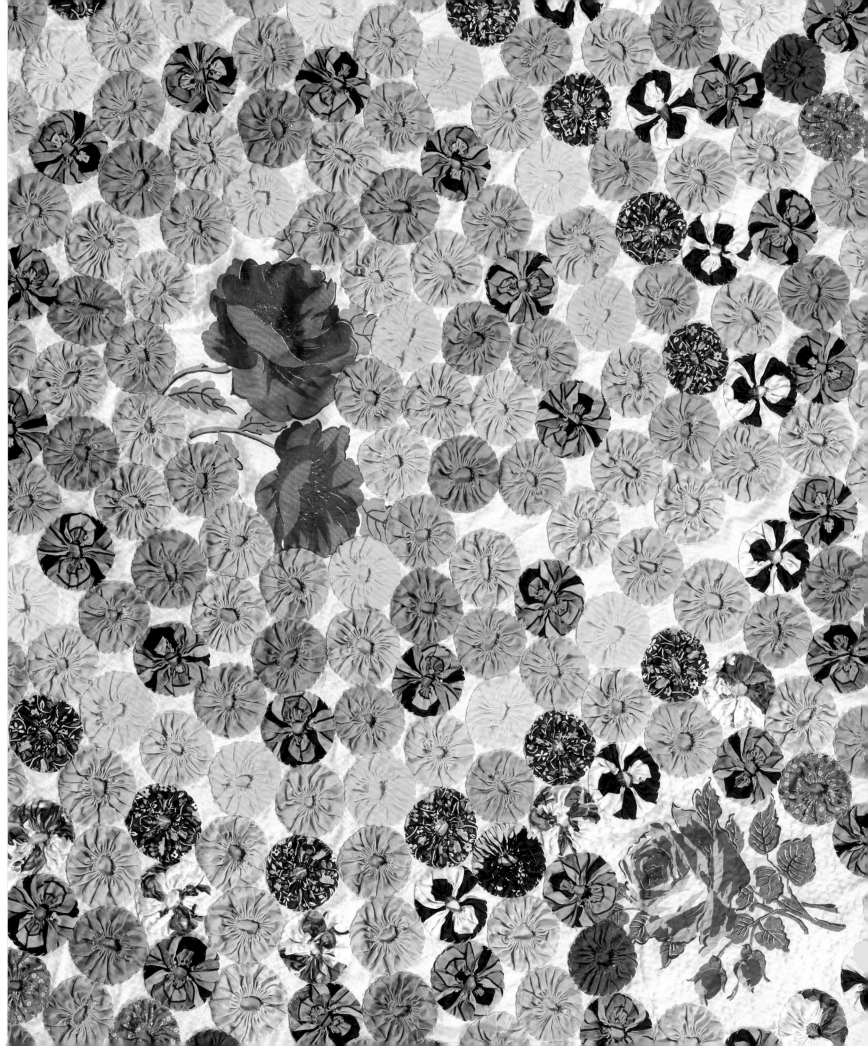

ELISSA AUTHER *is associate professor of contemporary art at the University of Colorado, Colorado Springs, and an independent curator. She is the author of* String, Felt, Thread: The Hierarchy of Art and Craft in American Art *(2010) and the co-editor of* West of Center: Art and the Counterculture Experiment in America *(2012). She co-directs the public program* Feminism & Co.: Art, Sex, Politics *at the Museum of Contemporary Art Denver.*

the quilting bee has resurfaced as a form of engagement. Smith's collaboratively produced quilt is one example (although not necessarily named as such), while others, such as Ginger Brooks Takahashi's project *An Army of Lovers Cannot Fail* (ongoing since 2004) consciously revives the form. This collaborative project—the title of which comes from an early gay liberation poster—is an ongoing quilting bee conceived as a form of LGBT activism rooted in community building.

Josh Faught's use of the quilt brings us back to The NAMES Project *AIDS Memorial Quilt*. In his 2012 installation *Longtime Companion*, Faught includes replicas of the *AIDS Memorial Quilt* in the form of woven jacquard blankets in which quilt panels have been digitally reproduced in a subdued palette. These works are quotations of the *AIDS Memorial Quilt* translated into a new medium and integrated into a larger installation about craft, sentimentality, and queer history and identity as the AIDS/HIV pandemic recedes from our immediate consciousness. Although Faught's works are not quilts per se, they propose a way of knowing quilts that highlights the sociality of quiltmaking, our sentimental attachment to quilts, and the quilt's history as a memorializing form. Faught's work is representative of the way contemporary artists embrace quilts as an affective medium, as a geometric language to be mined, and as an activist tool.

Quilts officially made their debut as art in the New York art world in the exhibition *Abstract Design in American Quilts* that opened at the Whitney Museum of American Art in 1971. The broader context of this reception, which it both complemented and complicated, was hard-edge abstraction in painting. The geometric abstraction of quilts continues to be valued in the contemporary art world, but it is quiltmaking's historical, social, and political meanings (all of which were actively suppressed in the Whitney exhibition in favor of a formalist reading of their designs) that appear at the forefront of artistic practice today.

OPPOSITE

String with Broken Grid

c.1950–1975
Found in North Carolina
COTTON
80 x 77 inches (203 x 195.5 cm)

The pink broken grid both overlays and completes the pattern of this quilt. The lattice appears anchored to a hilly landscape and holds the dynamic tension of the colorful patterned "string" pieces behind.

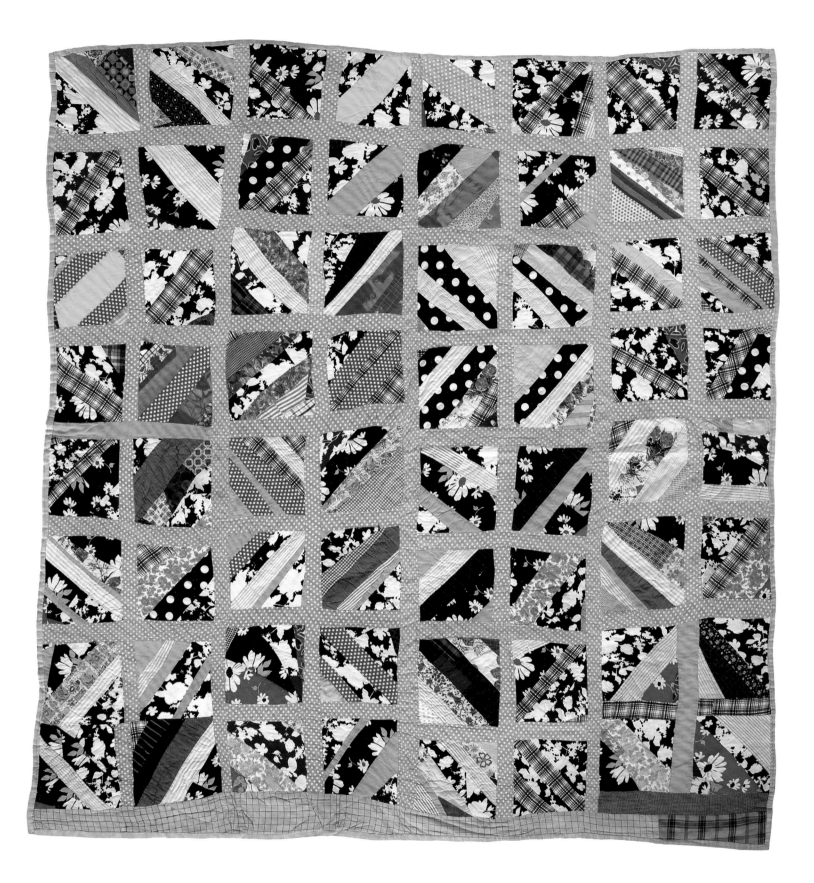

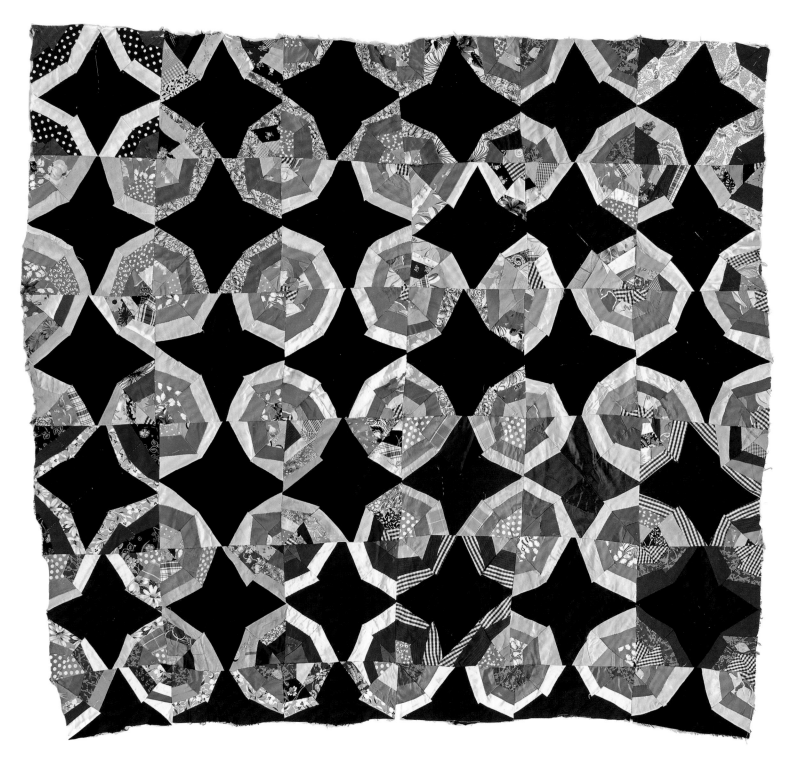

Spider Web (unfinished top)

c.1920–1940

Made in Oklahoma. Found in Lubbock,
Texas, at the estate sale of the maker

SILK, RAYON, SATIN, COTTON

FOUNDATION-PIECED

BY HAND AND MACHINE

67 x 76 inches (170 x 193 cm)

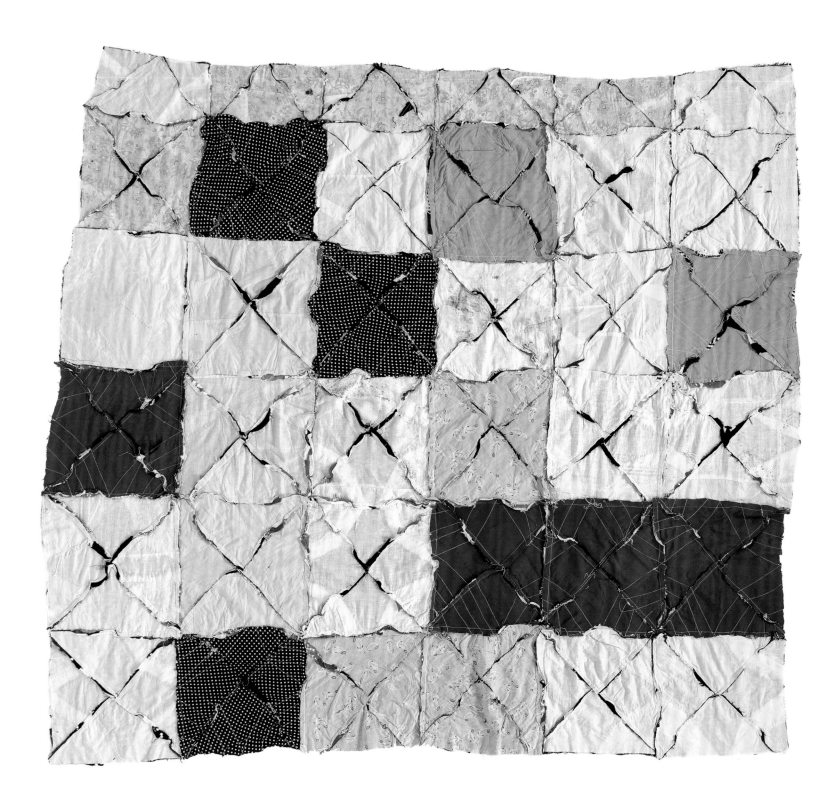

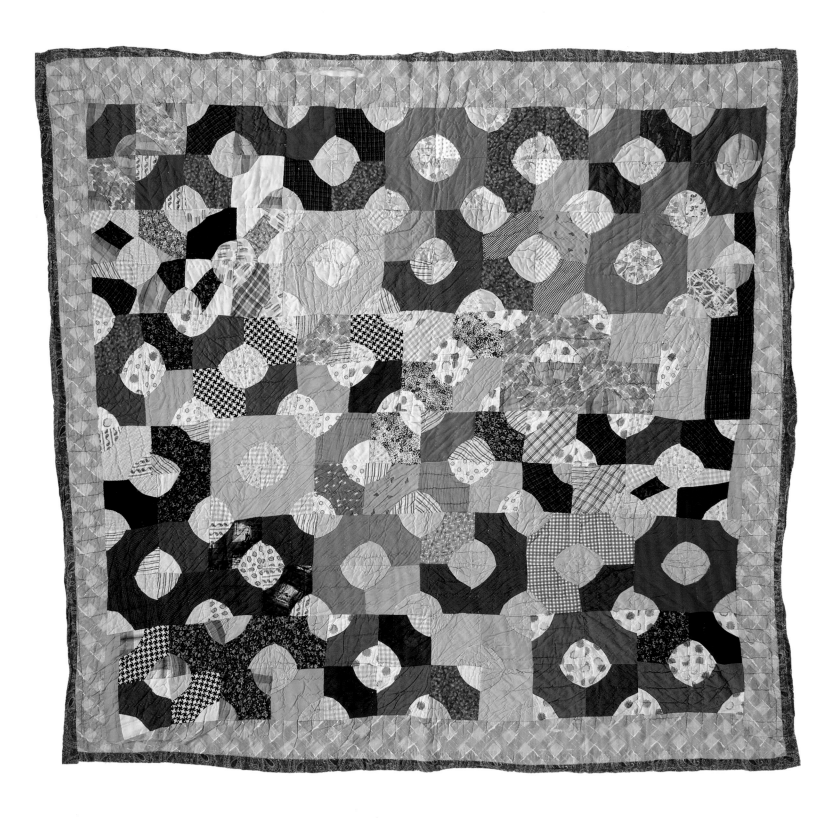

ABOVE

Baseball / Snowball, variation

c.1950–1975
Attributed to Sibyl Mays.
Found in Green County, Alabama
COTTON, BLENDS
79 x 84 inches (201 x 213 cm)

OPPOSITE

Log Cabin, variation

c.1950–1975
COTTON, CREPE, RAYON. TIED
85 x 67.5 inches (216 x 171.5 cm)

This unique and unexpected Log Cabin is full of brilliant geometric movement that brings to mind Picasso's Three Musicians *or Italian Futurism. Looking into the center of each block creates the illusion of almost falling into an abyss.*

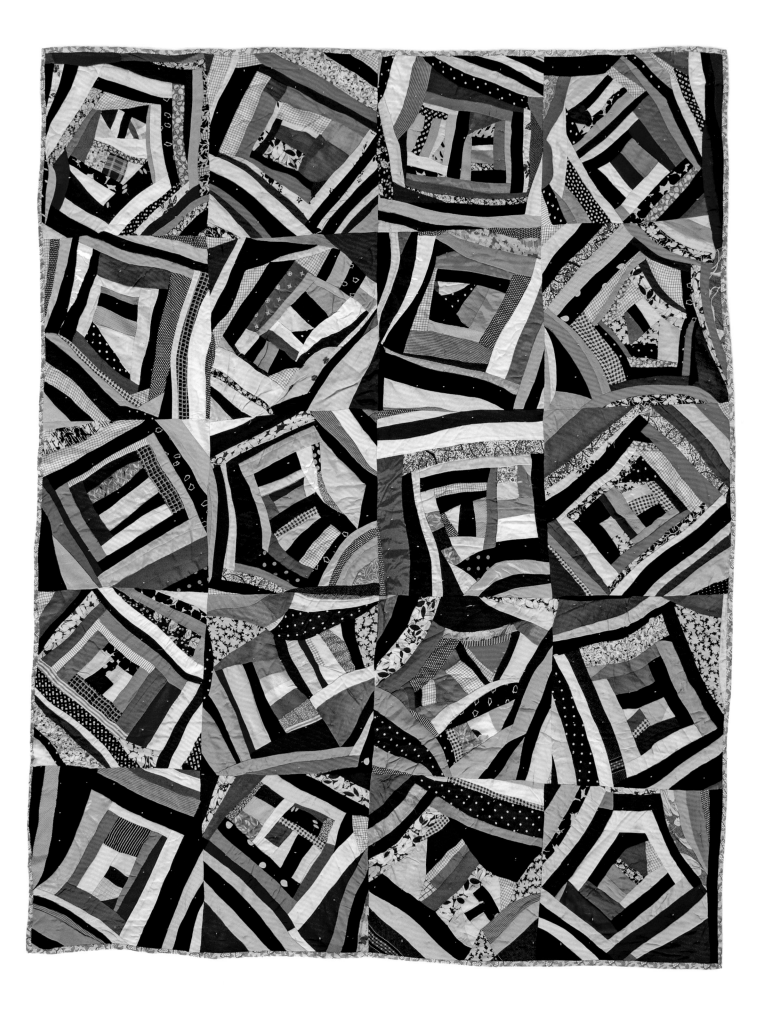

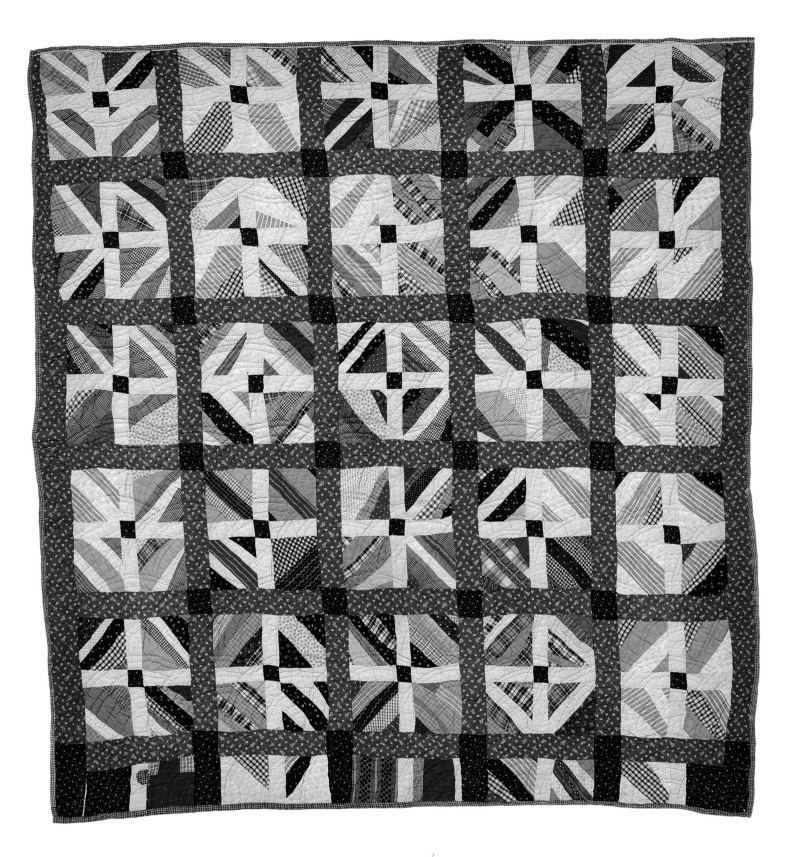

String with Double Grid

c.1900–1925
Found in Tennessee
COTTON
79 x 76 inches (201 x 193 cm)

124

This is an early example of a quilter beginning to break the rules and improvise. Compare this one to the later quilt on the opposite page by Frances Sheppard.

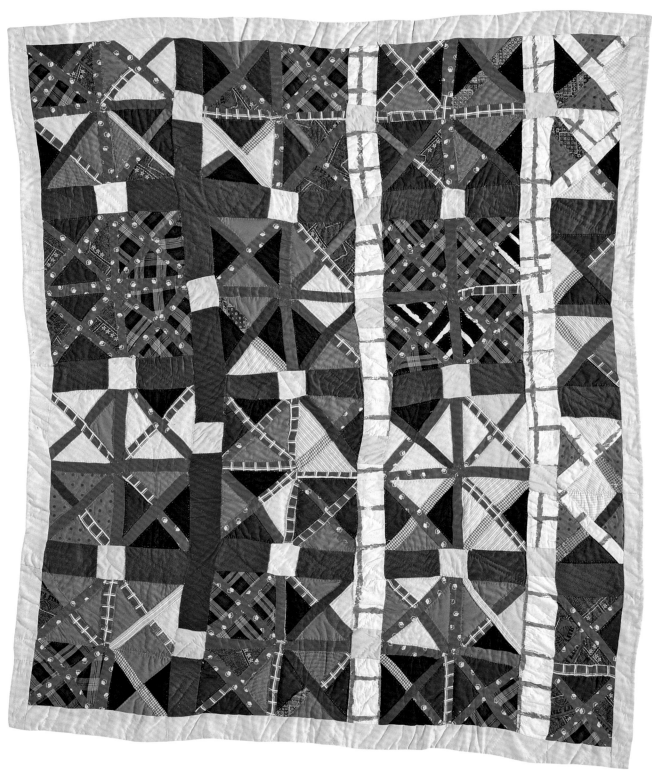

"Four X"

1980–1989

Pieced by Frances Sheppard, Las Vegas, Nevada (1980s).

Quilted by Irene Bankhead, Oakland, California (1989).

African American

COTTON, BLENDS

70 x 80 inches (178 x 203 cm)

Collection of Eli Leon

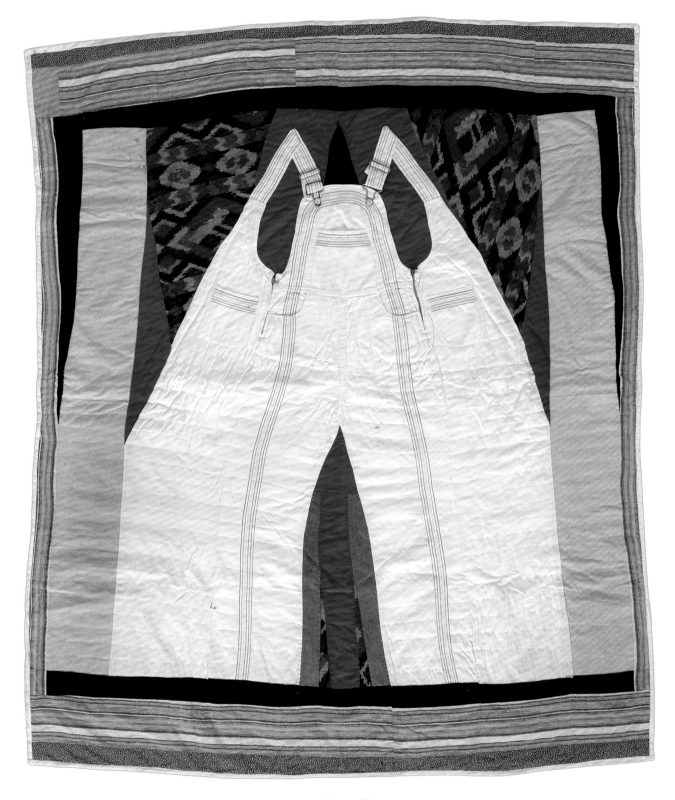

"Overall"

1993

Pieced by Arbie Williams. Quilted by Irene Bankhead.

Oakland, California

African American

COTTON, CORDUROY, UPHOLSTERY FABRIC

76 x 66.5 inches (193 x 169 cm)

Collection of Eli Leon

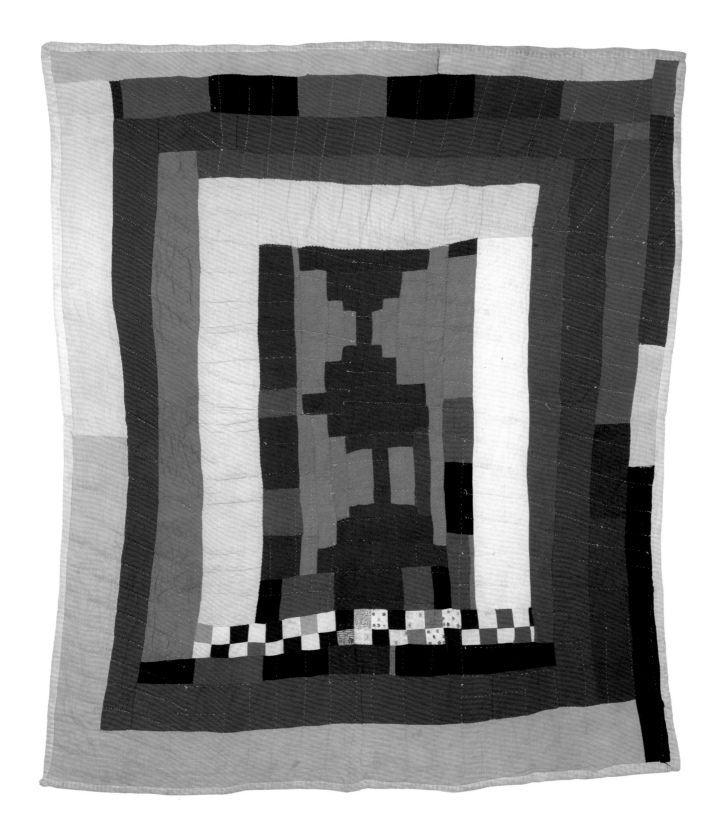

Log Cabin / Courthouse Steps, variation

c.1940–1970
Attributed to Ruby Noles McGill.
Found in Eldridge, Alabama
COTTON, WORK CLOTHING, FLANNEL,
CORDUROY. QUILTED WITH STRING
78 x 66 inches (198 x 167.5 cm)

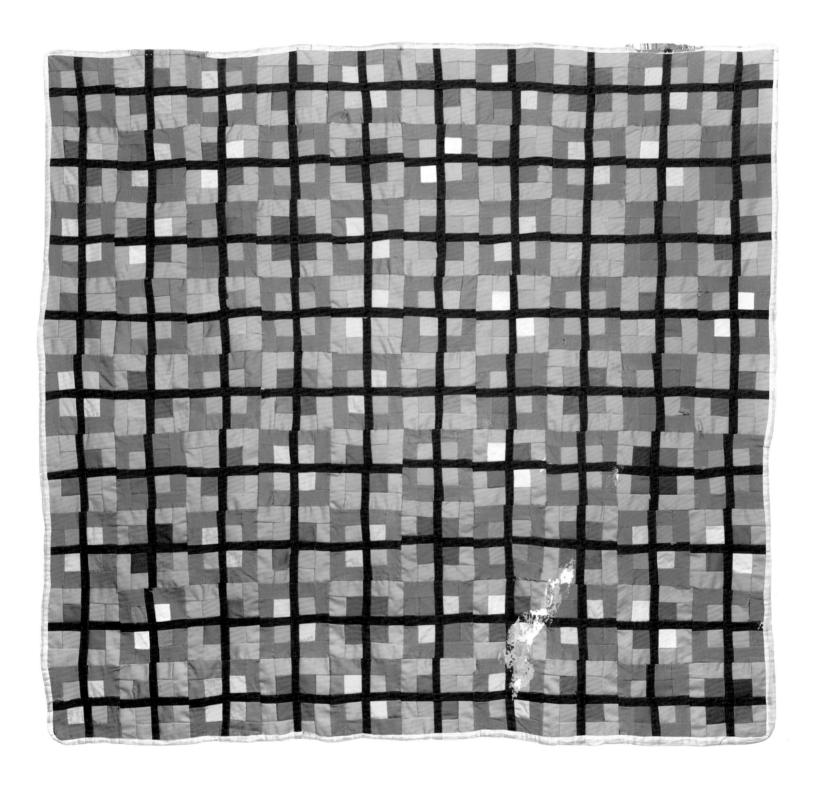

Broken Grid / Strips (double-sided)

c.1960–1975

Found in Kentucky

COTTONS, BLENDS, SATIN, POLYESTER. TIED

58 x 64.5 inches (147 x 164 cm)

Notice the two areas where the seams have separated (opposite); the larger one almost appears to be a slash on the canvas allowing the viewer to see the back of the other side. When I purchased this piece I had only seen the grid side of the comforter (above), but the rawness of the opposite side is stunning.

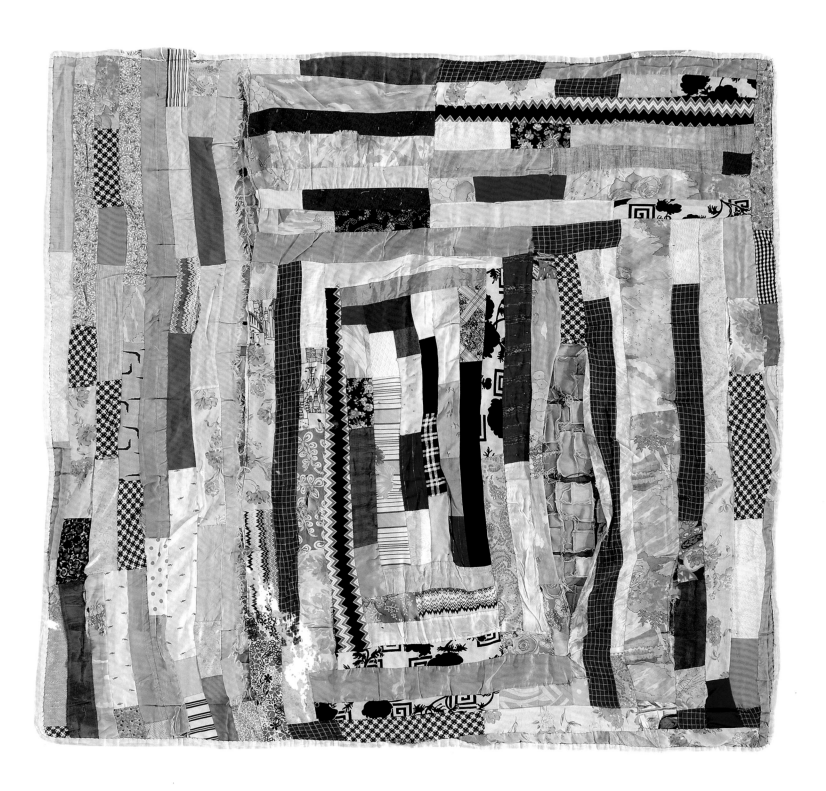

From Under the Bedcovers:
A Culture Curator's Perspective

ULYSSES GRANT DIETZ

I'VE BEEN A DECORATIVE ARTS CURATOR FOR THIRTY-THREE YEARS. Although I have never been trained as a textile specialist, the Newark Museum's holdings of fashion and textiles fall under my watchful eye. I did my first exhibition of quilts from Newark's collection in 1980, when I was twenty-five and had only been a curator for four months. The small exhibition in what we called our "community gallery" (really a holding pen for school groups) was "A Festival of Quilts: Colorful Examples from the Museum's Collection." As I recall, all of the quilts had a lot of red and green in them, to highlight the Christmas season. It was not by any stretch of the imagination a scholarly effort. My selection was entirely based on simple concern for color scheme and on how each quilt appealed to my personal aesthetic. I have no shame in having done this: It filled a need and pleased an audience. I have no doubt that the visitors to the museum during the holiday season in 1980 went away a little bit better informed than when they arrived. Any curator who claims his or her job is grander than that is delusional. A curator's job is to spark interest and provoke thought.

Thus it is that quilts, of all the textiles in Newark's storerooms, are the most near and dear to me. And the course of my career as a curator has followed the evolving scholarship on and interest in quilts—as material culture, as folk art, as fine art. If I differ from Roderick Kiracofe in my perspective on quilts, it is in my inner need to have a *story*. I find, after all these years, that the quilts I love most are the ones with full histories—the who, what, when, where, and (if I'm *really* lucky) why. On the other hand, for this project Kiracofe has embraced the

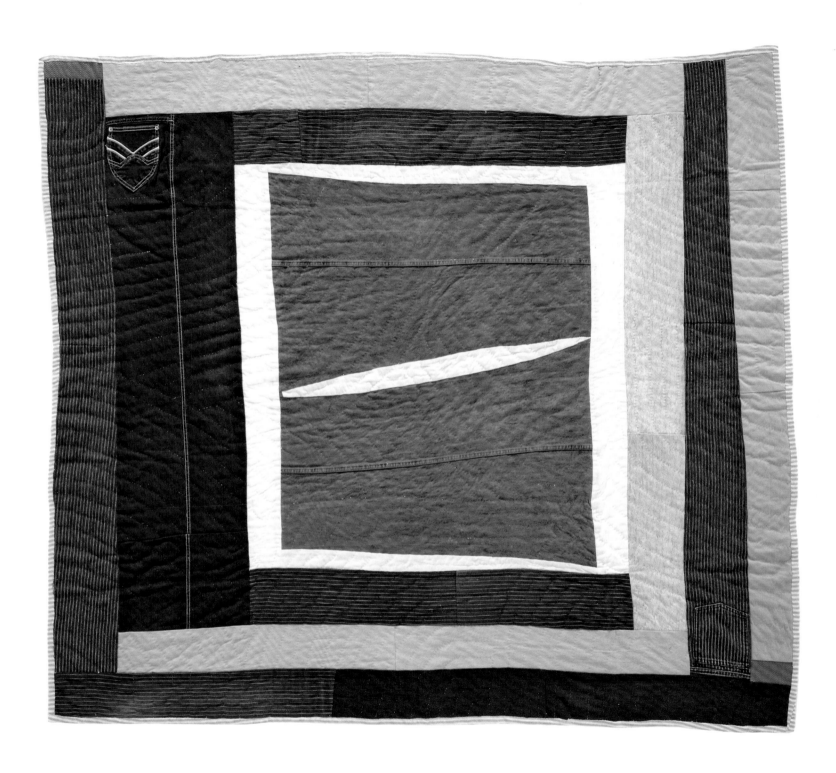

"Bell Bottom Medallion"

1991

Pieced by Arbie Williams. Quilted by Irene Bankhead.

Oakland, California

African American

COTTON, DENIM CLOTHING, CORDUROY

67 x 74 inches (170 x 188 cm)

Collection of Eli Leon

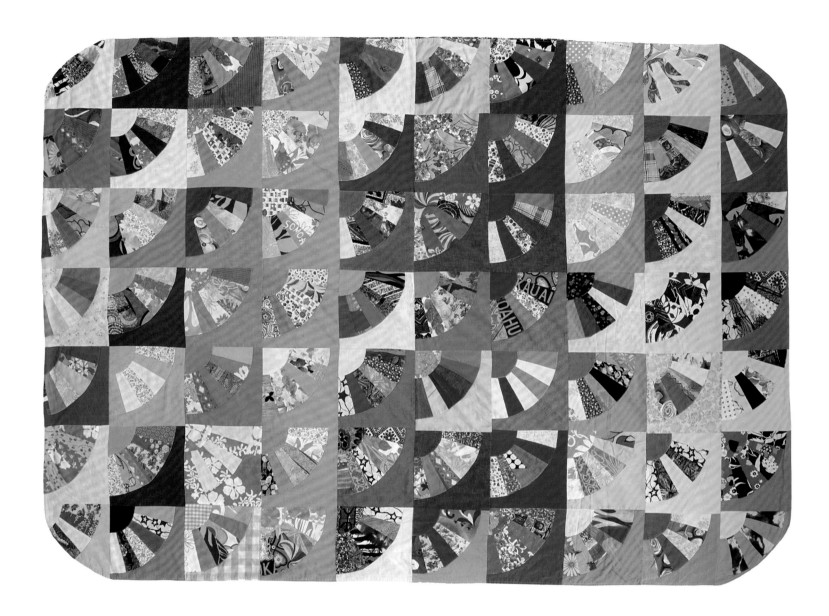

ABOVE

Fan

c.1970–1980
Attributed to Lori Apo.
Made in California or Hawaii
COTTON, BLENDS, CORDUROY,
NOVELTY PRINTS
90 x 72 inches (228.5 x 183 cm)
Ex. coll. Eli Leon

OPPOSITE

String

c.1940–1970
Attributed to "Aunt Etta."
Found in the Texas Panhandle
RAYON, VELVET, SATEEN. TIED
92 x 75.5 inches (234 x 192 cm)

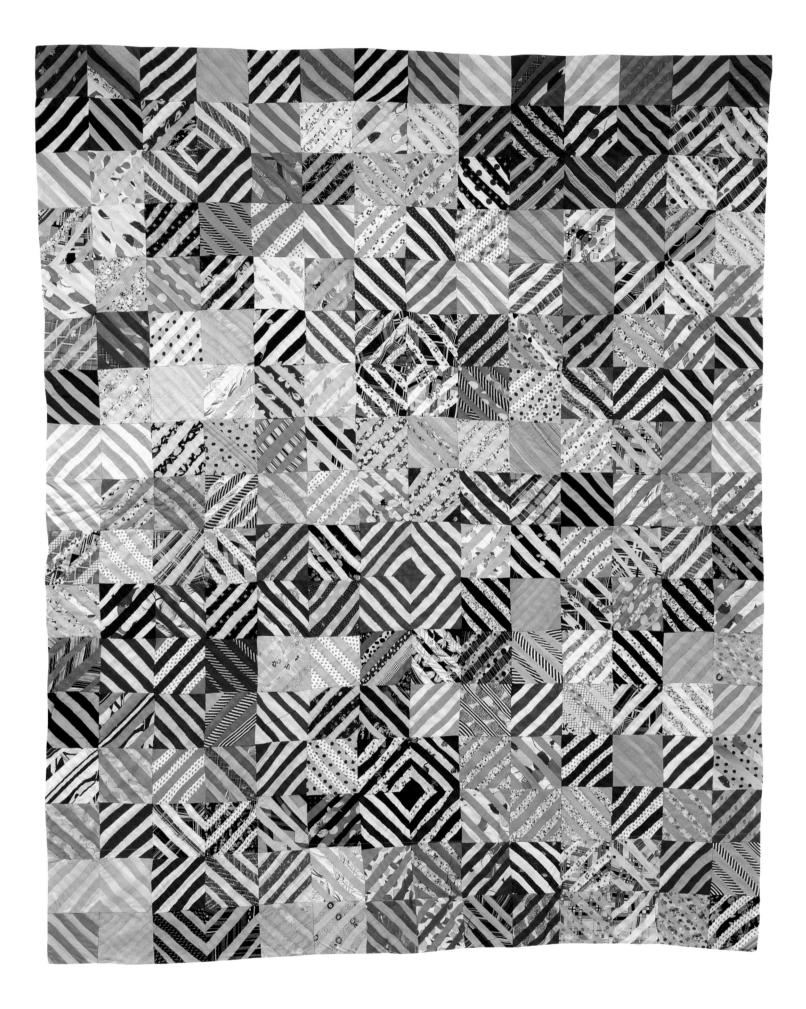

but the combination of ingenuity and frugality embodies the sacred mythology of scraps and proves both its truth and its aesthetic potential.

One type of quilt that Newark's collection does not have is the Spider Web, but I can readily see how this pattern would have flourished in the last quarter of the nineteenth century, because of the constant theme of spiderwebs within the Aesthetic movement of the 1870s and 1880s and because of the potential for visual dazzle with this pattern in the hands of a master. Three variations of this pattern, spanning an overall period of eighty years, are in Kiracofe's collection. I think their differing appeal is very telling and underscores the ways in which anonymous quilts can speak to the viewer.

The most recent of these quilts, made in the last quarter of the twentieth century, is also the most anonymous (page 144). The brilliant colors of the four-pointed-star voids created by the spiderweb motifs attest to its place in aesthetic history. The use of a multifarious group of scraps speaks to a keen eye wrangling a mess of color and pattern into coherence. But there is a precision here, a tidiness, an intentional *prettiness* that, to me, suggests that this is a quilt in which the scraps were a challenge and a virtue rather than a function of needful thriftiness. It is a very appealing quilt, but it is, somehow, less interesting to me than the other two. I also dare to suggest that this quilt, to me, of the three, is the one most likely to have been made by a white woman. More on that anon.

The second Spider Web quilt has the most detailed history—something that would have a special place in a curator's heart. It was made by an unknown African American woman between 1940 and 1970 in the Hard Bargain community of Franklin, Tennessee (page 145). In this version, two things strike me immediately: the spiderweb motifs are less carefully fitted together and the star-shaped voids recede from the eye due to the drab olive cloth of which they're made. Thus the grid of full, half, and quarter spiderwebs floats in the foreground, and their unevenly matched edges create a visual motion that keeps the eye moving, unsettled. It is altogether a different experience to look at than the later quilt and has an uncanny sense of "authenticity" about it that is borne out by knowledge of its origins. The

OPPOSITE (FRONT) &
FOLLOWING PAGE (BACK)

Crazy Log Cabin, variation
c.1950–1975
Found in Kentucky
COTTON, BLENDS
84 x 70 inches (213 x 178 cm)

Backing is constructed of hand-dyed feed sacks (page 138).

136

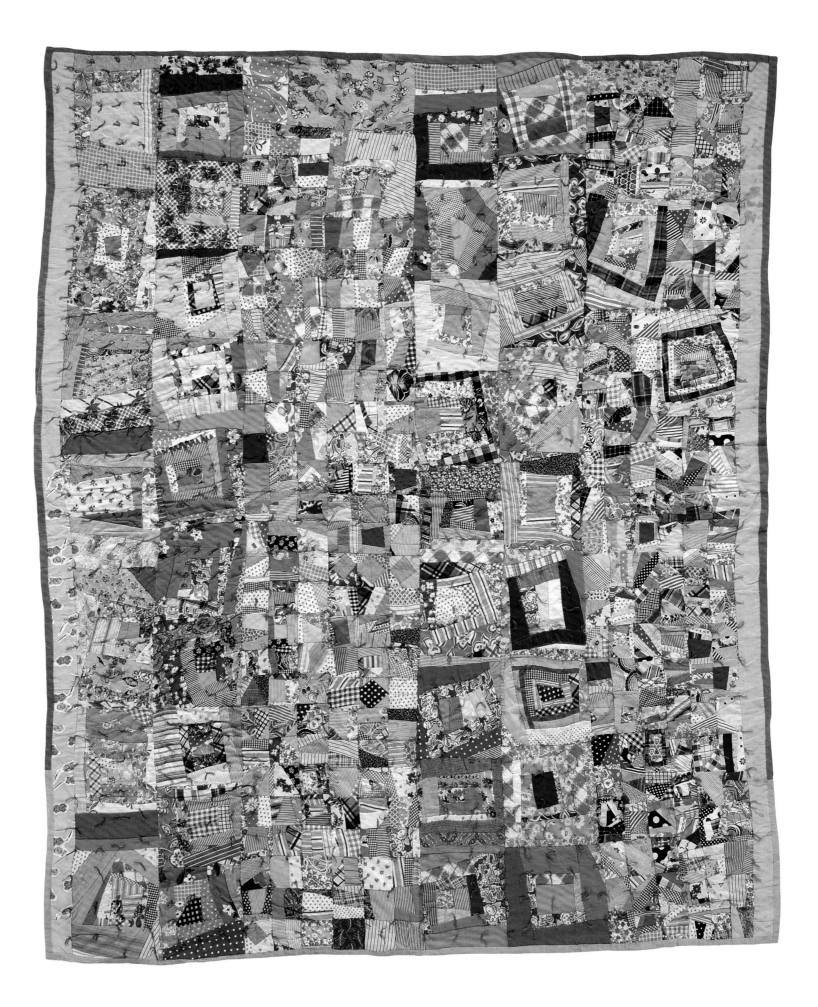

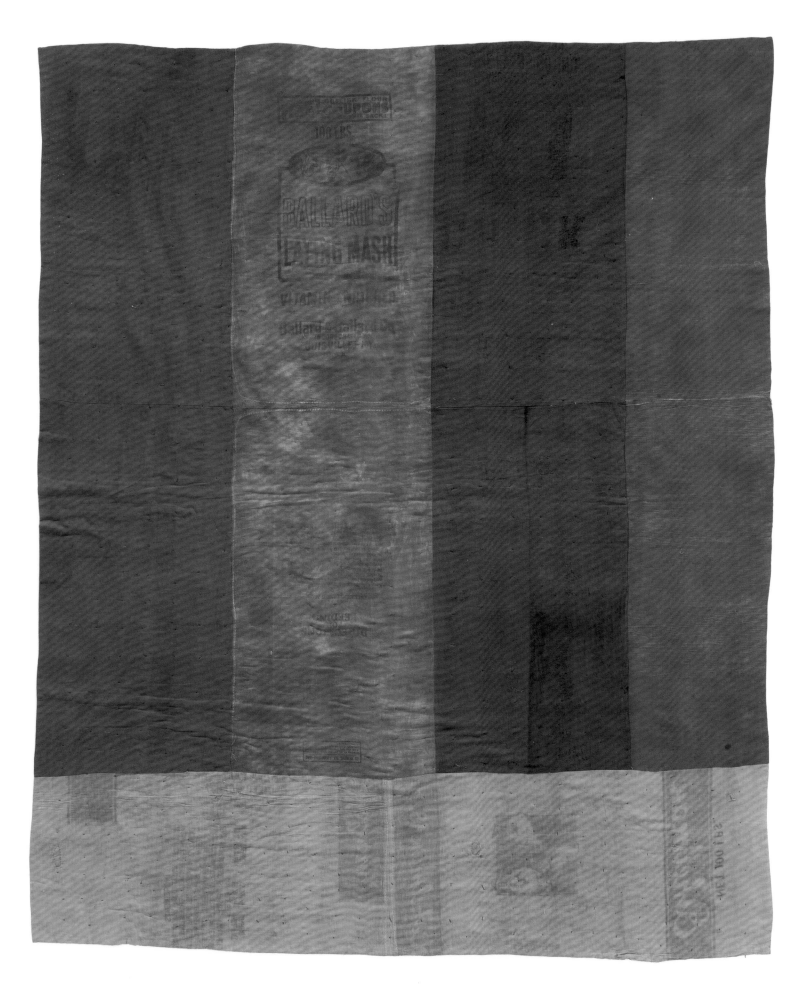

randomness in size, pattern, and color of the pieces of cloth simply adds to the "folk art" appeal it presents.

To me, the most interesting of the spiderweb variations is one for which the geographic origin is known, but nothing else (page 120). Produced in the 1920s in Lubbock, Texas, the improvisational nature of the piecing in this quilt top has gone a step further—the spiderweb corner segments are wildly misaligned, creating a jagged, whirling visual effect. The star-shaped voids are in black, and thus truly become voids, thrusting the more colorful webs up and off the viewing plane. It is the least "pretty," but the most exciting of the three Spider Web quilts. The visual interest inherent in the quirkiness and lack of adherence to formal pattern undoubtedly led to this quilt being included in the exhibition Fancy Work at the San Francisco Museum of Modern Art in 2010. The fact that I (unwittingly, unprompted) favored the quilt that ended up in a modern art exhibition is in itself telling. It speaks not just to the inherent aesthetic qualities of the quilt or the artistic skills of the maker, but also to the cultural moment that we—quilt collectors and quilt curators alike—are in right now. I call this the Gee's Bend Syndrome.

As a curator, I have purchased a number of twentieth-century quilts produced by anonymous African American makers. Like every other curator who has done so (and there really aren't so many of us), I was startled by and drawn to the uncanny resonance these quilts often have with modern art in the geometric abstraction. As a textile curator I was also fully aware of the presumed but not-quite-clear connection between these historically neglected "improvisational" quilts and African textile traditions dating back to the time of enslavement in the United States.[1]

And how did I become aware of this? It all began with the emergence of the quilts made in Gee's Bend, Alabama—in particular those quilts that premiered at the Museum of Fine Arts, Houston, and then made huge headlines at the Whitney Museum of American Art in New York in 2003 (where the exhibition got a lot more publicity). Suddenly the whole sophisticated modern art world was agog at these miracles of modernity produced in a rural backwater by a group of women who had no idea that they were making modern art.

The main concern I have always had regarding the Gee's Bend phenomenon is twofold. First, it fosters the false assumption that the quilters of Gee's Bend were in fact doing anything different from what every community of African American women anywhere in the United States had been doing for generations. Kiracofe's collection shows that indeed they were not. Additionally, the women of Gee's Bend were still working within the even larger tradition shared by all women across American cultural history—the tradition of scraps and frugality, the tradition of channeling artistic impulses into practical ends. In my cynical mind, the idea of Gee's Bend quickly ceased having any cultural importance and became a marketing tool for the mainstream collecting world across the country. Curatorial decisions and therefore museum exhibition trends in the United States have always been driven by the market, which has always seemed to me to be a blatant cooption of cultural truth for the sake of trendiness.

For me, one of the most compelling recent cross-cultural connections has been the emergence in the American consciousness of quilts made by the Siddi people of the Karnataka region of India, concentrated in two main villages of Kendalgiri and Mainalli.[2] Women in this isolated region of India have been producing brilliantly colored, improvisationally pieced bedcoverings for generations. What is most fascinating is that these women are part of a very old and distinct cultural subgroup in India—descendants of African immigrants (both slave and free) into Goa in the sixteenth century through the influence of the Portuguese.

In collaboration with both the African and Asian curators at the Newark Museum, I recently acquired two of these Siddi quilts—one made for a child, one for an adult. In the Kiracofe collection, there are many quilts that resonate across the world between India and the United States. One particular example jumps out at me as a visual link between these two far-flung parts of the African diaspora. The family circle of Mettie House Pressly of Wilcox County, Alabama, produced this strip quilt (opposite) between 1975 and 2000. Its bright colors, random-sized pieces, and quick practical stitchery, all echo similar elements found in Siddi quilts. The essential need for frugality among the Siddis parallels the same need in African American

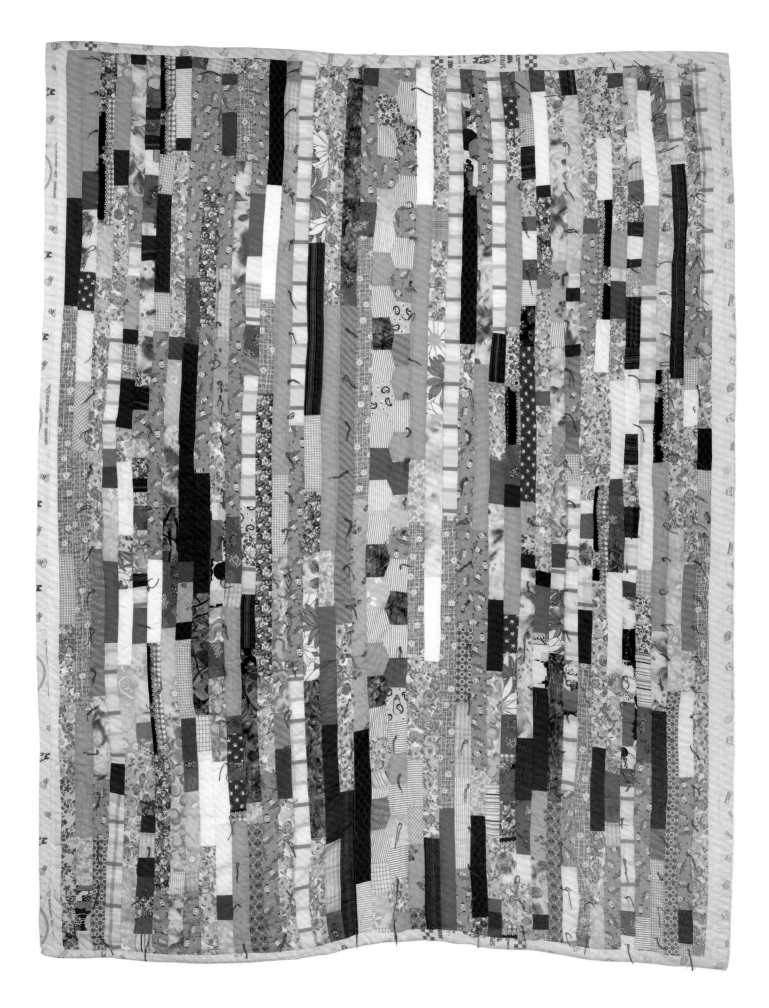

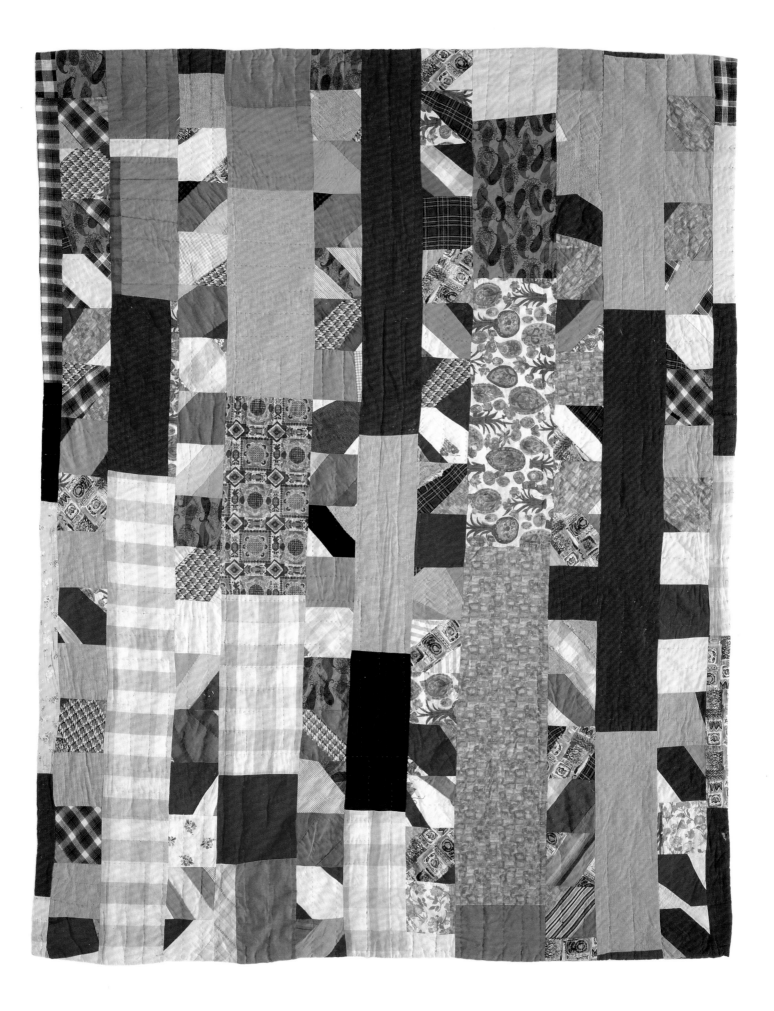

culture, particularly if one imagines the sparse economics of slave life in the nineteenth-century South. The thought that the women of Kendalgiri and Wilcox County have been making similar quilts, linked by oral traditions tied to some common point of origin on the African continent centuries ago, sends shivers up my spine.[3]

While well known in the world of Africanists and textile curators in America, the Siddi connection has not achieved the same sort of celebrity as Gee's Bend, although Professor Henry J. Drewal has created a compelling traveling exhibition that, one hopes, will find its way into at least a few American museums.

To conclude, I have to reiterate that my personal love of quilts stems from my training as a decorative arts curator. While I am not immune to the mental connections that my art historical education insists on making between many twentieth-century quilts and examples of geometric abstract art, I am very leery of such comparisons as a means of validating an object's artistic worth. I am, after all, emphatically *not* an art curator, and I am inclined to see these connections between modern art and African American quilts as false cognates—accidental intersections with no cultural weight beyond delightful coincidence. For me, the most valid way to discuss quilts is through their own virtues. Are they beautiful? Does looking at them give pleasure? Why is that so? The real art in these anonymous quilts is the remarkable, God-given gift for design and color, for layout and form that the unknown makers have brought to them. They need no further validation, and surely not the validation of the modern art world. These quilts would exist, and would mesmerize and inspire, even if modern art had never existed.

ULYSSES GRANT DIETZ *has been the curator of decorative arts at the Newark Museum since 1980. The curator of over 100 exhibitions during his tenure, Dietz is particularly proud of his work on the Newark Museum's 1885 Ballantine House, which was reinterpreted and restored as the centerpiece of the decorative arts department in 1994. In 1997 Dietz was the project director for The Glitter & The Gold: Fashioning America's Jewelry, the first-ever exhibition and book on Newark's once-vast jewelry industry. He was the curator of Great Pots: Contemporary Ceramics from Function to Fantasy in 2003, an exhibition of the museum's studio ceramics for which he wrote the catalog. For the museum's centennial he organized 100 Masterpieces of Art Pottery, 1880-1930, for which he also wrote the catalog. Also in 2009 he cowrote Dream House: The White House as an American Home.*

OPPOSITE

Original Design

c.1950–1975
*Attributed to Jessie McAdams.
Found in Sand Hill, Alabama*
COTTON, BLENDS, UPHOLSTERY
FABRIC. HAND-QUILTED
WITH PINK THREAD
83 x 66 (211 x 167.5 cm)

The bold pieced vertical sashing bands appear to stand in front of the chaos behind them.

143

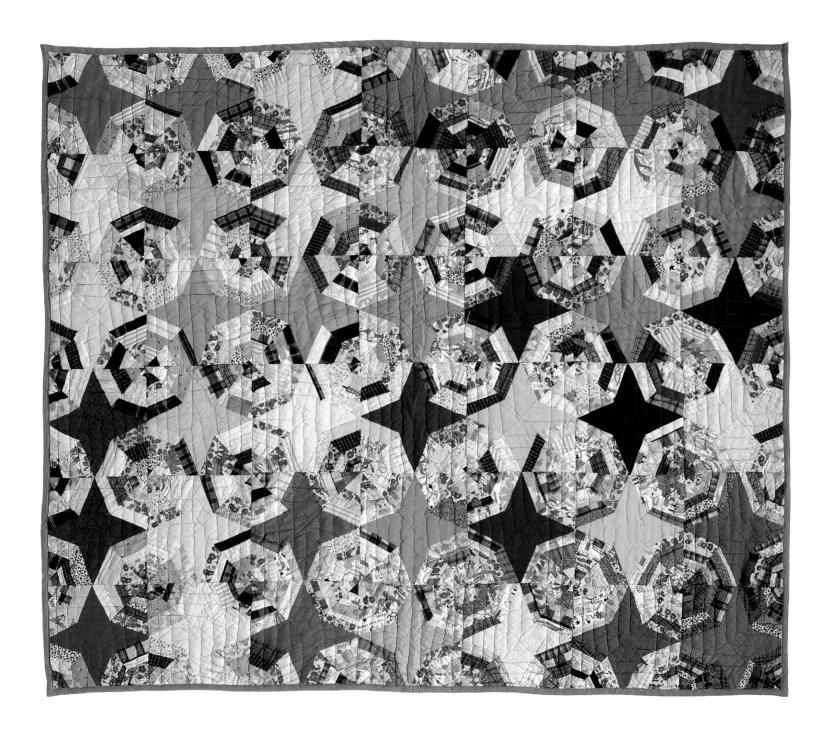

ABOVE

Spider Web

c.1975–2000
COTTON, BLENDS
HAND- AND MACHINE-QUILTED
86 x 73 inches (218 x 185.5 cm)

OPPOSITE

Spider Web

c.1940–1970
*Made in the Hard Bargain community
of Franklin, Tennessee, a predominately African
American community dating back to the 1870s*
COTTON, SOME HAND-DYED
80 x 64 inches (203 x 162.5 cm)

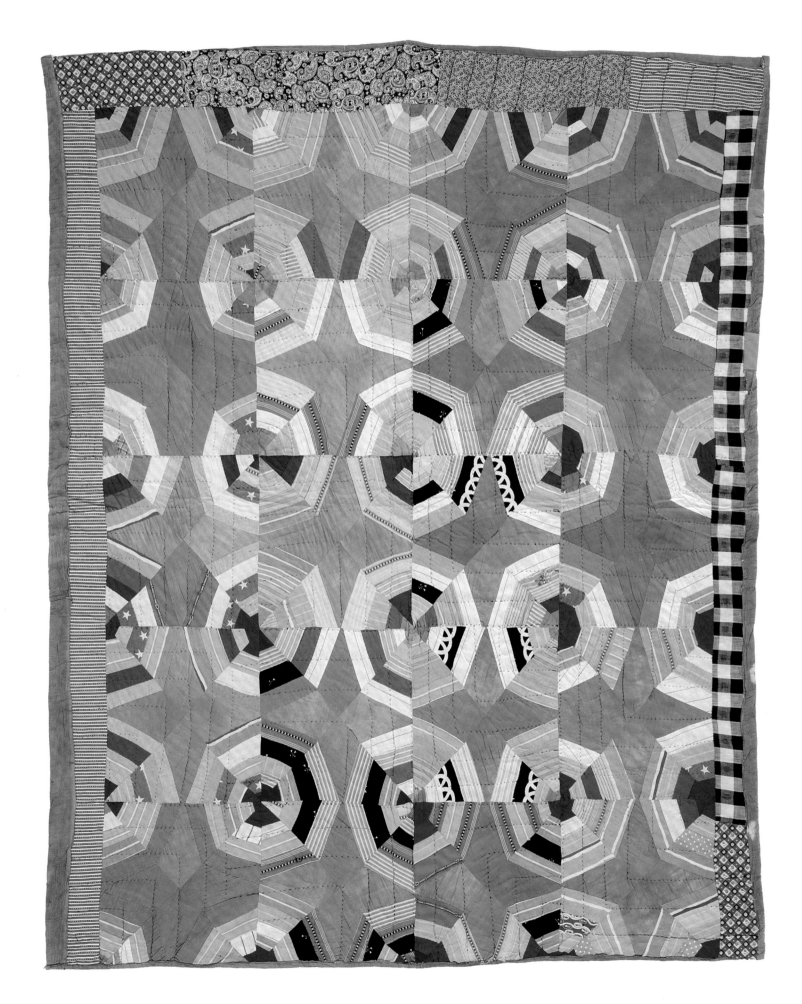

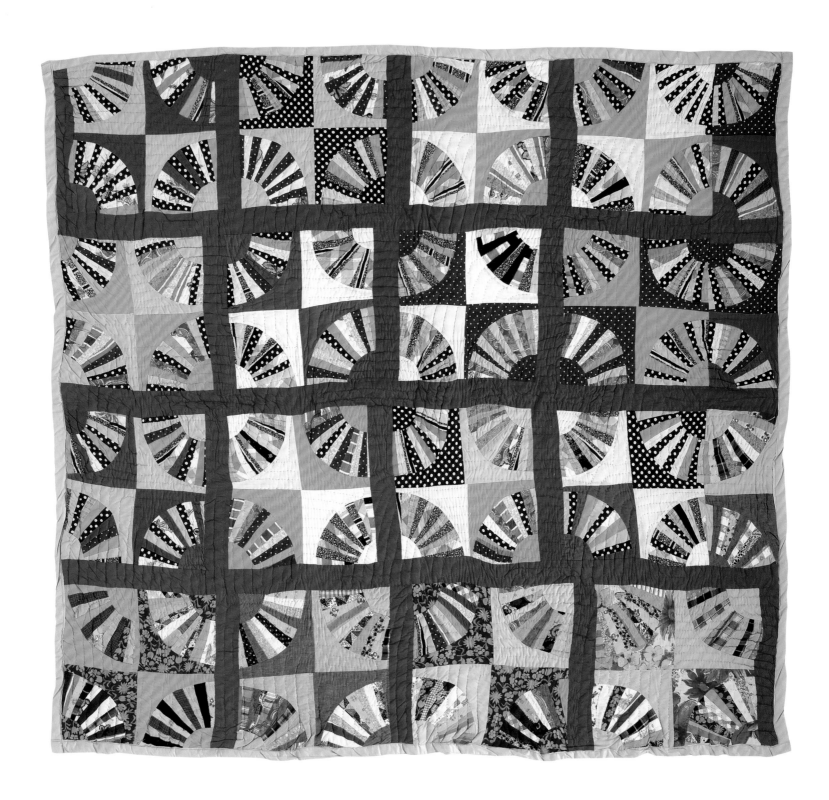

Fan

c.1975–2000

Found in Wood County, Texas

COTTON, BLENDS, POLYESTER

HAND-QUILTED WITH GREEN THREAD

79 x 86 inches (201 x 218 cm)

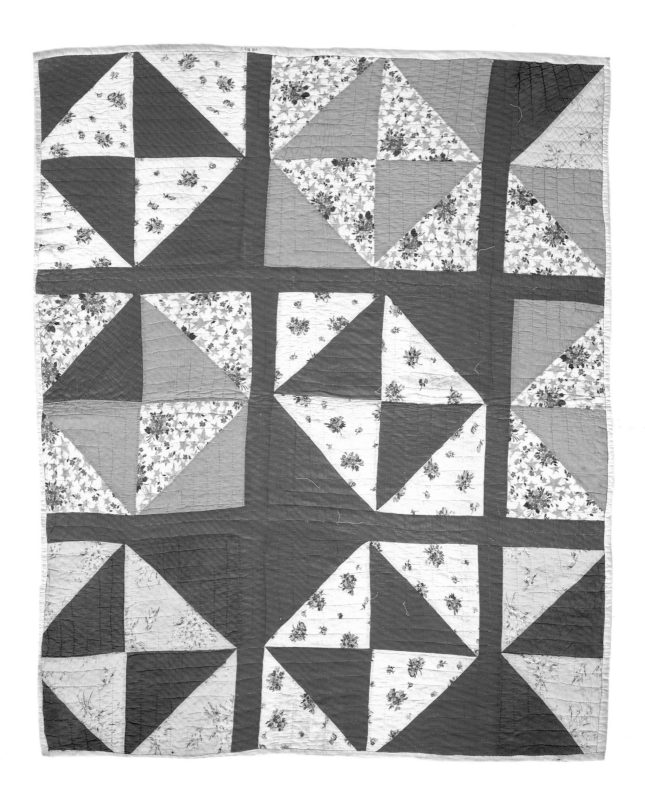

Oversized Broken Dishes, variation

c.1930–1950
Attributed to Ellen Moseley.
Found in Autauga County, Alabama
COTTON
83 x 69 inches (211 x 175 cm)

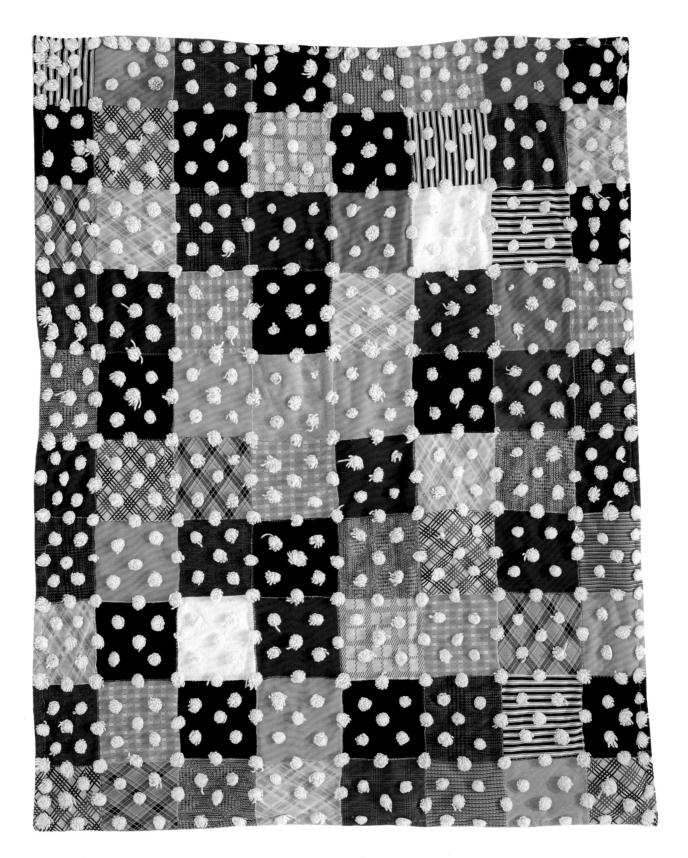

One Patch

c.1950–1980

Found in Arkansas

POLYESTER, TIED

77 x 63 inches (195.5 x 160 cm)

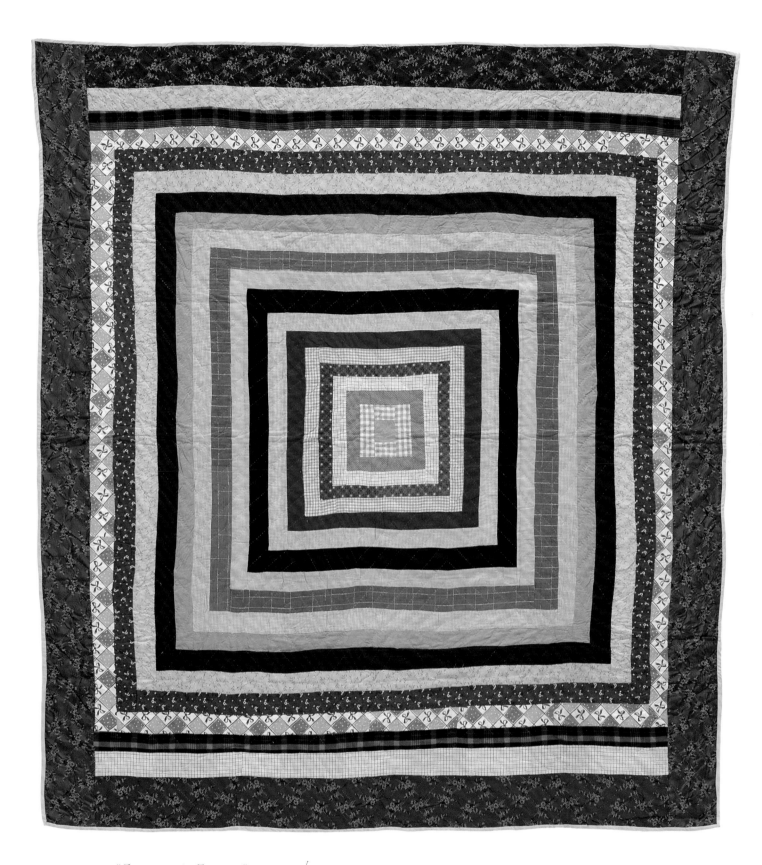

"Concentric Frames"

c.1950–1975
Found in Pennsylvania
COTTON, BROCADE SATEEN
74 x 67 inches (188 x 170 cm)

In the deep South this pattern is typically referred to as Housetop. This example resonates with Josef Albers's Homage to the Square series undertaken from 1949 to his death in 1976, remarkably, the same time frame to which this quilt is dated.

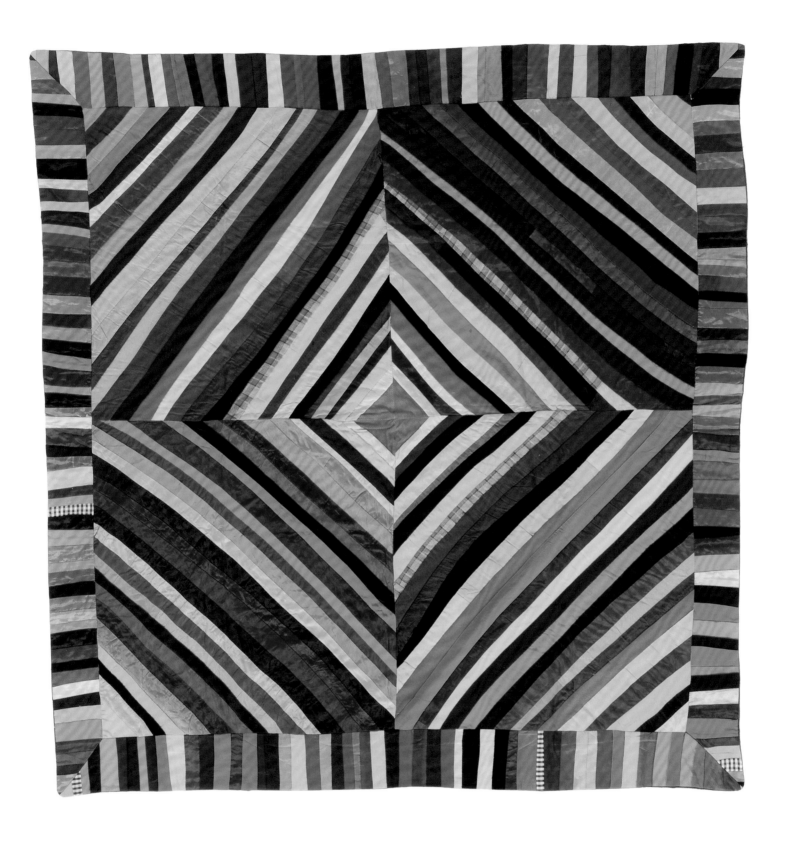

Oversized String
with Piano Keys Border

c.1940–1970
Found in Ohio
COTTON, SATIN, CORDUROY
150 67 x 65 inches (170 x 165 cm)

This vibrant String quilt in a four-block configuration is reminiscent of a Lancaster County (Pennsylvania) Amish Diamond in the Square, or a Southern Housetop turned on point. It is also reminiscent of Frank Stella's paintings. The red corduroy diamond in the center of the quilt shows that the maker anticipated the final outcome.

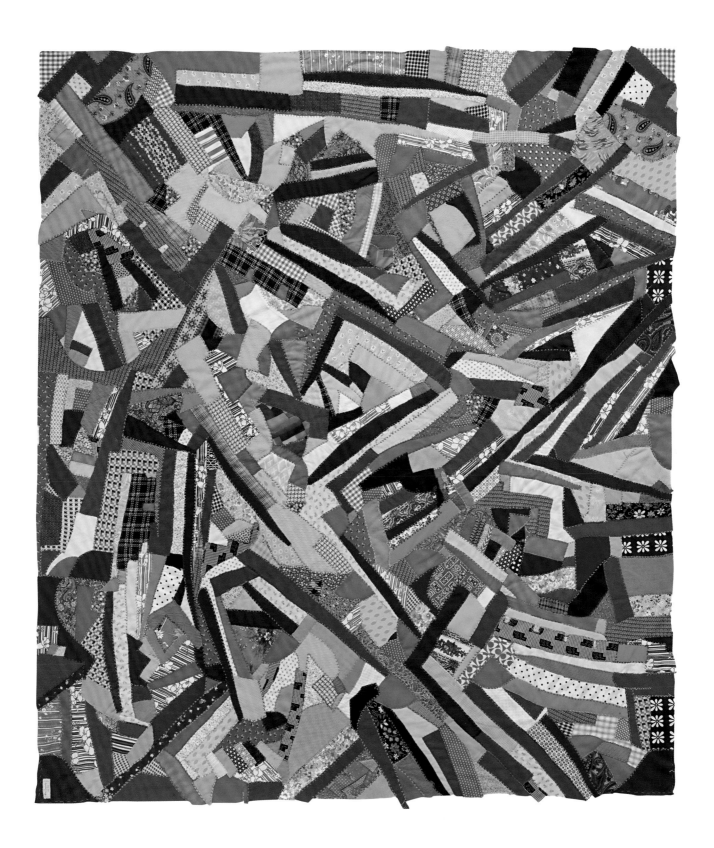

"Victoria's Crazy Quilt," unfinished top

1988

Elda Wolfe. Wabasha, Minnesota

POLYESTER DOUBLE-KNIT, BLENDS, COTTON

74 x 85 inches (188 x 216 cm)

Collection of Victoria Findlay Wolfe

"Made especially for you by Elda Wolfe" tag attached to reverse. This was a graduation gift from grandmother to granddaughter.

151

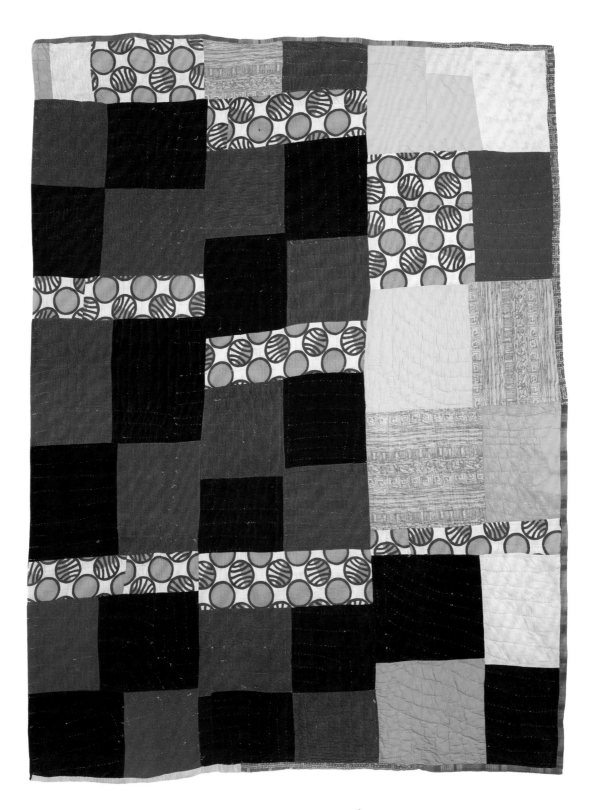

Four Patch, variation
(double-sided)

c.1950–1975
Found in Clarksville, Texas
COTTON, BLENDS, CORDUROY, VELVETEEN
87 x 63 inches (221 x 160 cm)

Strip

c.1950–1975
Attributed to Nona Belle Wallace.
Found in Cordova, Alabama
COTTON
83 x 69 inches (211 x 175 cm)

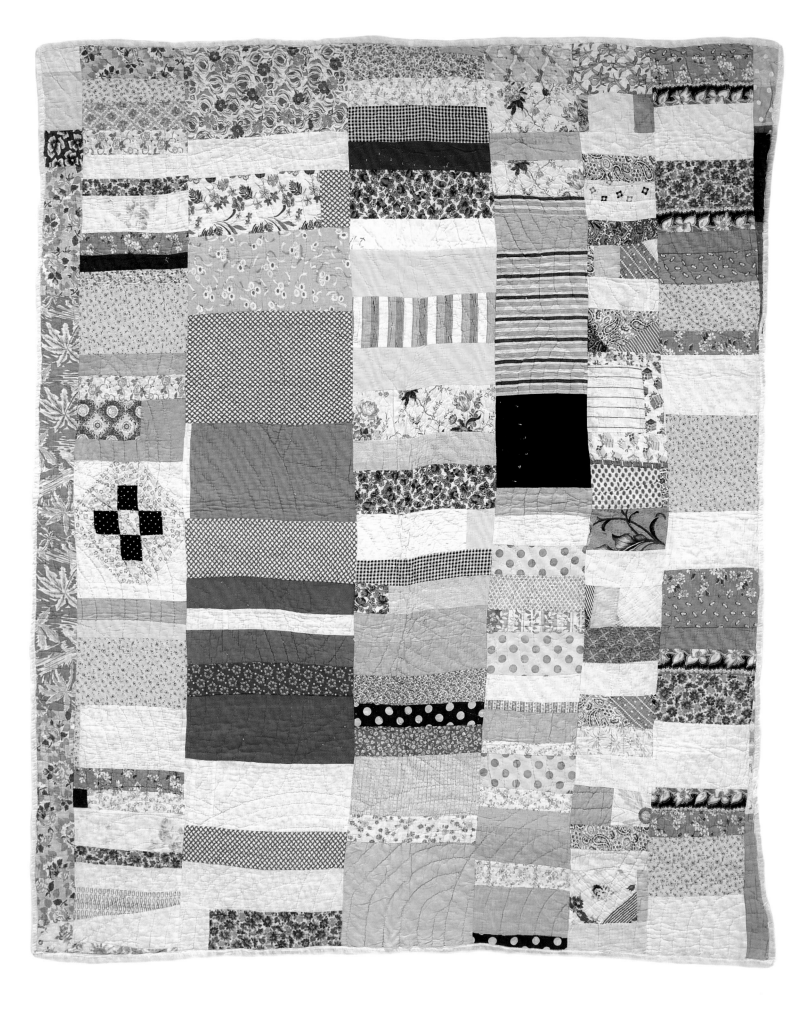

"Pieced Backing"
c.1940–1960
Found in Texas
COTTON. HAND-QUILTED
WITH STRING
86 x 66.5 inches (218 x 169 cm)

Quilts Are Quilts

ALLISON SMITH

I'LL NEVER FORGET THE DAY A FRIEND OF MINE invited Roderick Kiracofe to my studio in Oakland, California, to show me quilts from his collection. She told me that as a historian and former quilt dealer, Rod had literally examined, appraised, and handled thousands of textiles and that he had honed his collection down to a very special selection. She said that his quilts were not to be believed, and she was right. As I recall, Rod arrived with several oversized duffel bags, and one by one, he brought out his quilts, holding them up in the sunlight or laying them across my large worktable. Each one had a distinct personality, improvisational and eccentric, yet also extremely intentional. With surprising fabrics like polyester double knits, unusual color combinations including neons, and even humorous details such as pompoms, they were indeed unbelievable. So unlike the examples of restrained mastery we often see in quilt exhibitions, and yet totally confident in their asymmetry and materiality, these were twentieth-century quilts. I was so impressed that Rod didn't seem interested in collecting the oldest and rarest of nineteenth-century quilts, nor quilts with the recorded provenance of an illustrious maker or owner, nor even quilts of the utmost precision that would seem to foreground the skill or patience of the quilter. Instead, he seemed to be looking for another kind of rarity, something more akin to personality, charisma, or even flamboyance, for each quilt in his collection was a true gem.

In many conversations since that day, Rod and I have talked about what makes these quilts special, and how to articulate what defines them as a collection. Certainly, they are "like paintings," brought together by Rod's own subjective, discerning taste and his well-developed curatorial eye. But the comparison of quilts to abstract paintings

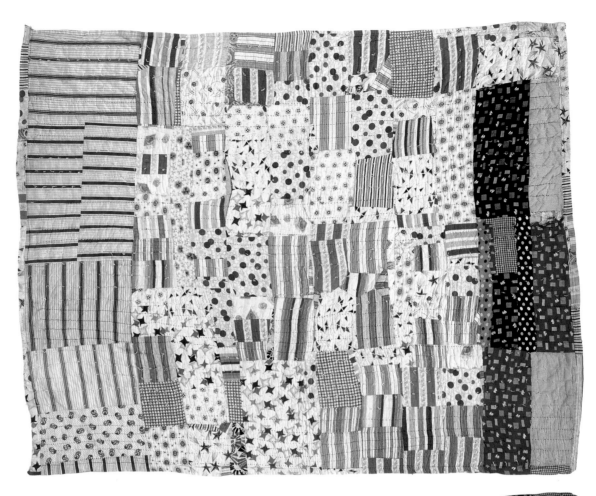

has been made many times over, in an attempt to insert quilts into the canon of Western art history. The logic goes, if we agree that quilts are visually and formally similar to paintings, then we can appreciate them as fine art and we should question why they are considered to be inferior to paintings within hierarchies of art, and also less valuable in the art and antiques marketplace. Much research has been done to situate quilts historically within various social contexts outside of the conventions of art and its institutions. And of course in today's art world, quilts as a chosen form or an appropriated concept are just as viable as any other. However, mythologies linking quilts to issues of identity, notions of authenticity, hidden labor, and anonymity, as well as to the matrix of class, gender, and race, persist in the popular imagination: How can these "everyday folks" create works of such striking beauty and ingenuity? Painting and the allegory of the genius artist loom large within discussions of quilts, still considered a form of folk art. Does the "craft genre" of quilts make the "discipline" of paintings that much more impressive, or are unsung quilters, in fact, geniuses? For many, it *does* seem unbelievable that people without specialized training in art can nevertheless make works that speak so directly to Modernism, with a casual self-confidence it takes painters many years to achieve. But even given our desire to champion the underdog, can quilts ever shake off their inferior status? Or is their inferiority to painting part of what constitutes quilts themselves?[1] Can we prove that affinities between paintings and quilts are more than coincidental? What is at stake in considering paintings and quilts as parallel endeavors? Do we reinforce their differences when we marvel at their similarities? A real analysis of quilts, *as quilts* and unlike paintings, is in my opinion still yet to be written.

While stretched canvases' permanent state of tension may project strength visually like a shield of armor, more than, say, a well-loved security blanket, quilts are intentionally set free of their frames, precisely so they can be experienced with all of the senses. Illustrating Glenn Adamson's idea that craft should be seen *in action*; that craft always exists *in motion*,[2] quilts flow over pillows and throws, edges of beds and bodies, under and over arms and legs, onto the floor and out into the world. We think of the trajectory of a painting as being born in a studio but coming of age in

OPPOSITE (FRONT) &
FOLLOWING PAGE (BACK)

String Diamond
c.1950–1970
Found in South Carolina
COTTON, BLENDS
80 x 66 inches (203 x 167.5 cm)

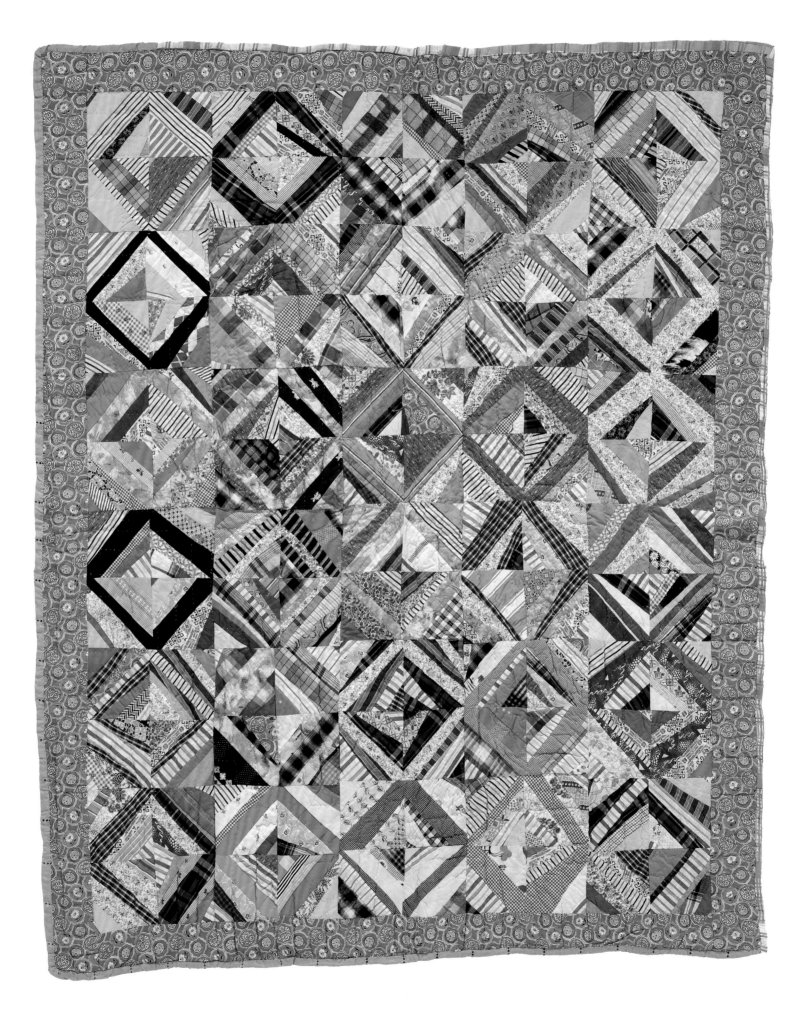

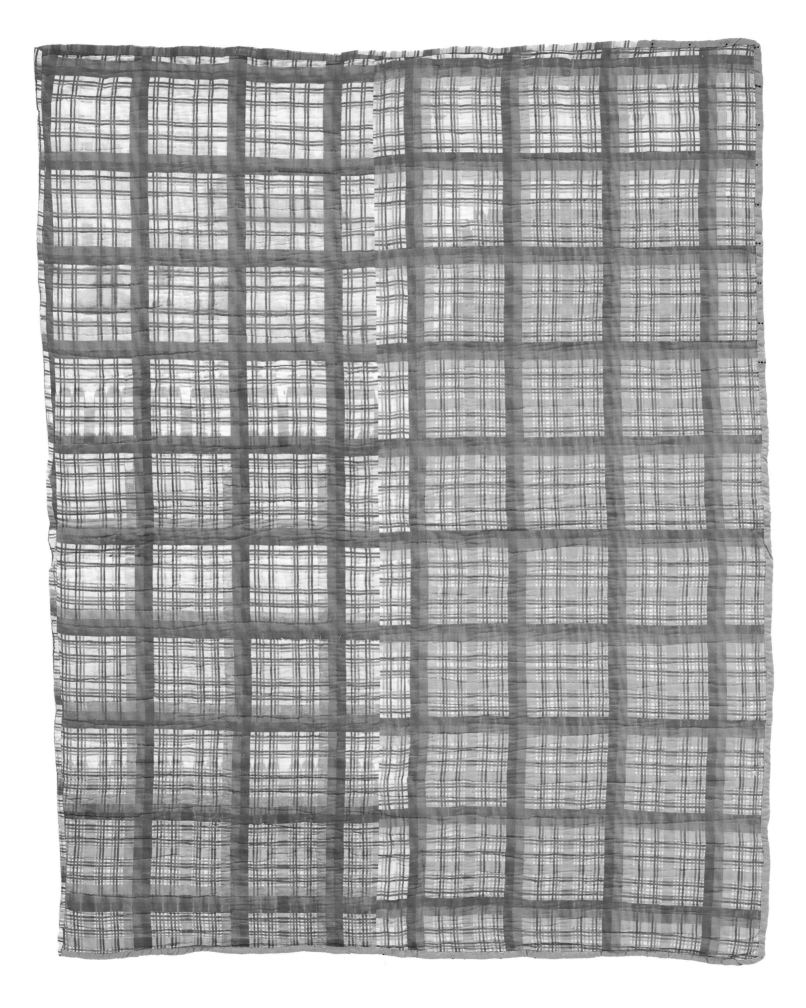

galleries and museums, often ending up in a collector's home. Quilts are born at home, circulate from home to home, move outward into the world, and occasionally into the art world. A quilt presented in a gallery is generally seen as a slice of life, of private space, of home, becoming visible and public. Quilts operate in a life cycle of comings and goings. Quilts are perhaps not meant to project outward, assuming a viewing public. Instead, they project inward, their insides literally steeped with history and sentiment. Fabric settles like the foundation of a house. It also has a memory. Perhaps this is why we love quilts, and also why we take such pleasure in thinking of them as paintings. They have an aura cloaked in love and humility, like Dolly Parton's "coat of many colors." This love is as much about bringing painting "down" as it is about bringing quilts "up." So when we see a place where a seam wanders off its course, we may wonder, was the quilter daydreaming, making intuitive decisions, or consciously innovating? Where was she going with that?

Perhaps another way we perpetuate the notion of quilts as being similar but unequal to paintings is by thinking of them as having fronts and backs. Without a backing, it's called a top; without the batting, it's not strictly a quilt. But do quilts actually have fronts and backs? Is one side meant to be seen, and the other hidden? Or can we think of quilts as two-sided from their conception? Can we read two quilts in one object, like a diptych fused back-to-back, or are quilts simply reversible? Do they have double identities, or alter egos? Both sides of a quilt are critical, in fact, the "back" of a quilt can confirm that we are looking at a quilt and not, technically, a quilt top or coverlet. By their most basic definition, quilts are made of layers—cloth + batting + cloth—fixed in place by lines of stitching. Despite the complexity of pieces and patterns that define the side we typically think of as the "front," it is the "back" that reveals the logic of the quilted stitches, which can echo the pieced pattern or reveal an entirely different one. Quilted stitches are the structure, that network of internal points of tension that hold a quilt together from the center outward. They are also a form of expression and whimsy. This conjoining of two-dimensional planes into double-sided low relief is another part of what constitutes a quilt. Quilts are not flat, but fat. Quilts have sides and curves, bumps and blisters, rows and furrows, not just on one surface, but mirrored in opposite on two.

Obviously, many quilts have one side that demands more of our attention, exhibiting the time, labor, and decisions of its maker. It may be more colorful, comprise more pieces, or seem to be more considered. However, the "other" side of a quilt is only ever completely hidden when a quilt is displayed like a painting or photographed. And if you observe quilters observing quilts, you will notice that the back never goes unnoticed. Many of the quilts in this collection seem to revel in the fact of their double-sidedness, with pieced backs of printed cloth or several panels of dyed fabric. While we assume that most quilts have a plain side, these quilts make us wonder about other quilts we have seen in pictures or in museums that, in fact, have other sides, other dimensions, and other stories to tell. Not only do these quilts have two "tops" but, in comparison to the predetermined "top" edge of a painting, they can also be rotated, suggesting variable compositions and orientations. We can never know the intentions of the quilter, any more than we can know the intentions of the potter or even the painter. Without a signature, literally and figuratively, we are free to interpret and speculate.

In "Aerial Urban Landscape" (page 165), each side of the quilt resembles a place at a distance. Are these aerial views of urban and rural landscapes, as seen or imagined from above? Are these maps, a material unfolding of spaces and territories? To my contemporary eye, the complementary languages of Google Maps and Google Earth come to mind: buildings, lights, systems and infrastructure, crops, counties, keys, codes, and pixels. Being that detail is difficult to achieve in cut cloth alone, even the most representational quilts are abstract. If the maker of this quilt was trying to map a place, her interlocking marks are decidedly "low resolution." Quilts are simultaneously maps and sites—of desire, dreams, and more.

Marcel Duchamp tried to draw attention to the non-neutrality of paint in his 1961 talk "Apropos of 'Readymades,'" in which he stated, "Since the tubes of paint used by the artist are manufactured and readymade products, we must conclude that all the paintings in the world are 'readymades aided' and also works of assemblage." Quilts are readymades aided par excellence, insofar as they are composed of found and purchased everyday materials/things. Since a quilt is a "piece" made of many pieces, comparisons to collage (to glue), assemblage (to assemble), or bricolage (making-do) are understandable.

However, none of these can account for the particularities of cloth or for the processes necessary for piecing it together into an overall pattern or design. In short, the above terms do not take into account the need to cut pieces larger than they will appear, hence negotiating what is physically cut with what will actually be seen, and the repeated moments of blindness involved when two pieces are sewn facing each other, the nature of their connection only to be revealed by opening conjoined elements and pressing them flat. Quilts are "works" that speak of work, and reworking. Somewhere between the tendency of the material and the countless decisions of the quilter we may find some logic to the kinds of eccentric abstraction that quilts offer up.

In Original Design (page 157), shades and tones on one side suggest a picture of spatial relationships. Household ticking and polka dot cotton party dresses recombine to suggest striped wallpaper, confetti, and party streamers, a doorway to another room, someone coming around the corner? On the other side, feed sacks provide the ground for two cows and a sow in a golden field of wheat and light. It is known that manufacturers published instructions on how to bleach out the labels of these sacks, anticipating the resourcefulness of women. However, here she has ingeniously bleached out the instructions and brand names but left the cows and sow, gazing in opposite directions, grazing in her vast color field. Is this the view from her window? From up high on a grain silo? High and low, fabrics for people and potatoes, scenes of chaos and quiet, interior and exterior, leisure time and work time, abstraction and representation, all informing one another in the same object.

When the layers of a quilt are ready to be quilted, they are temporarily affixed to a quilt frame, positioned horizontally and taking up the larger part of a room. Historically most people didn't have the space in their homes for a permanent quilt frame, so not only did many hands make quilting go faster, but working together allowed for a space in the home to be occupied for a shorter period of time before being turned back over to its original use. While paintings can be done alone, quilts lend themselves to collaboration. I've always loved the story of Susan B. Anthony delivering her first political speeches on women's rights at quilting bees. At a quilting bee, the quilt can provide a platform or arena for a much needed

ALLISON SMITH's *artistic practice investigates the cultural phenomenon of historical reenactment, or Living History, using it as a means of addressing the relationship between craft, identity, and social activism. Smith has produced over twenty-five solo exhibitions, installations, performances, and artist-led participatory projects for the San Francisco Museum of Modern Art, Public Art Fund, the Aldrich Contemporary Art Museum, Museum of Contemporary Art Denver, Mildred Lane Kemper Art Museum, Berkeley Art Museum, and Indianapolis Museum of Art, among others. She is on the faculty of California College of the Arts, where she is a tenured professor and Chair of the Sculpture Program.*

discussion; it is the reason for gathering and contains the residue of collective energy and conversation. There is a long documented history of quilts being made and auctioned to raise money for various community concerns and political causes. More than paintings, quilts are like flags, suggesting in their very making the notion of something to rally around. In fact, Betsy Ross was an upholsterer and quilter. The word "thing" in old German can refer to both objects as well as gatherings to discuss contested matters. Quilts are *things* that provide a framework for political action, whether gathering for debate, or exchanging news, information, or other concerns of the group, it is in this gathering, holding, giving, outpouring, and warming that quilts exist most vividly to me. The warming, life-preserving, potentially healing aspect of quilts is a familiar trope, for quilts are both physically warm and symbolic of warmth.

In Bars/Original Design (pages 166–167), a Mobil gas flag featuring a flying red horse on a white background is incorporated into one side of the quilt. On the reverse are multicolor stripes with ties forming a pattern of white thread "stars." Muse of poets, according to legend, everywhere the Pegasus struck his hoof to the earth, an inspiring spring burst forth. This seems an appropriate metaphor for quilts themselves, as things encoded with infinite significance, sparked by imagination, but also the warm cover of dreams. Arjen Appadurai writes that from a theoretical point of view human actors encode things with significance, but from a methodological point of view it is the things-in-motion that illuminate their human and social context.[3] As thing theorist Bill Brown writes, "we look *through* objects (to see what they disclose about history, society, nature, or culture—above all, what they disclose about *us*) but we only catch a glimpse of things.[4]

With quilts, there are always at least two sides of the story. Instead of paintings, what if quilts were more often compared to flags? Only quilts-in-motion can illuminate their human and social context. Like a flag set in motion by the wind, we can only catch a glimpse of a quilt's true meaning. We just can't pin it down.

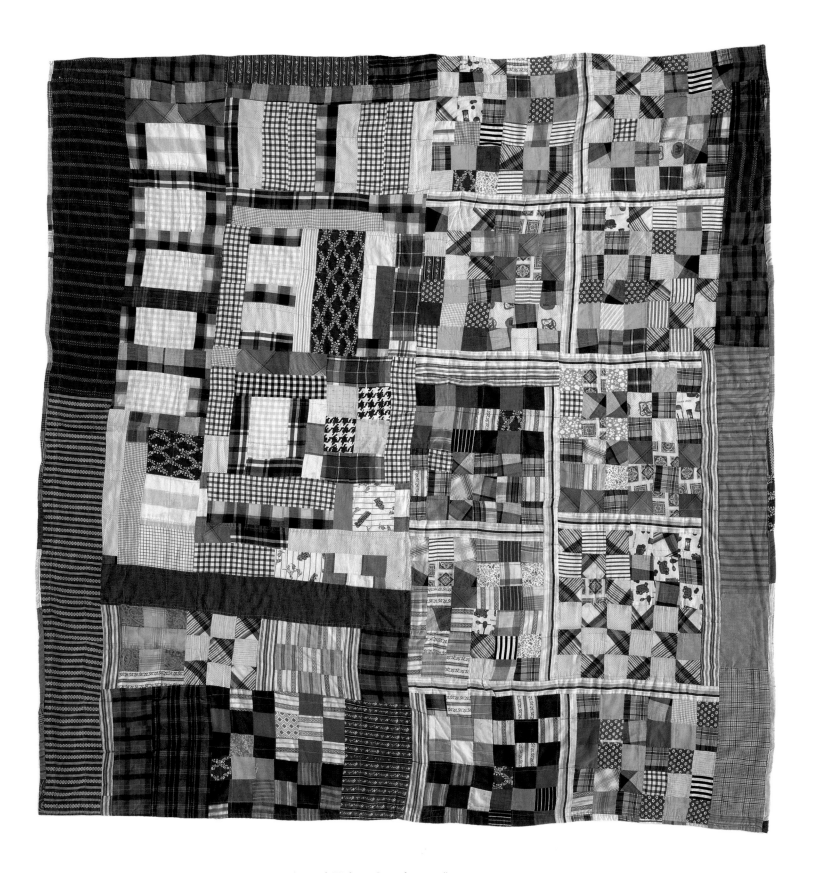

"Aerial Urban Landscape" (double-sided)

c.1960–2000

Found in Memphis, Tennessee

COTTON, BLENDS. MACHINE-QUILTED

74 x 73 inches (188 x 185.5 cm)

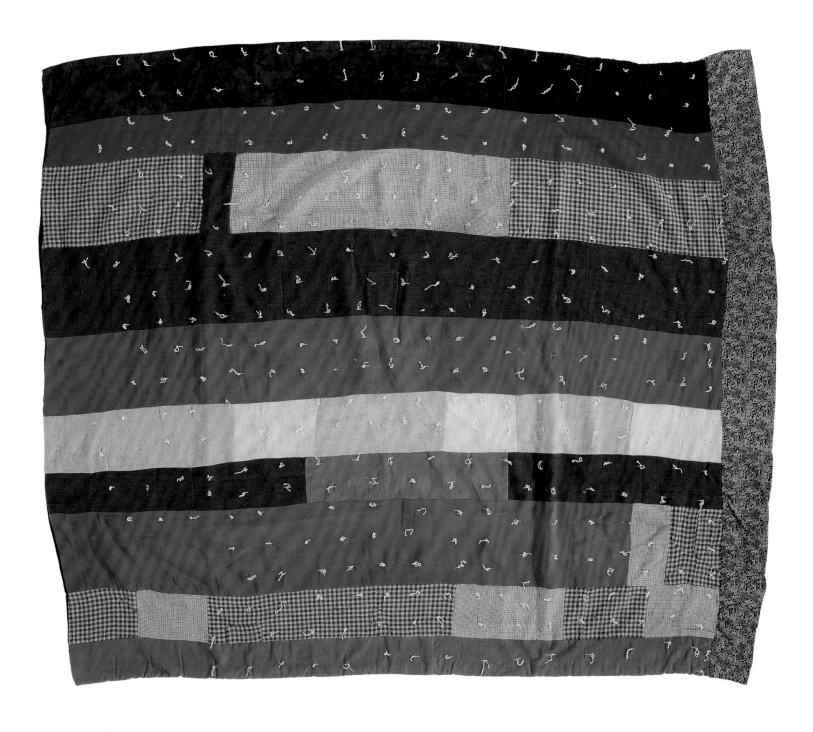

Bars / Original Design

(double-sided)

c.1930–1950

Found in Missouri

RAYON, WOOL, CORDUROY,

PANNE VELVET. TIED

166 65 x 78 inches (165 x 198 cm)

Where did the maker acquire this Socony-Vacuum Oil Co (later Mobil Oil) red Pegasus banner, and what possessed her to incorporate it into this bedcovering? Was the Pegasus visible on top of the bed, or kept secret under the bars? Taken from the bed and hung on a wall, the piece finds obvious parallels to Andy Warhol's 1985 work with the same logo. This is an extraordinary work of Pop Art in its own right.

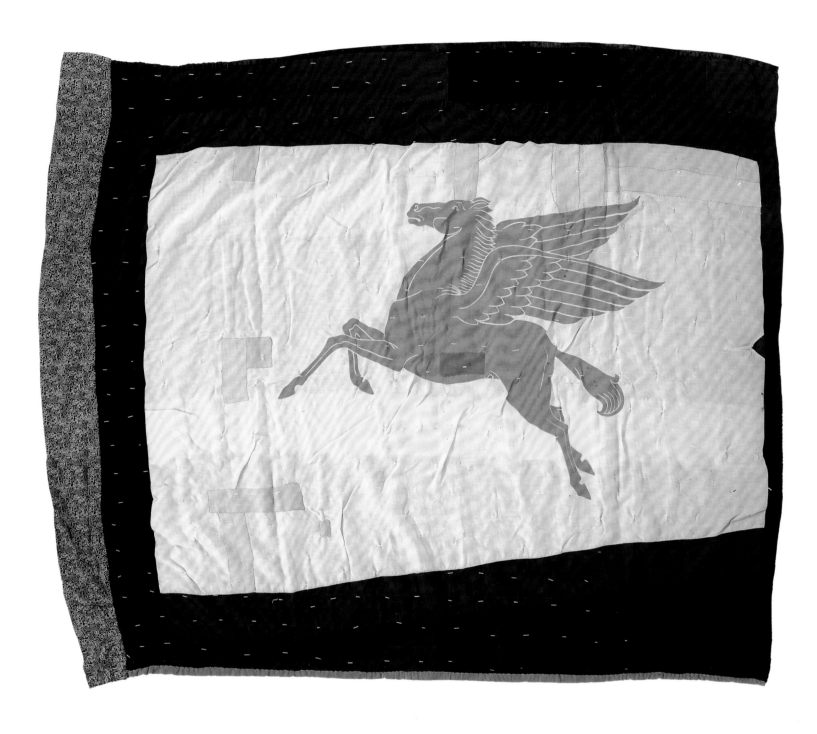

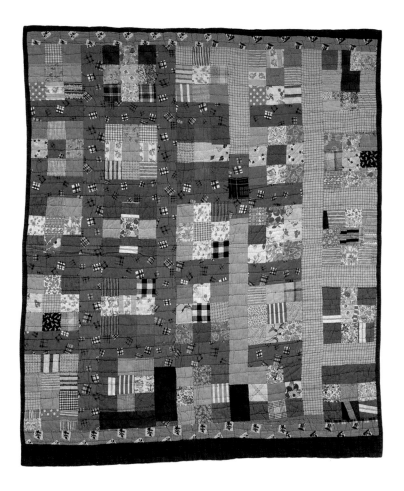

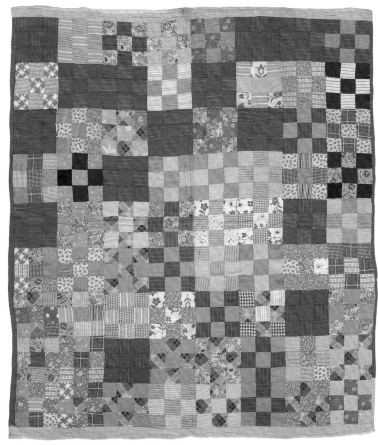

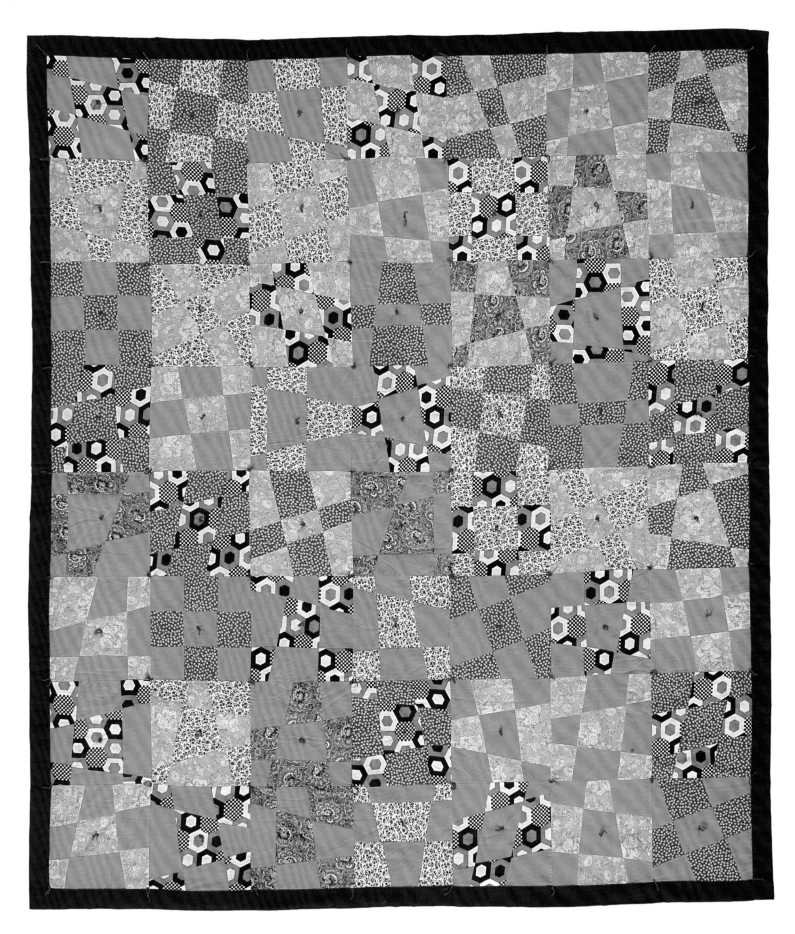

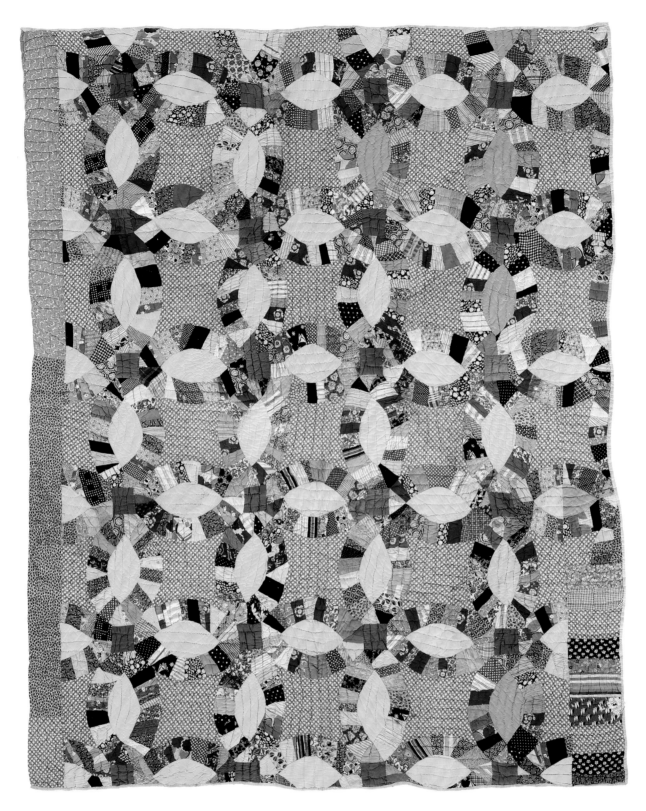

ABOVE

Double Wedding Ring, variation

c.1930–1950

Found in Texas

COTTON

79 x 63 inches (201 x 160 cm)

OPPOSITE

Rattlesnake / Snake Trail

c.1940–1970

Found in Alabama

COTTON

86 x 64 inches (218 x 162.5 cm)

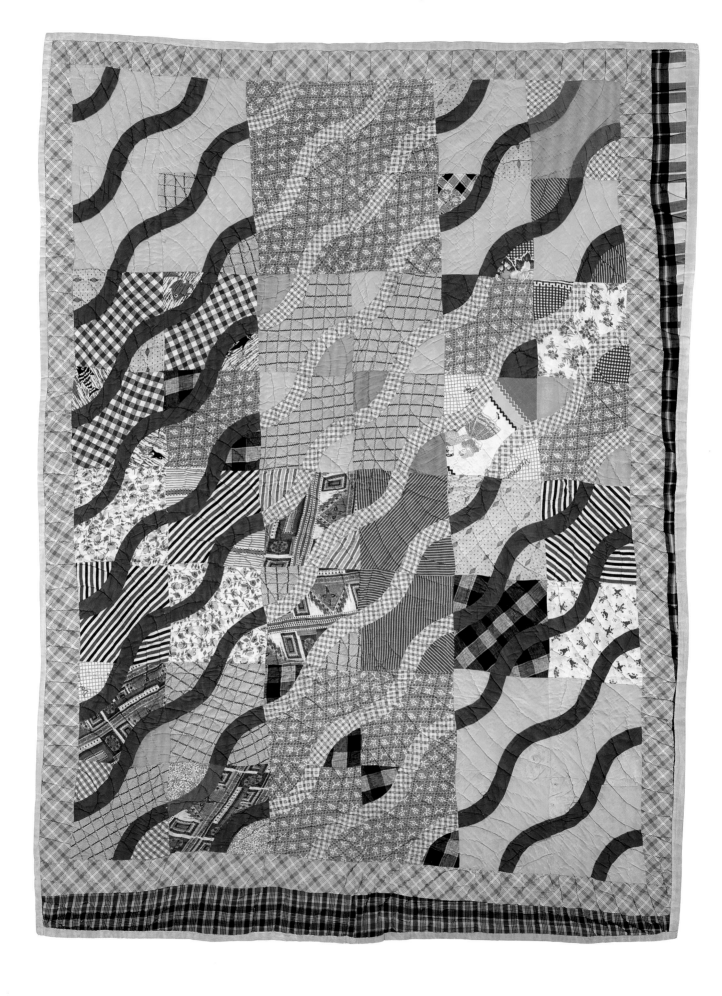

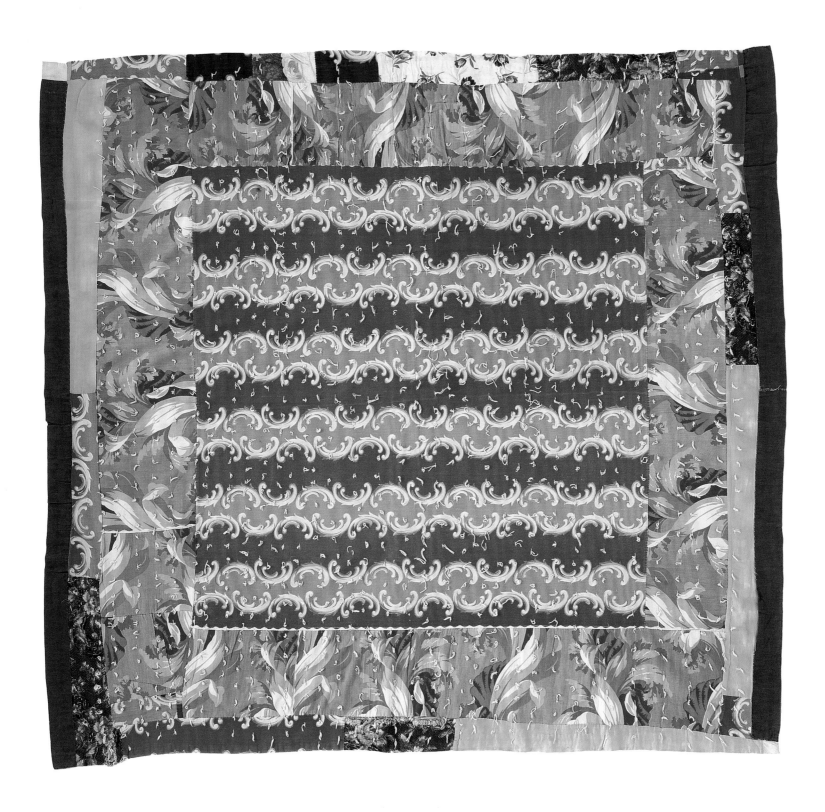

Central Medallion

c.1950–1975

Kansas City, Missouri

African American

BARKCLOTH, TIED

79 x 72 inches (201 x 183 cm)

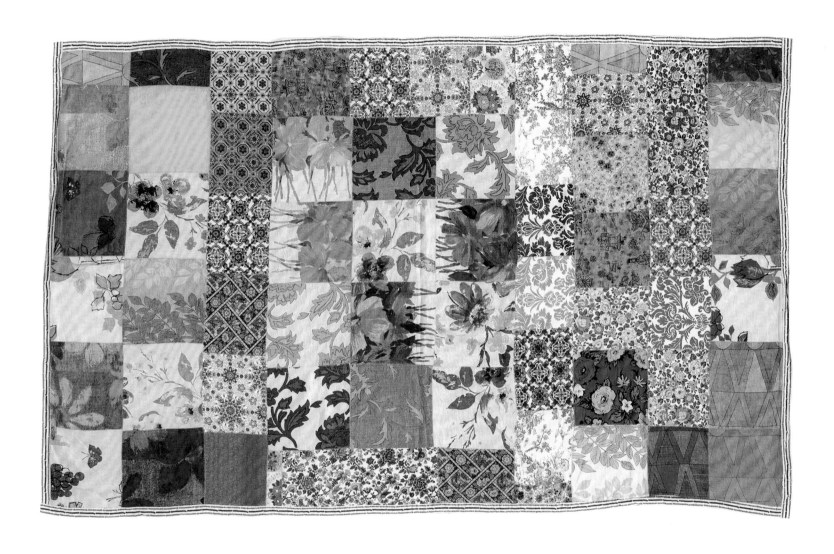

One Patch

c.1960–2000

Found in Texas

COTTON, BLENDS (UPHOLSTERY
FABRIC). SPREAD (BACKING
AND BINDING WITH NO QUILTING)

57 x 94 inches (145 x 239 cm)

The Joyous Anarchy of Color and Pattern

KAFFE FASSETT

I'VE ALWAYS TREASURED AND BEEN INSPIRED BY THE COMPLEX rather than the plain in life. Even as a child I was delighted by, and attracted to, multitoned color combos wherever I could find them. My mother sent my siblings and me to charity shops to buy our secondhand clothes. Thumbing through racks of shirts, I was always on the lookout for the jazziest, most colorful items I could find—life was too gray to put up with neutrals.

When it comes to quilts it's invariably the scrappy, highly patterned quilts that draw me in. While classic, graphic, two-color quilts in red or blue and white catch my attention, they don't hold my interest. So this collection of quilts is right up my alley. Made by people who, like me, are turned on by highly detailed patterns filled with color, they are not the norm, to be sure. I travel the world visiting quilt collections in museums, galleries, and private homes, and at festivals. Simple, graphic, or very pristine, perfectly balanced quilts make up the majority of what I see. Looser, more expressive works filled with joyous colors—even in neutral palettes— are quite rare but delight me when I find them.

When I saw Roderick Kiracofe's collection for the first time, I felt I knew exactly where these makers were coming from, responding instinctively to a collection of lively fabrics. I recognized the buzz of detail I am always on the lookout for.

The Bow Tie, variation quilt from Wood County, Texas, opposite, sums up the anarchy of color and pattern that I love. There is a wonderful rippling effect to the repeated patterns and abstract use of red and white stripe with flat dark fabrics. I get the giddy feeling that I'm seeing it through a mirrored kaleidoscope. Any abstract painter would be thrilled to have created this quilt.

The Spider Web quilt on page 145 is so elegant in its cool palette of dusty blue and pea-soup green that you don't at first see how scrappy it is. The sparse use of prints with so many stripes and solids gives the quilt a graphic coherence. The shots of cream flood this work with light.

174

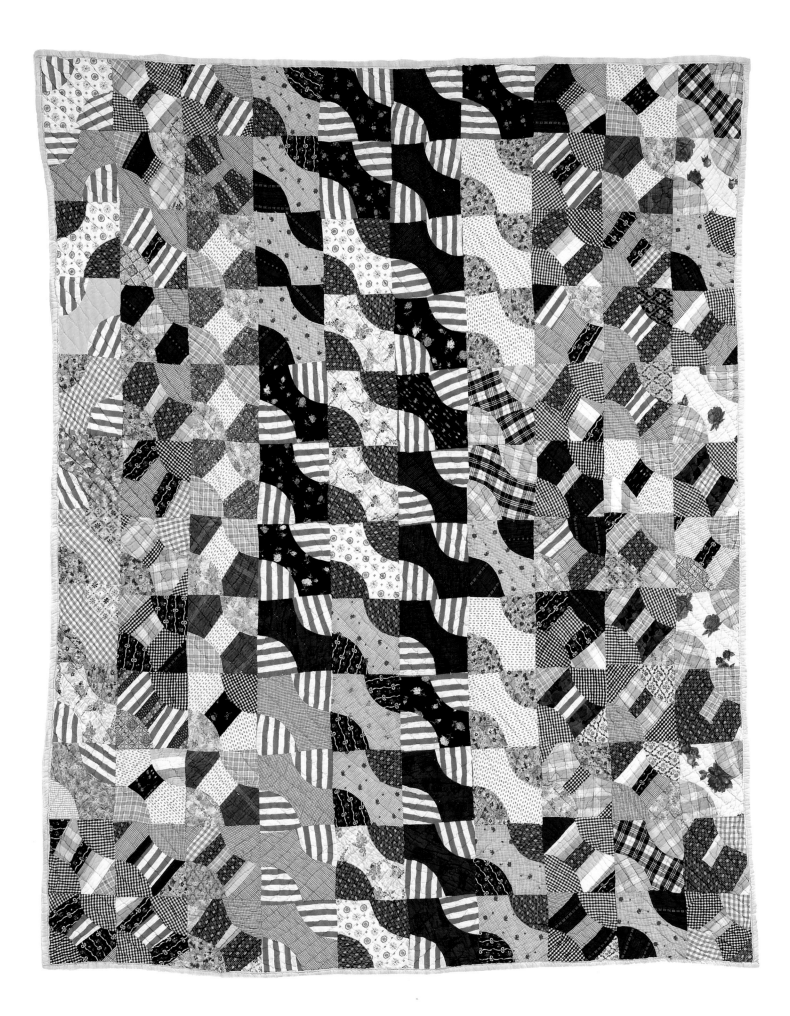

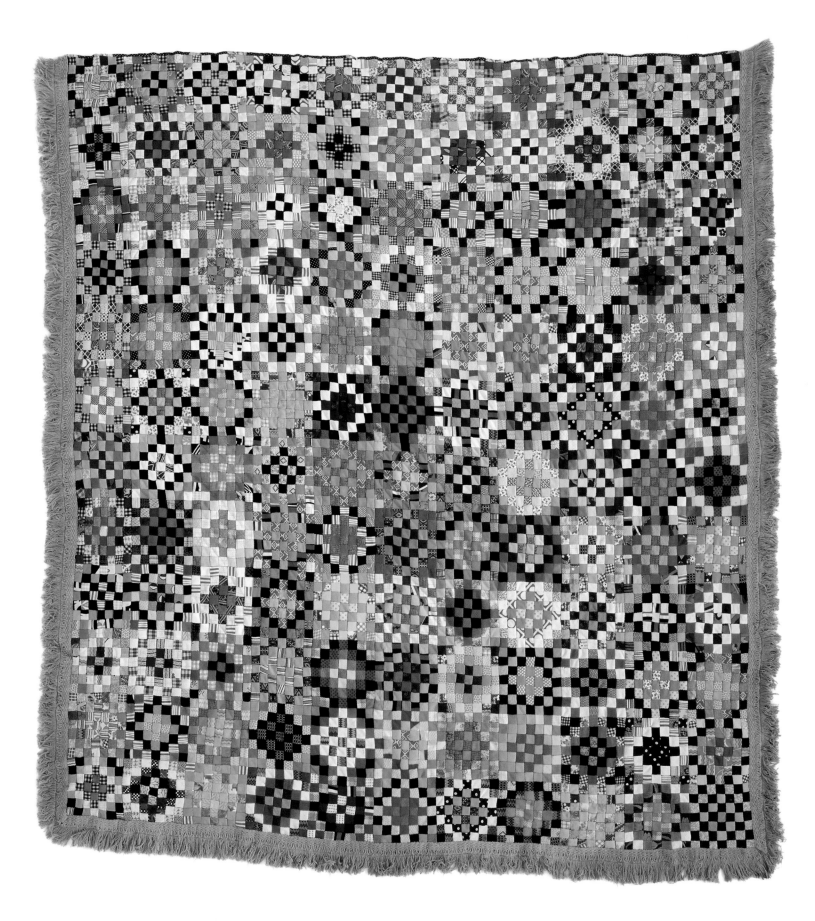

176

The intense use of small squares in bright jewel colors gives the Mosaic Rose quilt, opposite, a beaded appearance. I like the way some blocks are done in close-toned colors and really wink at you, giving a mysterious movement to the piece when seen from a distance. It's strange how quite harsh colors like scarlet and black can look so attractive in this complex work.

The Brick Wall quilt (page 32), found in Akron, Ohio, is definitely my kind of quilt—a collection of disparate, lively prints including dots, stripes, and plaids as well as florals. These are arranged in diagonals of colored bricks separated by plain colors that provide a powerful clarity to what could have become a confusing kaleidoscope of prints.

The Rattlesnake/Snake Trail quilt (page 171) is like warm rivulets of water snaking over a windowpane. The chalky palette of terracotta prints, dusty blues, and minty greens would be wonderful to live with. The strong repeat of curved lines is a perfect foil for the blocks of stripes, plaids, and small-scale florals. The touch of hot mustard and bright turquoise just lifts the pinks and greens.

As one who finds expressive multitoned worlds simple to negotiate, I find it easy to understand how these quilts came about. I can see that there are those who need a far stricter sense of order to exist in. Two or three colors are more than enough to satisfy them. Many only go for one color, producing whole cloth quilts that show the quilting stitches to advantage. Perhaps it is those of us who take delight in celebrating bold and offbeat color who feel a need to conjure our special sort of magic in our quiltmaking. By the simple act of collaging patterned fabric together, a dance of color and form is created. Something that once looked ordinary, such as old clothing or furnishing fabric, becomes transformed when brought together in repeating patterns of patchwork.

I applaud Roderick Kiracofe for seeing the value in these expressive celebrations. How these quilts must have lit up countless rooms before they made their way into this collection! Seeing all of these quilts together is such a life-enhancing confirmation for me. A license to break free, they certainly should inspire wonderful flights of fantasy in quiltmakers today.

KAFFE FASSETT *teaches quilters and other creative people across the globe to work with color in an instinctive way through his lectures, workshops, and books. His unique color sense and drive to create, combined with his desire to encourage others, has earned him a reputation as a guru in the world of color and textiles.*

OPPOSITE

Mosaic Rose
(based on One Patch)
c.1950–2000
Found in Arkansas
POLYESTER DOUBLE-
KNIT. COTTON FRINGE
ON THREE SIDES
94 x 94 inches (239 x 239 cm)

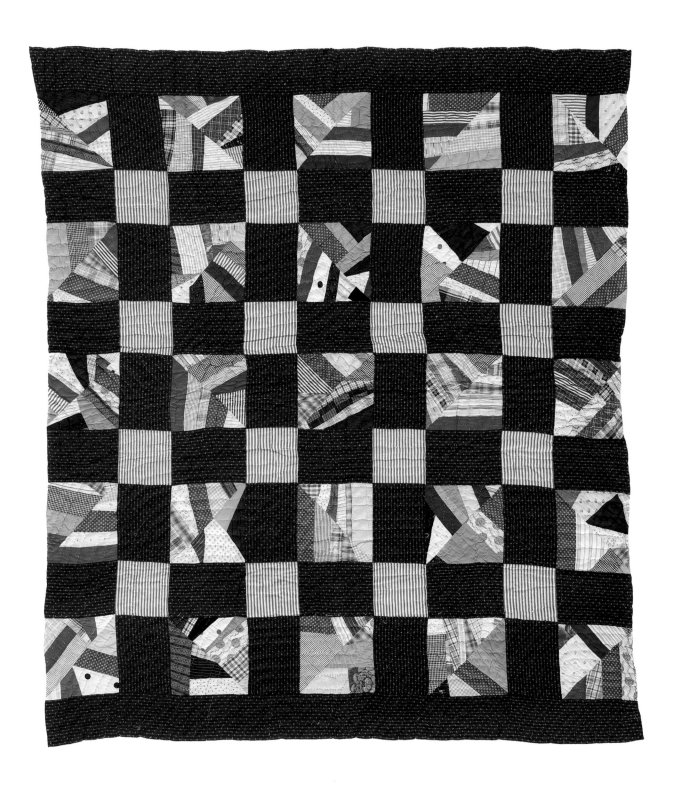

String

c.1920–1950

Found in Tennessee

COTTON

78 x 68 inches (198 x 173 cm)

Private collection

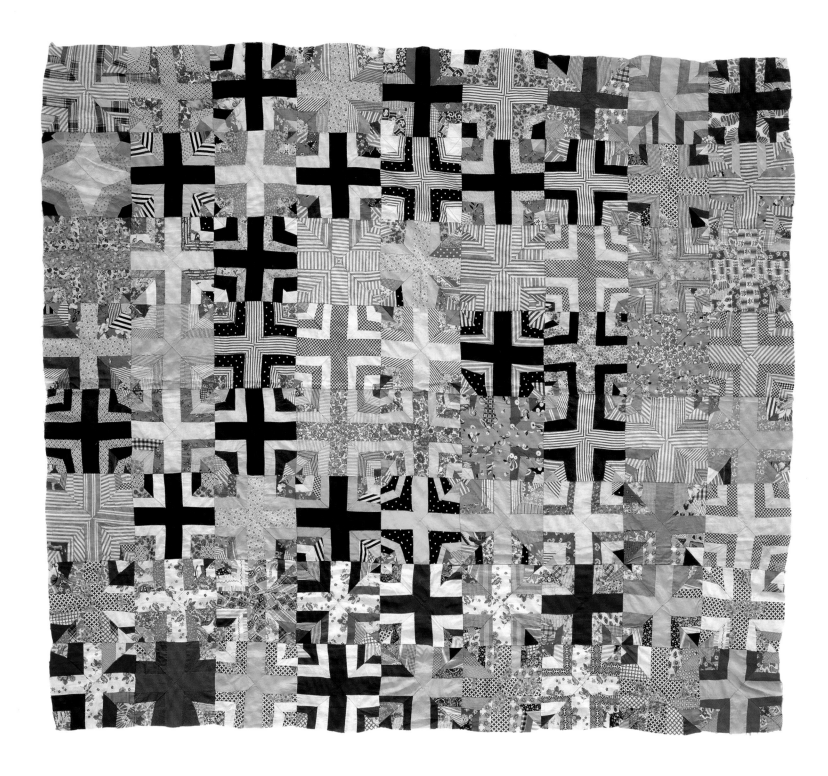

"Cross" (unfinished top)

c.1940–1970
Found in Alabama
COTTON
71 x 81 inches (180 x 206 cm)

While the cross is a motif that can be found throughout art history, this top, in particular, brings to mind Andy Warhol's 1981–1982 series of large cross paintings in bright colors, including yellow and red, against strikingly austere black backgrounds.

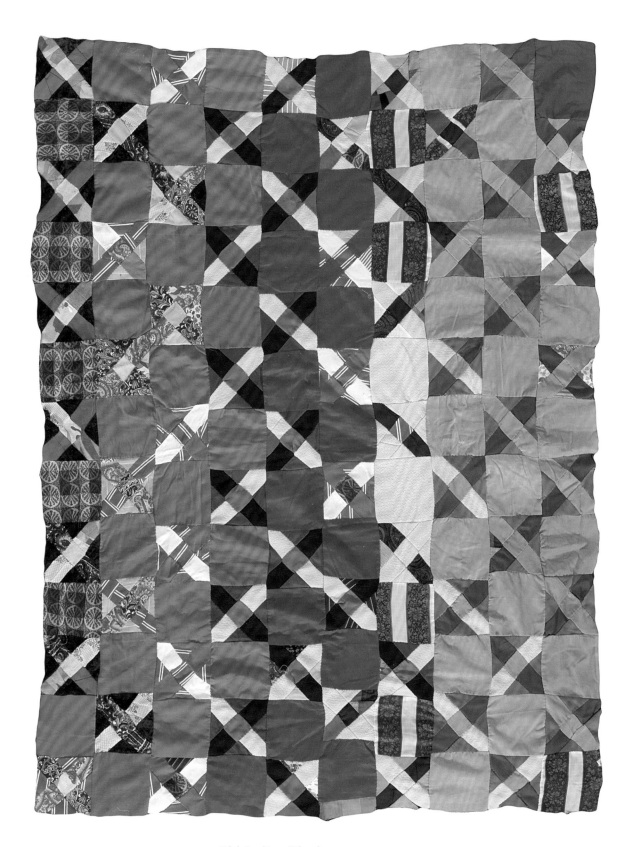

Old Italian Block, unfinished top

c.1960–1980

Found in Quanah, Texas

COTTON, CORDUROY, FLANNEL, BLENDS

57 x 77 inches (145 x 196 cm)

Collection of Marjorie Childress

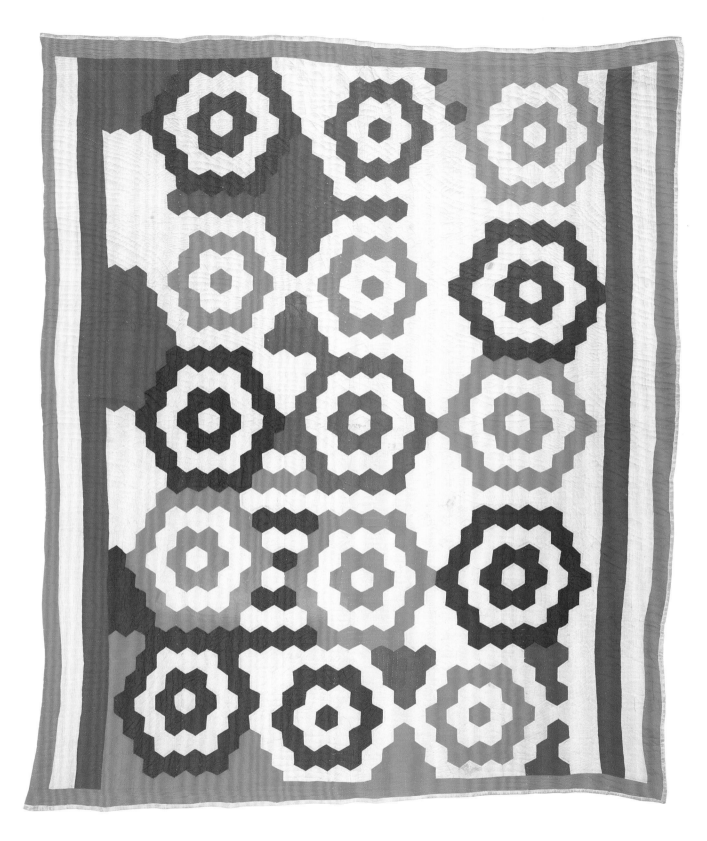

Grandmother's Flower Garden, variation

c.1950–1975

Attributed to Donna Settles.

Found in Cook County, Illinois

COTTON

82 x 71 inches (208 x 180 cm)

Nine Patch / Central Medallion (double-sided)

c.1975–2000

Found in Texas

POLYESTER DOUBLE-KNIT, VELOUR. TIED

81 x 61 inches (206 x 155 cm)

Nine Patch

c.1975–2000
Found in Oklahoma
POLYESTER DOUBLE-KNIT
73 x 80 inches (185.5 x 203 cm)

184

This is a fantastic representation of evolving fabric palettes in the late-twentieth century, with bright polyester double-knits packing a punch. The diagonal movement, rhythm, and flow of this piece is made extraordinary by the placement of color, particularly the yellows and the surprising green and white print block in the center of a shocking pink cross.

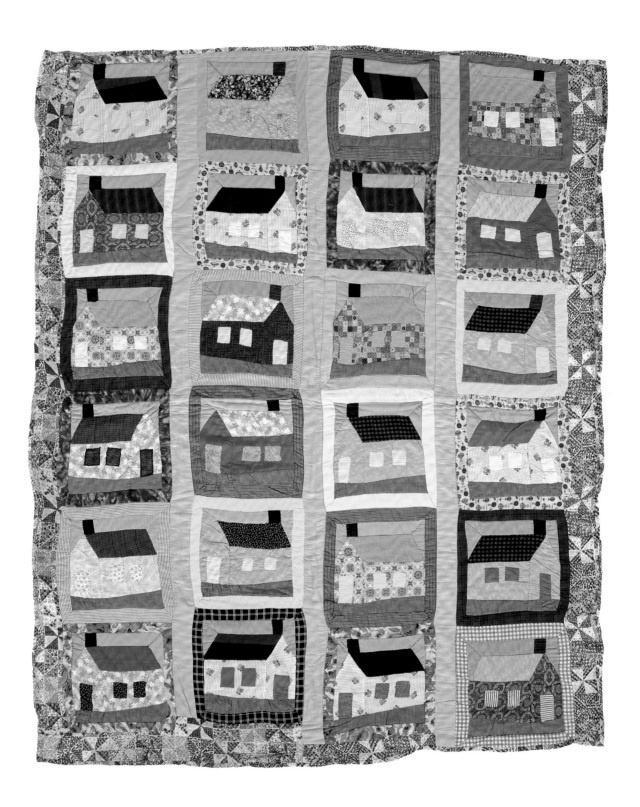

House

c.1960–1990
Found in Alabama
COTTON, BLENDS, CHEATER
CLOTH. MACHINE-QUILTED
92 x 75 inches (234 x 190.5 cm)

This piece, with its houses atop green lawns, evokes the quaintness and sentimentality of hearth and home. Yet it demonstrates artistic expression and execution that transcend the trope.

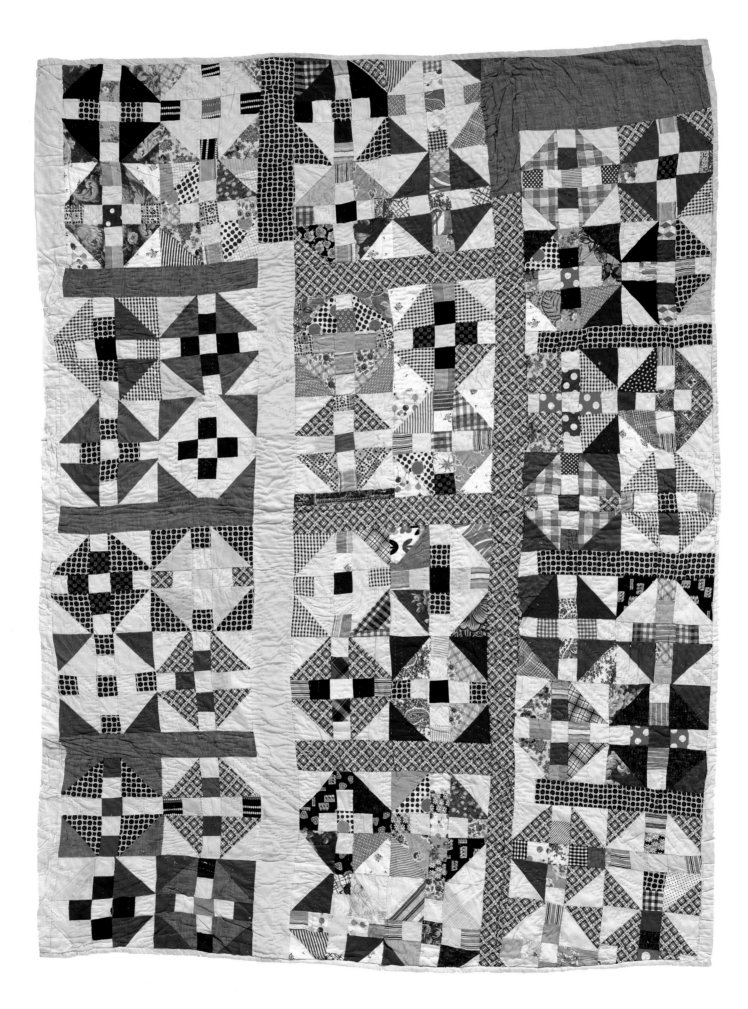

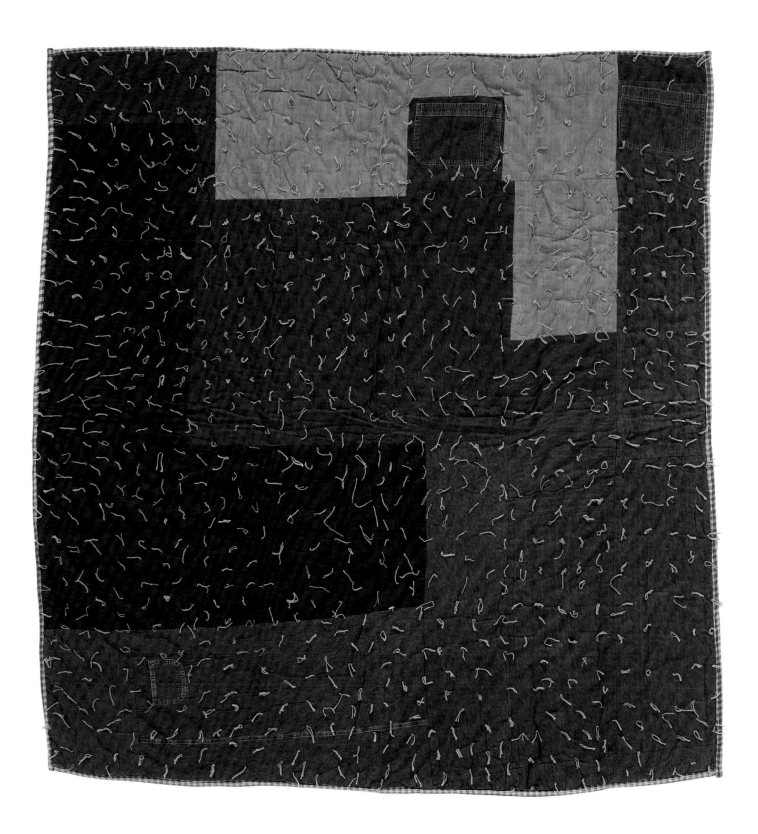

OPPOSITE

Unknown Pattern

c.1950–1975
Found in Georgia
COTTON
63 x 82 inches (160 x 208 cm)

ABOVE

Whole Cloth "L"

c.1940–1960
Found in Ohio
COTTON DENIM, TIED
78 x 74 inches (198 x 188 cm)

187

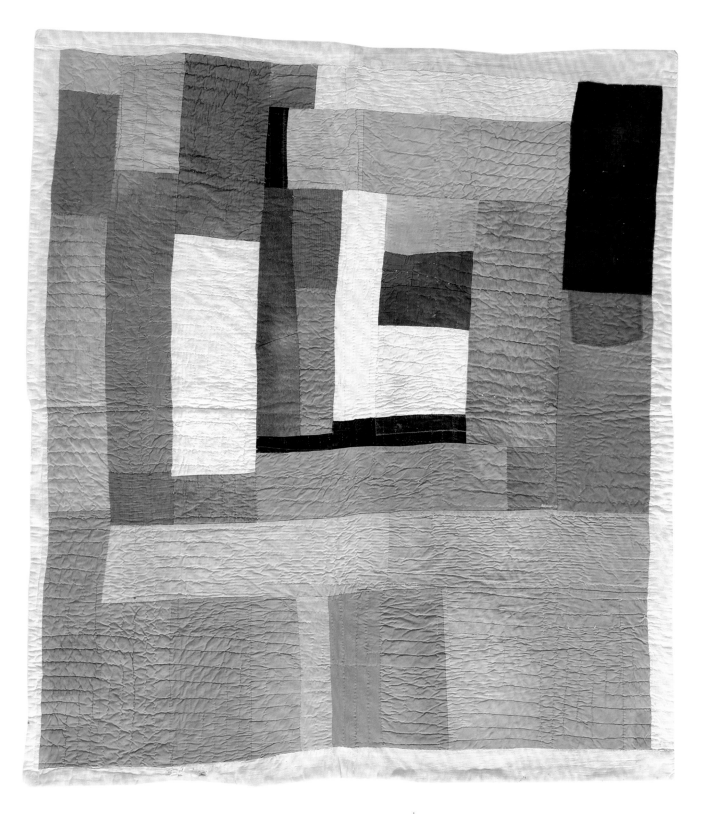

ABOVE

Original Design

c.1930–1960
Found in Selma, Alabama
African American
COTTON, WORK-CLOTHING FABRICS
77 x 69.5 inches (195.5 x 176.5 cm)

OPPOSITE

"Blue Bars and Crosses"
(double-sided)

c.1930–1960
Found in Texas
COTTON, RAYON, TIED
77 x 56 inches (195.5 x 142 cm)

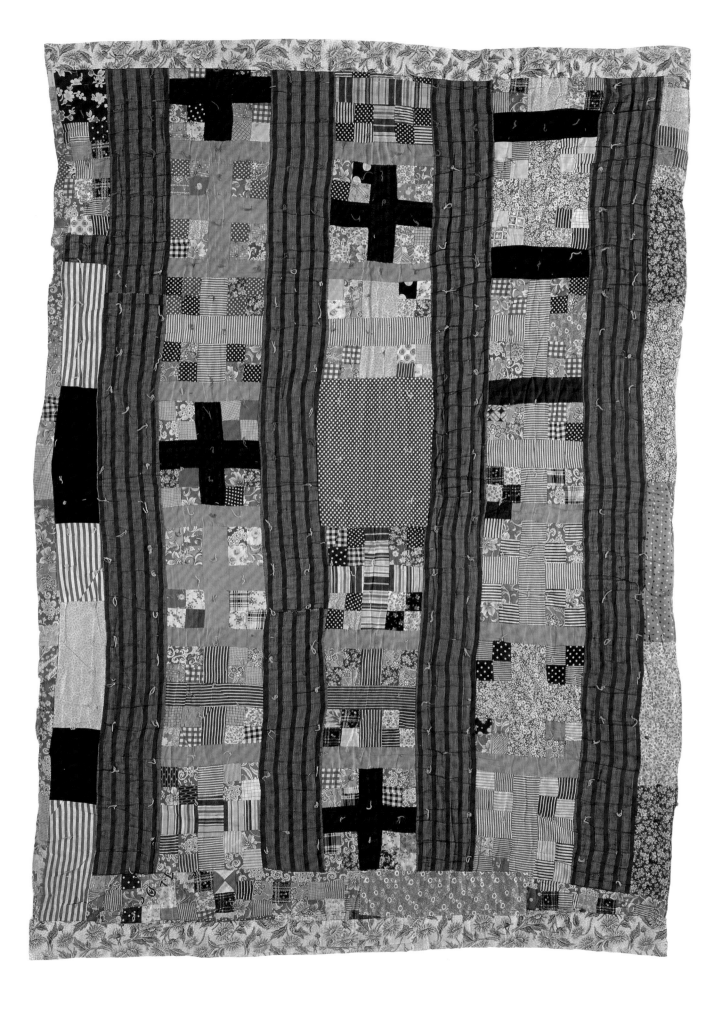

The Beauty of Making Do

DENYSE SCHMIDT

NECESSITY IS THE MOTHER OF INVENTION. I believe it is one of the driving forces in the innovations—both major and minor—of many historic quiltmakers, and particularly of the quilts in this collection. I love the notion of making do with what is on hand. I teach improvisational patchwork workshops that are about process, and the practice of recognizing and letting go of learned ideas about color and composition. In my workshops I talk about the *Paradox of Choice* by Barry Schwartz. His research and anecdotal evidence suggest that the more choice we have, the more unsatisfied we usually are with our experience, whether it is purchasing salad dressing or a new pair of jeans. I think this is part of why the idea of making do—and the experience of it—are so satisfying and rewarding. Somehow, with fewer options there is less at stake: We are free to experiment with what we have on hand, and there is a sense of having nothing to lose. I think we can appreciate the results more, or feel satisfied with the process because we have seemingly created something from nothing. We haven't spent undue time on a frustrating search for the "perfect" material; we spend the time instead on the experience of making.

In my workshops I set time limits so that everyone creates blocks very quickly, and all the patches for each block are drawn blindly from paper bags, one piece at a time. The process of having to use whatever we draw from the bag connects us to the idea of scarcity, of using what we have on hand. It helps us avoid getting bogged down in endless second-guessing. By focusing on only one piece at a time, it's also easier to stay in the moment and respond to what is happening *now*, rather than planning ahead or working toward preconceived ideas. It's sometimes very hard to let go of controlling the outcome, to allow things to come together with a degree of chance,

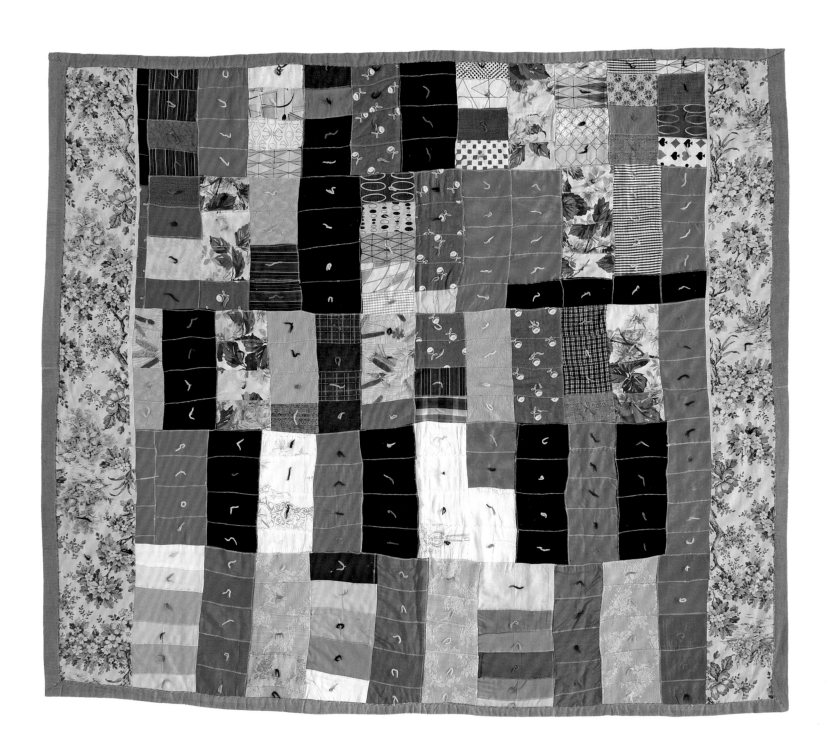

One Patch, variation

c.1950–1975

COTTON, BLENDS, WOOL, FURNISHING

FABRIC, MACHINE-EMBROIDERED, TIED

71 x 83 inches (180 x 211 cm)

but the payoff is the opportunity to make discoveries about combinations of scale, color, and pattern that we might not have ordinarily seen. I believe that the only way we really absorb this kind of learning and unlearning is to have it happen viscerally, to have it come from our own hands. The improvisational process releases us from choice and judgment, allowing for a degree of freedom and fun that is truly liberating.

The makers of the quilts in this collection may not have been practicing at improvisation or recreating a sense of scarcity as an exercise. My guess is that they were simply working instinctively with the materials on hand. These quilts feel authentic, simple, honest, unselfconscious, and uncomplicated. They are uncompromisingly, unapologetically themselves, and there is great beauty in the freedom that implies. To me it is evidence of joy in the making with nothing to prove, of working easily and quickly, unencumbered by any need to get things "right" or perfect, or of deliberating over choices. Whatever the skill level of the maker, or her knowledge of conventions, there is a confidence and directness in these quilts: "This is what I can do; this is what I am." The work as a result is powerful, full of pure personality.

I especially enjoy what some traditionalists may see as imperfections, or mistakes, in these quilts—a random fabric here, a wobbly edge there, a seam that doesn't align. These "mistakes" make the quilts come alive and give us a sense of the people who made them, along with some hint perhaps of their individual stories. They draw us in because they are surprising and intriguing, and somehow forgiving. They are reassuring evidence that we are human, and are opportunities for creative discovery and exploration. While our minds seem to crave the repetition that is inherent in a quilt pattern, the variations on the theme—especially when subtle and surprising— spark our imaginations and make us see more, and look harder, for all the delights the piece might offer up. They keep us interested. The seemingly haphazard addition or substitution of a color or print makes the formality of the pattern both clearer and less rigid at the same time. When the blocks in a quilt top are not all the same size, the act of stitching them together prompts creative problem solving, such as sashing of varying sizes and shapes, or an added oddball row or blocks or strips. I love when pieces of fabric are imprecisely cut—triangles are not all the same size or shape for instance (maybe cut with scissors instead of a rotary cutter and definitely without

OPPOSITE (FRONT) &
FOLLOWING PAGE
(DETAIL OF BACK)

String with Grid
(unfinished top)
c.1950–1975
Found in Alabama
COTTON, BLENDS, SEARS,
ROEBUCK & CO. CATALOG
PAGES, FOUNDATION-PIECED
BY MACHINE
86 x 68 inches (218 x 173 cm)

*I love the colorful, dynamic
front with its grid, color, crosses,
and Xs in the background,
but it is the back that truly
compels me. These are the
same Sears catalog pages
that I nostalgically remember
leafing through as a child in
the fifties and sixties, strikingly
re-conceptualized as arte
povera or Rauschenberg-esque
assemblage.*

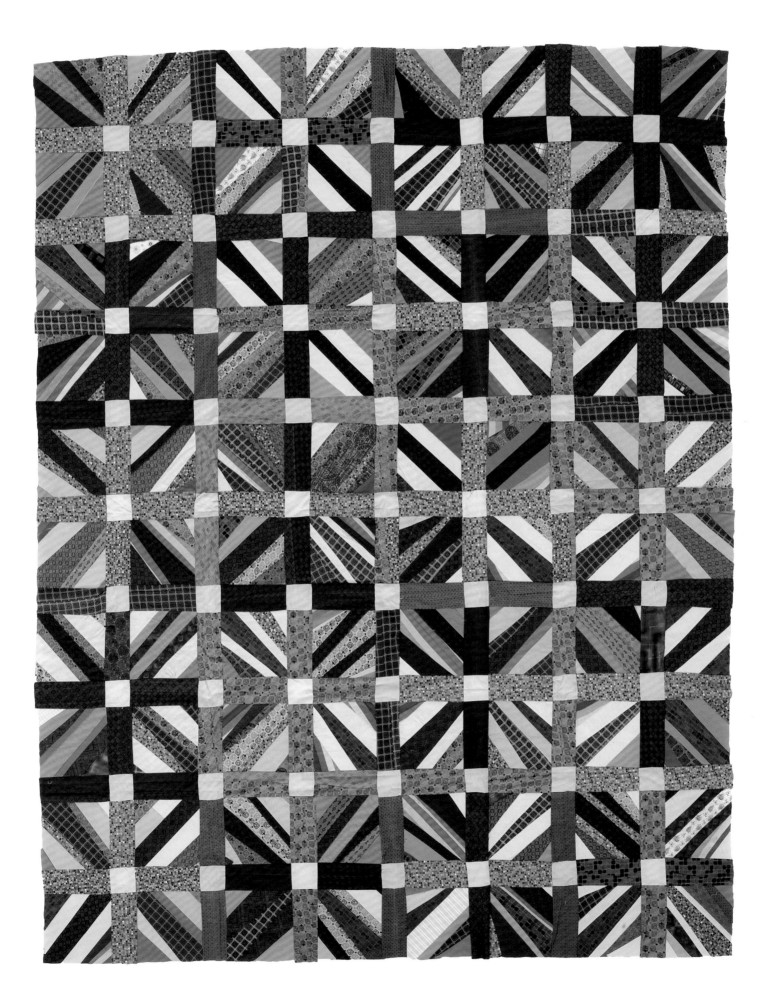

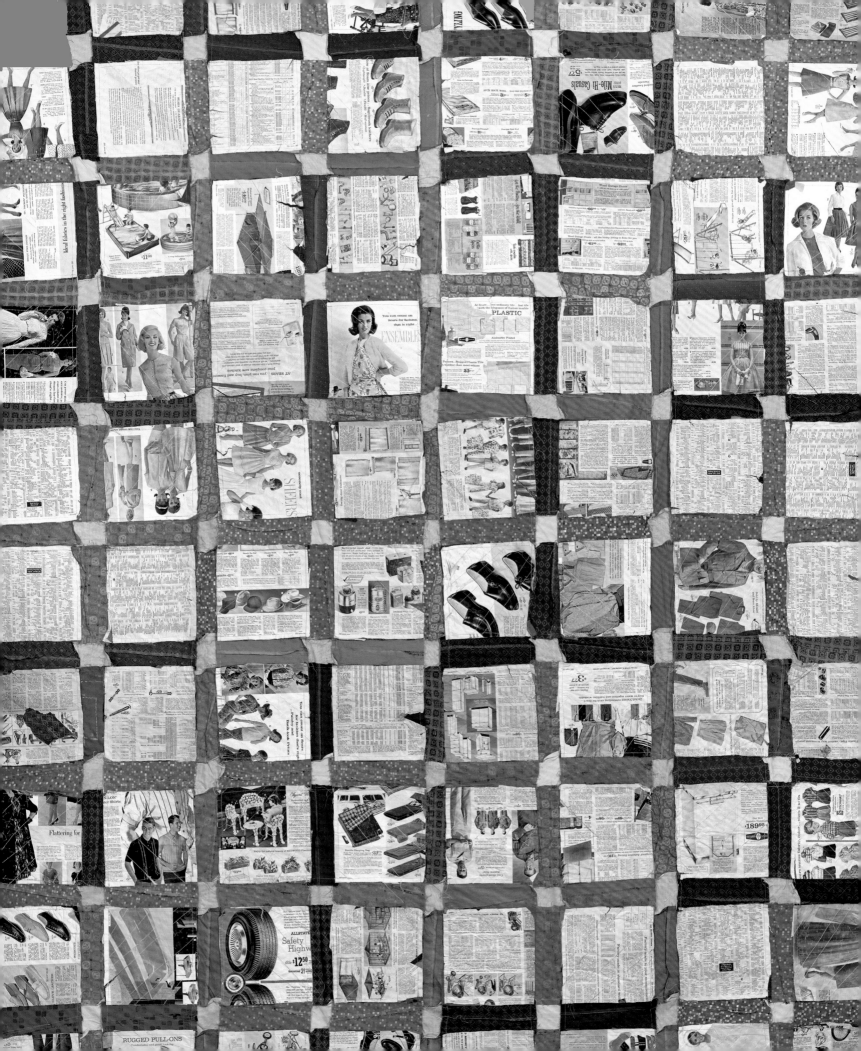

a ruler)—and yet somehow they are coaxed into patchwork, into a cohesive crazy whole, with spirit and resourcefulness. And I love the way the makers of these quilts used fabrics that surprise us, that seem out of left field but that are brilliant in their strangeness, in particular the polyester double-knits. I've always been comfortable mixing materials, maybe because I've had so much experience sewing all kinds of fabric so I'm not intimidated by, nor do I question, mixing it up. The double-knit fabrics used in these quilts are wild and so vibrant. I've no doubt they add to the movement—visual and literal—of the quilts themselves. And they speak so eloquently to the time period in which these quilts were made, as so much of our clothing then was made of this material, and the use of it in these quilts is a clear indicator of making do.

Most of the quilts in this collection draw on historical patterns at least as a starting point. Some of these quilts show a clear relationship to a known quilt pattern, while others draw on the historical only in that they use a block structure or strip piecing as the foundation of the design. For the most part, the reference to historical pattern in this collection is refreshingly free and loose—there is no apparent need to rigidly conform to convention or expectation, whether by accident or by design. Colors and prints are mixed unconventionally and that is what makes many of these quilts so exciting. I tend to think that these combinations stem from using what is on hand. The beautiful truth of making do is that the act of sewing two random and perhaps clashing pieces of fabric together means they now "go" together, simply by virtue of being stitched together into one object. That the combinations are partly the result of happenstance, rather than careful consideration and forethought, is the magic.

One of the reasons I fell in love with quilting in the first place is that, at its best, it is an open forum that welcomes people at all levels, of all intentions, making all kinds of quilts. Every person brings something different to the process, and a single pattern can be made in an infinite number of variations. Taking inspiration from the quilts in this collection, we are reminded to take chances, to experiment, to be open to the opportunities inherent in mistakes, to close our ears to critics and shun expectations, to be true to our own intuition, and to trust our gut instincts.

A former graphic designer and graduate of Rhode Island School of Design, DENYSE SCHMIDT has changed the way we think about quilts. Intrigued by the historical nature of quilts and inspired by beauty born of necessity, Schmidt adds her distinctive aesthetic sensibility—clean, spare lines, rich color and bold graphics—to this art form. Though firmly rooted in the techniques of American quiltmaking, Schmidt is renowned for her fresh, offbeat approach to design and color and has won acclaim from the worlds of art, design, and craft. As author of Denyse Schmidt Quilts (2005) and Modern Quilts, Traditional Inspiration (2012), fabric designer for FreeSpirit and Fabric Traditions, and teacher of a series of popular improvisational patchwork piecing workshops, Schmidt continues to inspire with her witty take on tradition.

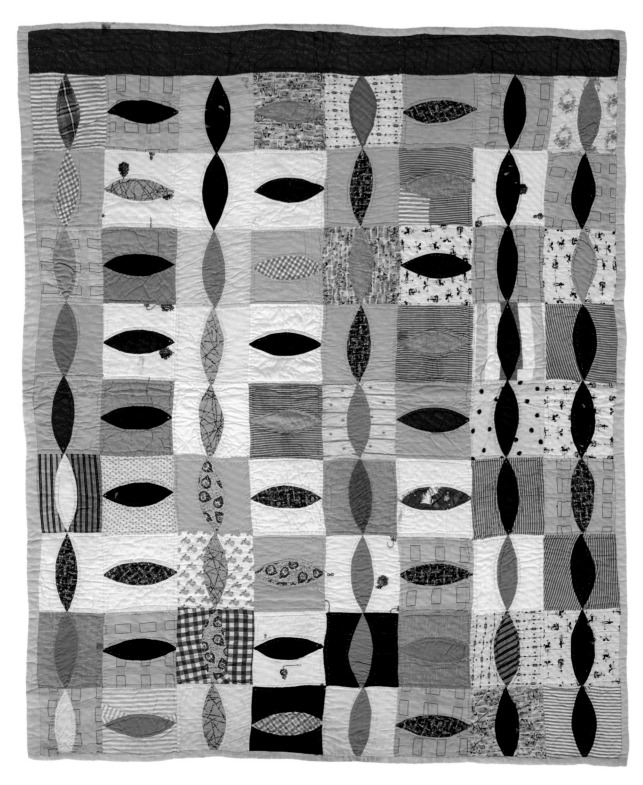

ABOVE

Unknown Pattern

c.1940–1960
Attributed to Frances O'Dell.
Found in Cordova, Alabama
COTTON. QUAKER OATS CO. "LAYING MASH"
FEED SACKS USED AS BACKING
81 x 69 inches (206 x 175 cm)

OPPOSITE

Strips

c.1975–2000
BLENDS, POLYESTER, RAYON,
FURNISHING FABRIC
80 x 63 inches (203 x 160 cm)

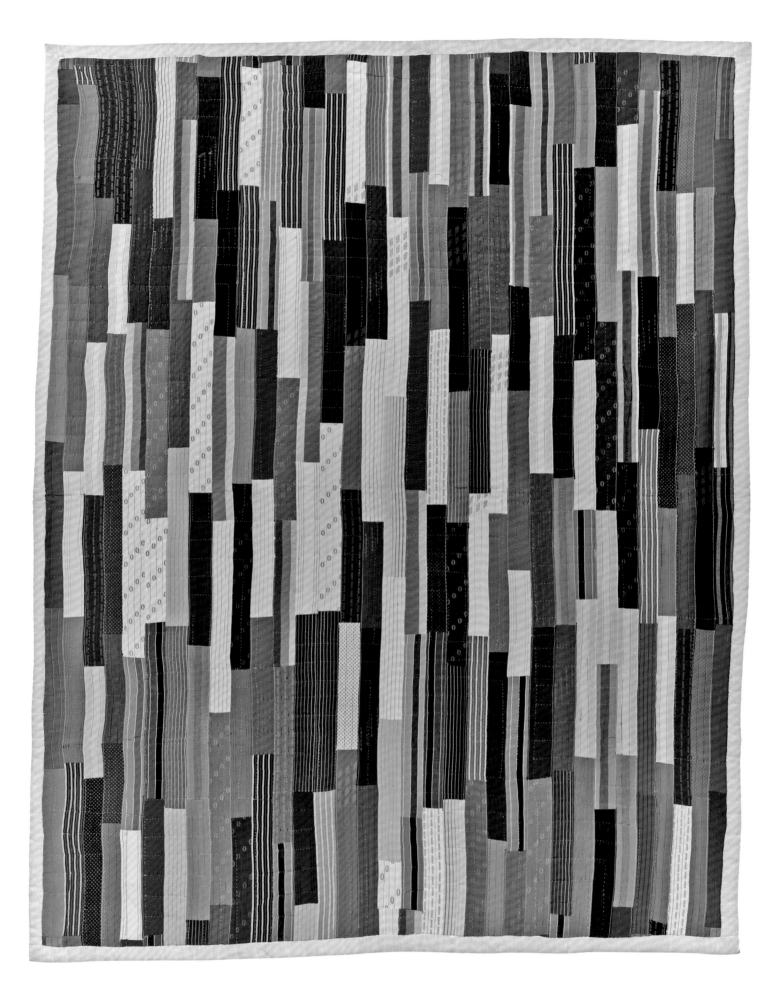

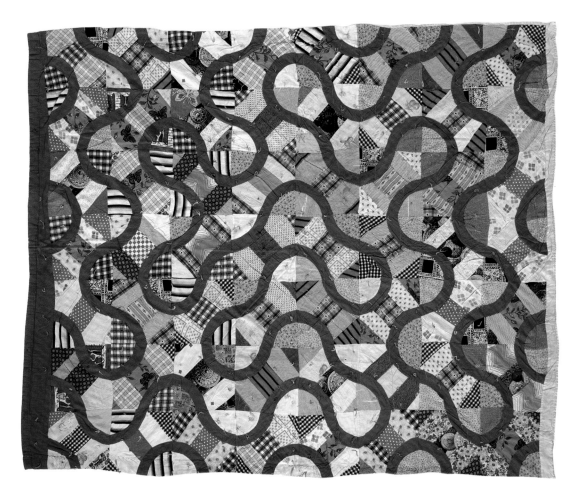

ABOVE RIGHT

Snake Trail

c.1950–1975
Found in Texas
COTTON. TIED
82 x 68 inches (208 x 173 cm)

BELOW RIGHT

Snake Trail (unfinished top)

c.1975–2000
Found in Alabama
SYNTHETIC
83 x 65 inches (211 x 165 cm)

OPPOSITE

Rattlesnake or
Snake Trail, variation

c.1940–1970
Found in Missouri
COTTON
87 x 72 inches (221 x 183 cm)

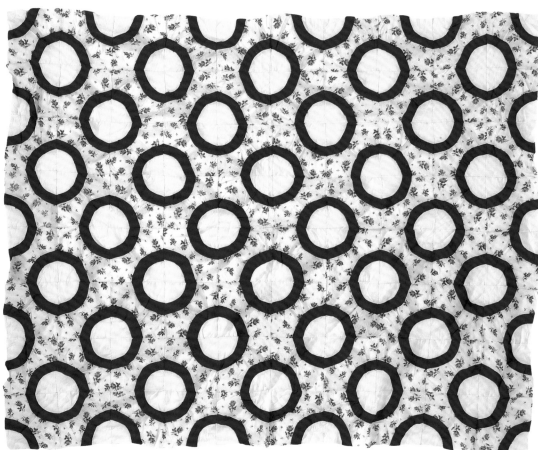

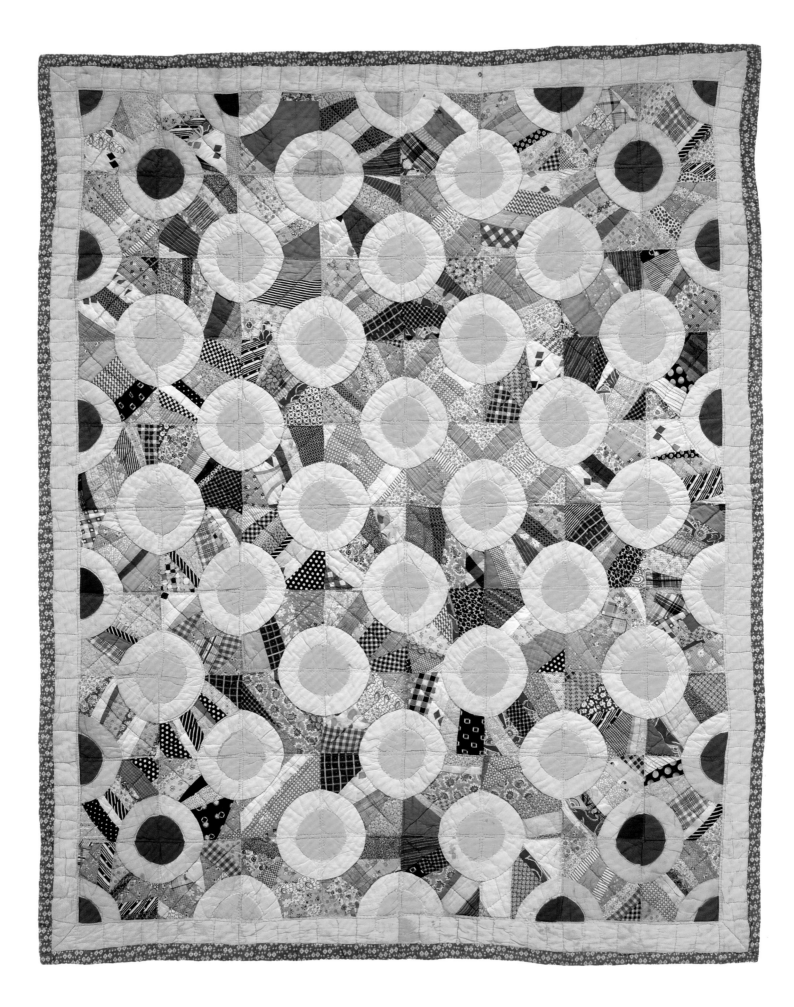

Cup and Saucer

c.1950–1960
Found in Oklahoma
COTTON
70 x 84 inches (178 x 213 cm)

Cup and Saucer was a published pattern from the Kansas City Star in 1946, preceded by Coffee Cups in 1935. When I first saw Coffee Cups (plate 51) in The Pieced Quilt: An American Design Tradition *thirty-five years ago, I was instantly attracted to it. It was the only example I had ever seen until I found this one and added it to my collection in honor of Gail van der Hoof and Jonathan Holstein, the collectors whose quilts were shown at the Whitney Museum of American Art's 1971 show. This quilt entices reference to Pop Art's repetitions and Duchamp's elevations of the mundane. The mix of prints used for the cup and saucers complements the bold solid colors. The patterns were published with handles to the right. Interestingly, this maker changed hers to the left.*

Original Design

c.1970–1990

COTTON, BLENDS. TIED

64 x 72 inches (162.5 x 183 cm)

ABOVE

Unknown Pattern

c.1975–2000
Attributed to Sally Owens.
Found in Fayette, Alabama
COTTON
80 x 69 inches (203 x 175 cm)

OPPOSITE

"Corner Chimney Log Cabin"

c.1960–1980
Found near Tyler, Texas
COTTON
86 x 69 inches (218 x 175 cm)
Collection of Eli Leon

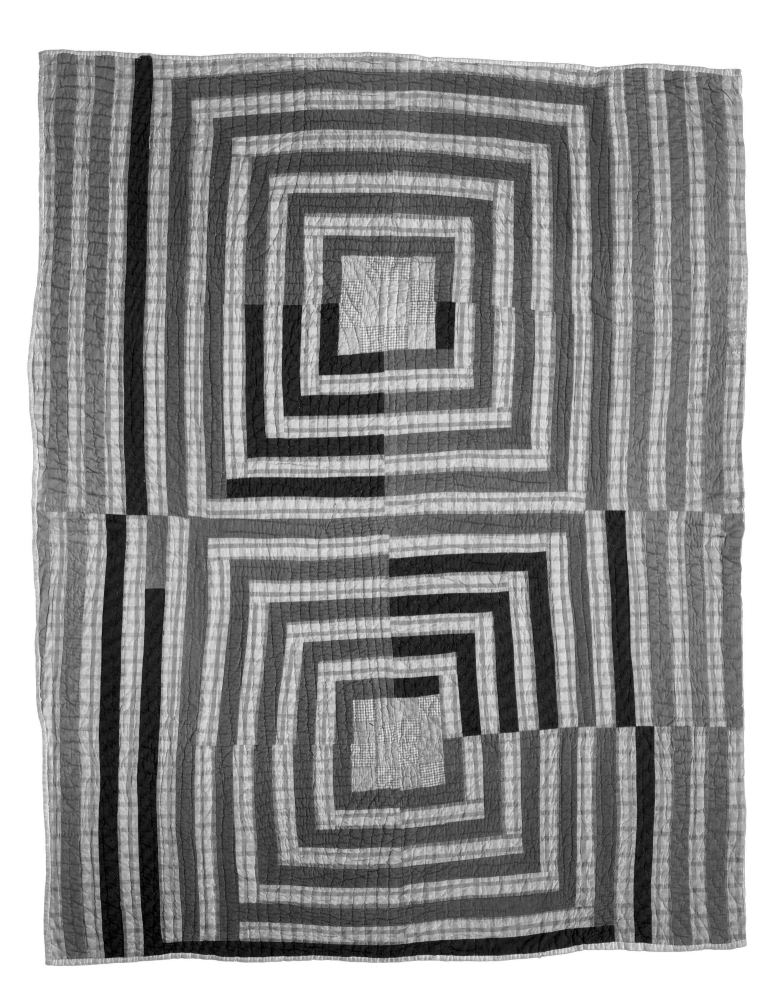

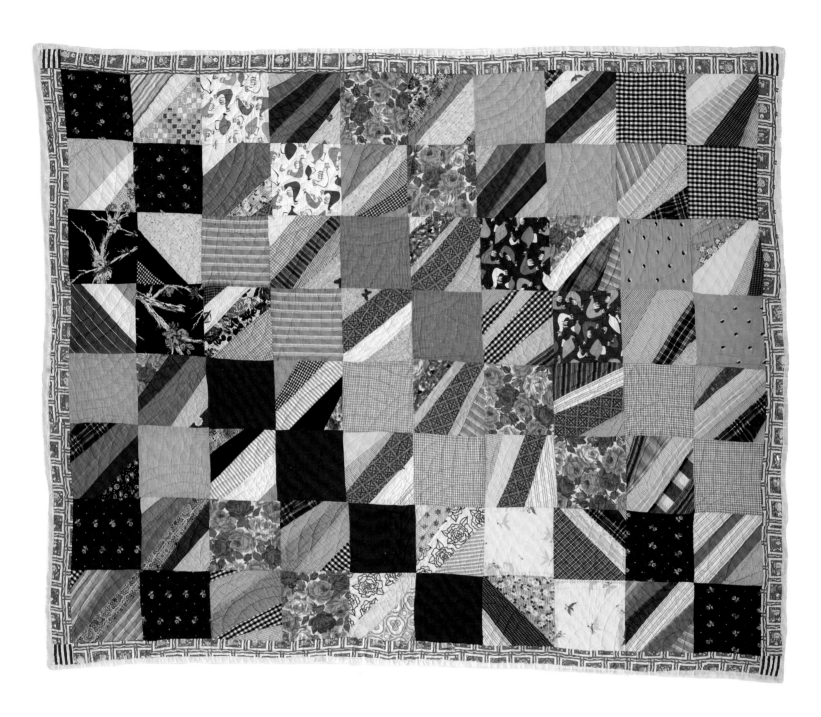

Four Patch / String, variation

c.1950–1975

Found in South Louisiana

COTTON. HAND- AND MACHINE-PIECED

66 x 83 inches (167.5 x 211 cm)

OPPOSITE

String / Strip Crazy

c.1950–1980

Attributed to the Martin family.

Found in Illinois via southern Alabama

African American

COTTON, RAYON, POLYESTER. TIED

90 x 68.5 inches (228.5 x 174 cm)

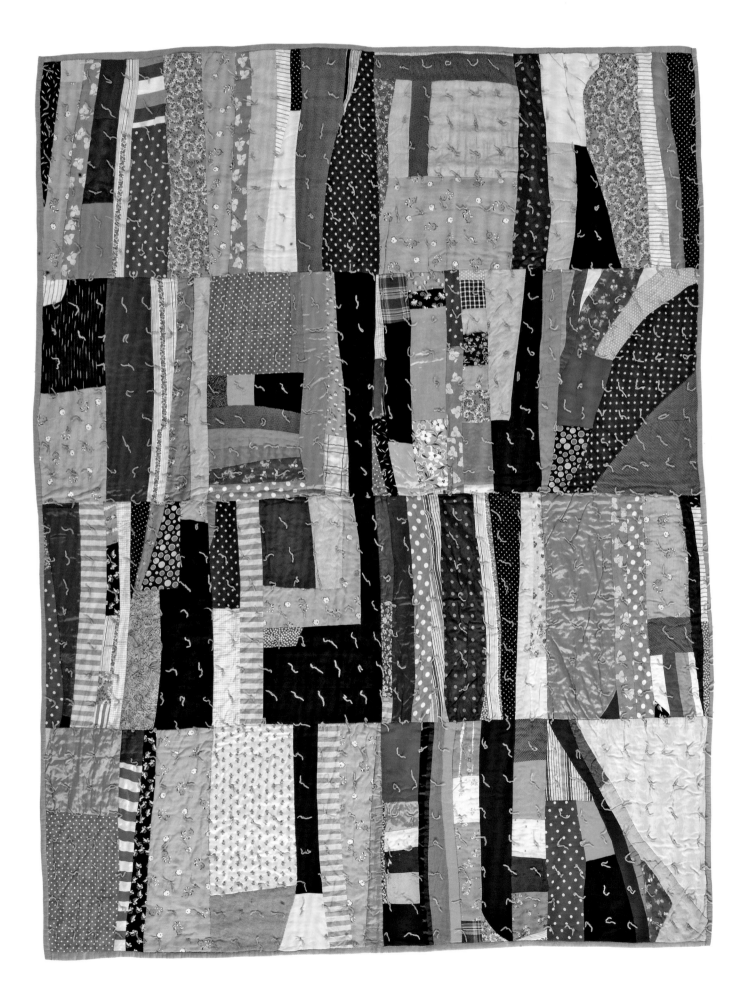

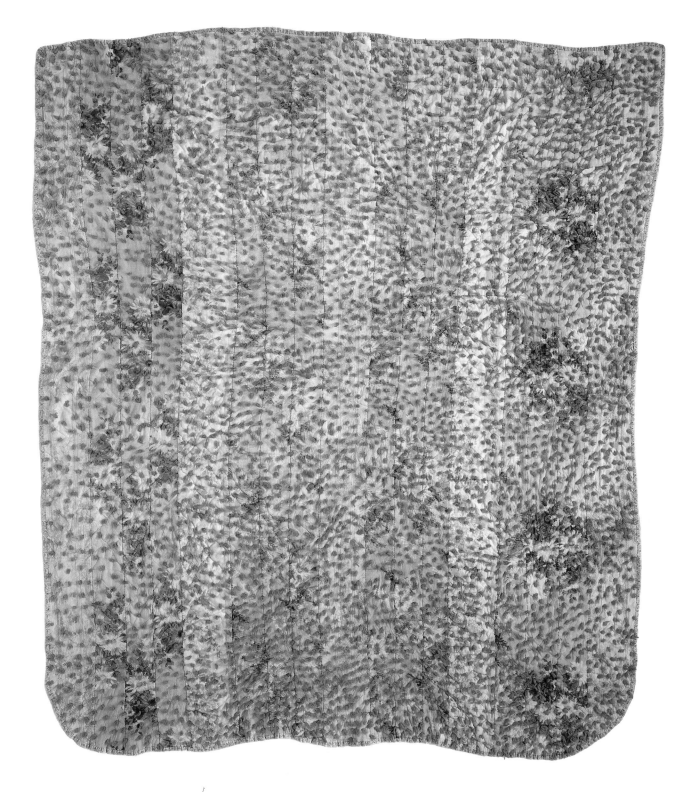

Whole Cloth

c.1950–2000
Found in Tennessee
STORE-BOUGHT POLYESTER
BEDSPREAD, TIED
96 x 84 inches (244 x 213 cm)

206

This is one of the most unusual and remarkable pieces in the collection. The photo on eBay made it look as though the piece was on fire due to the orange glow and the quality of the camera used. Once the piece arrived its uniqueness, quirkiness, and oddity was revealed. I discovered that the maker had purchased a bedspread from Sears, Roebuck & Co., J. C. Penny, or another local home furnishing store or had taken one already in use in her home; cut it into long strips; and then sewed it back together. You can see the full-blown roses motif of this very typical spread of the era beneath the ties. Batting and a backing were used and then an uncountable number of polyester orange yarn ties were hand-tied to attach the three layers. Why, one asks? We will never know the motives or inspiration of this maker.

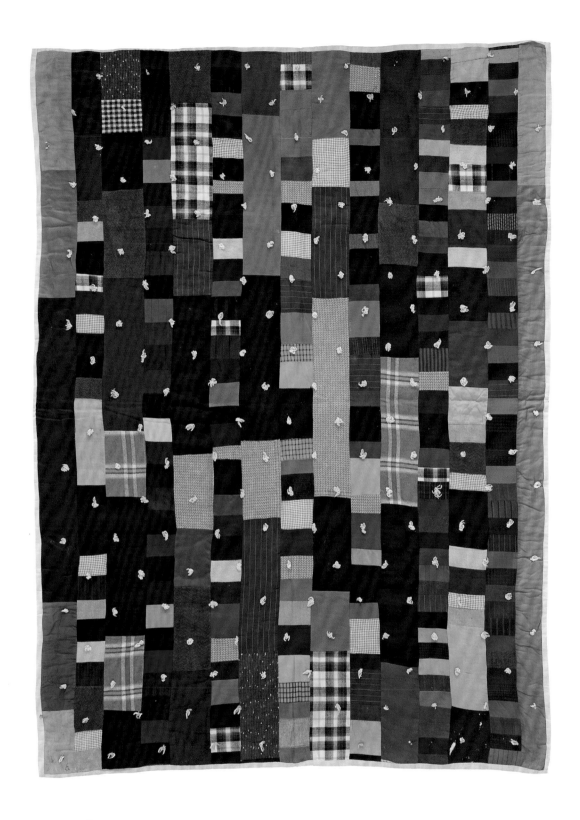

Strips

c.1930–1950
Rebecca Page.
Possibly made in New Jersey;
Found in Florida
WOOL, COTTON SATEEN
MACHINE-PIECED. TIED
83 x 61 inches (211 x 155 cm)

The subtly and judiciously placed large yarn ties seem to float above the surface. The focal point, and the longest piece of fabric used in this quilt, is the bright red strip along the right border. This seems to be a bold statement by the maker because of its placement alongside the darker and more neutral tones.

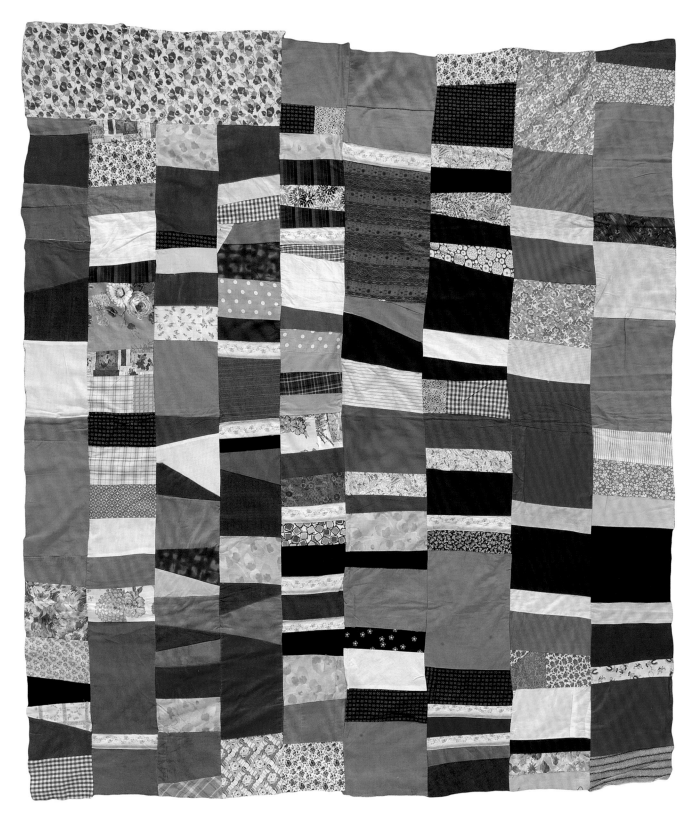

Unknown Pattern (unfinished top)

c.1975–2000

Found in Alabama

COTTON, BLENDS, FURNISHING FABRIC, CORDUROY,

NOVELTY PRINTS. FOUNDATION-PIECED BY MACHINE

208

78 x 87 inches (198 x 221 cm)

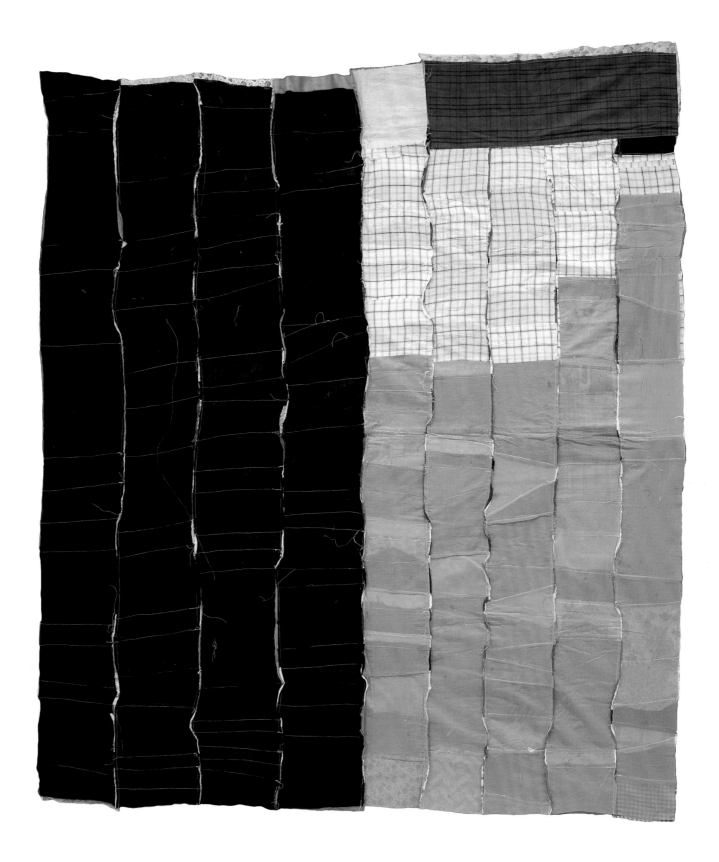

209

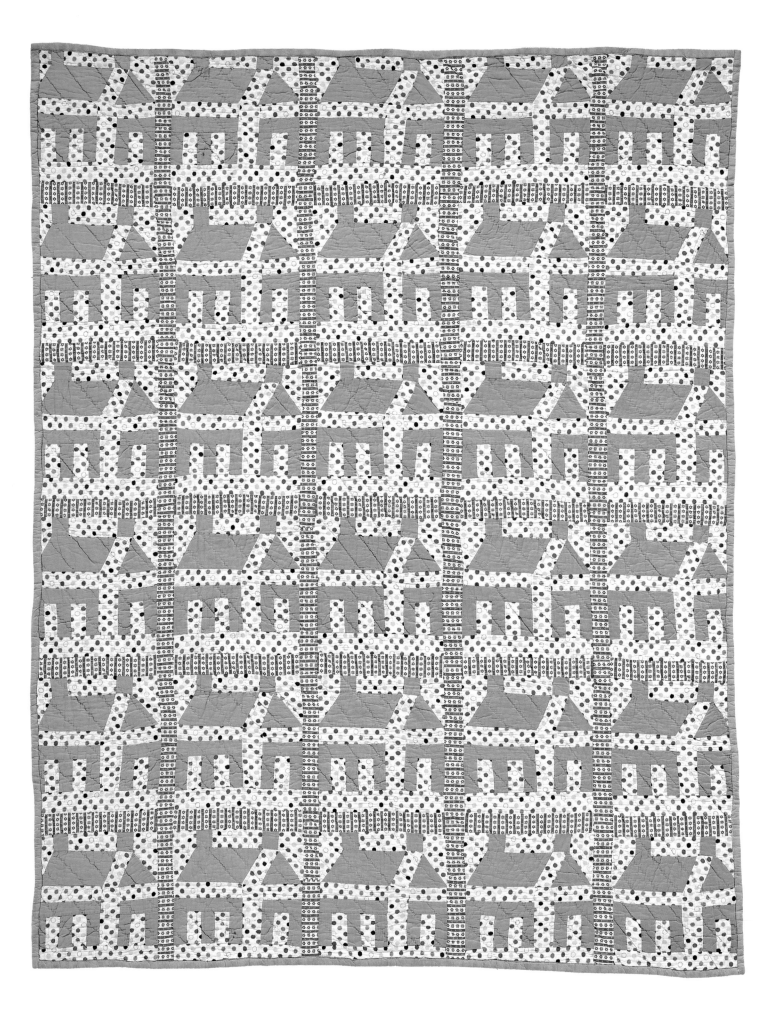

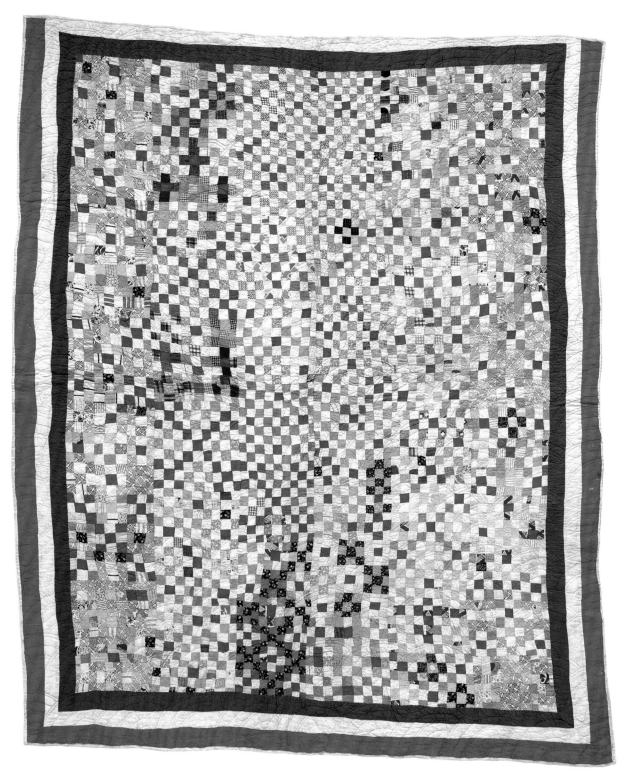

Schoolhouse / House

c.1940–1960
*Possibly made in the
Appalachian area of Virginia*
COTTON
81 x 64 inches (206 x 162.5 cm)
Ex. coll. Ardis and Robert James

Postage Stamp

c.1930–1960
Found in Indiana
COTTON
82 x 69 inches (208 x 175 cm)

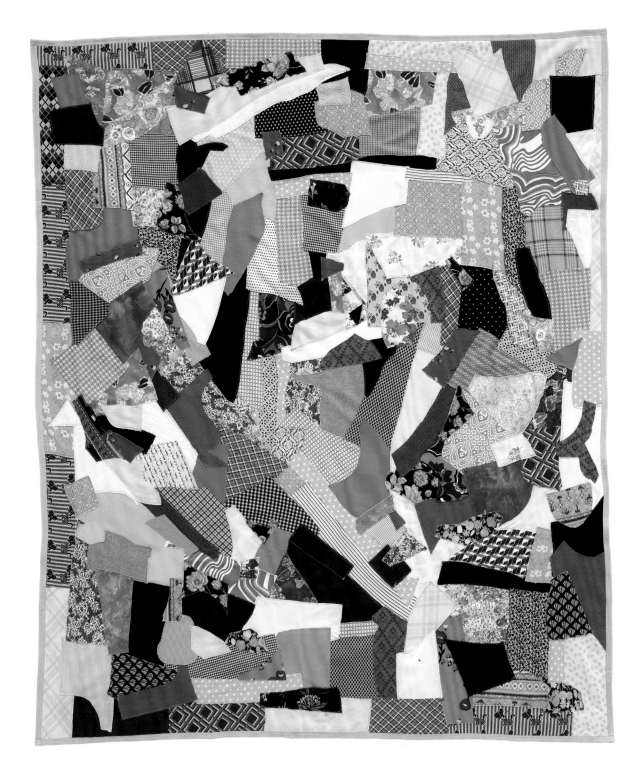

Crazy

c.1975–2000

Attributed to Opal Guthrie.

Found in Winfield, Alabama

COTTON, POLYESTER, DOUBLE-KNITS

MACHINE-PIECED AND APPLIQUÉD

83 x 69 inches (211 x 175 cm)

This quilt and others like it call into question the long-held belief that the "crazy" fad extended from the last twenty years of the nineteenth century into the first twenty years of the twentieth, then wound down to an abrupt halt. It did not.

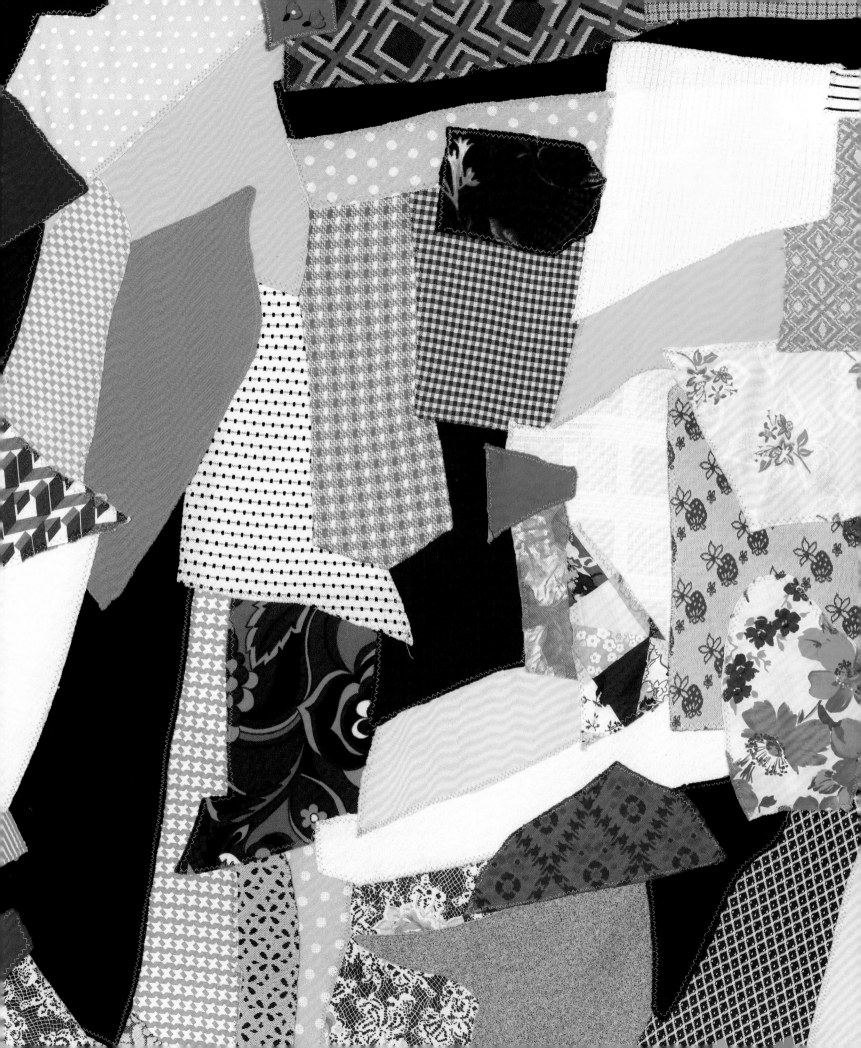

This Picture Is Not a Family Heirloom

ABNER NOLAN

"A sort of umbilical cord links the body of the photographed thing to my gaze: light, though impalpable, is here a carnal medium, a skin I share with anyone who has been photographed." —Roland Barthes, Camera Lucida: Reflections on Photography

WHEN GEORGE EASTMAN INTRODUCED HIS REVOLUTIONARY IMAGING system in the late nineteenth century, his motivations were based largely on imperatives of efficiency and capital. The snapshot, as it quickly would come to be known, was the solution to the problem of scale: how to make the still relatively cumbersome tools of photography available to the widest possible audience. The delicate material reality of these early popular images was dictated by this financial reality, but in time would prove to be a primary component of the small, jewel-like pictures' capacity to hold to our memories and our imagination. Like the timeworn bits of fabric pieced together to make many of the quilts seen in this collection, the snapshot gains significance as it is used and touched—sometimes in the service of aiding (or manufacturing) memory, sometimes as a kind of shelter from the unknown.

Before the majority of our personal images were stored on computer hard drives or in the memories of smart phones, photographs were glued into albums or crammed into wallets or pocketbooks and carried between moves from house to house, and between one generation and the next, a physical reminder of a connection to our particular place in the history of the world. Despite the fugitive nature of many popular

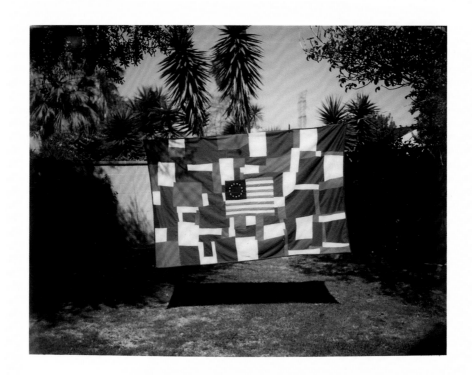

photographic processes and the flimsy papers that were employed by drugstores and other inexpensive photo processors, pictures managed to survive, and to thrive. In this constant handling, in the physical exchange, the snapshot gains another kind of history from the one that is pictured. Imbued with desire or longing as it is passed between hands over time, the picture becomes a kind of talisman or shrine, taking on a significance that stands in stark contrast to its humble material condition.

Here now we have another photograph (above). The small color image has been gently yellowed by time and the once white border has imperfections, perhaps due to unwashed hands not wanting to interfere with the subject matter. The photographic process that was used can help place it within the last thirty or forty years, not quite historic but just distant enough in time to invoke the past and its related bend towards nostalgia. We can see a stark, hot sunlight illuminating (perhaps) a cherished possession or simply an object of some fascination. Centered in the middle of the frame, the red, white, and blue patchwork quilt could be replaced with a new car or the facade of a first home or a newborn baby in any number of amateur snaps. Taking a picture is an act of possession, an

ABNER NOLAN *is a Bay Area-based artist and educator. His photographs and installations have been exhibited nationally, and his monograph of works derived from vernacular images was published in 2009.*

acknowledgment of significance made between the subject, the photographer, and the world. The same relationship perhaps existed in the slow, thoughtful process of constructing the quilt itself. Through the matching and sewing of disparate parts, an image is eventually revealed, a clear desire to hold something—an idea of patriotism or historical commemoration—in a form both familiar and seductive.

This picture is not a family heirloom. Like many of the quilts in this volume it was rescued from a sea of discarded or unwanted objects, plucked from obscurity, and given meaning and context through a different act of possession. Perhaps it was deemed unremarkable or unnecessary, and only now, without the distractions of its specific circumstances, can we see fully the dazzling light, the peculiar arrangement of Americana and palm trees, and the desire to elevate the handcrafted object that is its subject. Smudgy fingerprints on the edges of well-loved pictures or the imperfect stitches in any number of these beautiful quilts are small reminders of the animate life of objects, a secret, visceral account of our time here.

OPPOSITE

Pattern #7015 / House

c.1950–1975
COTTON
79 x 64.5 inches (201 x 164 cm)
Ex coll. Charlotte Ekback

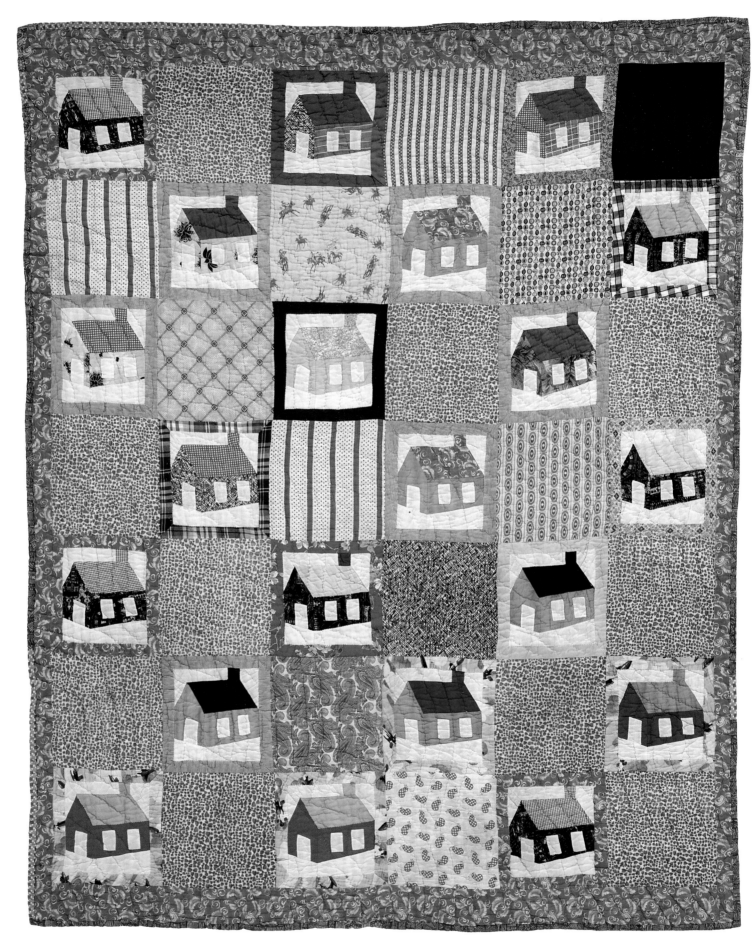

RESOURCES

Endnotes

Unconventional Wisdom: The Myths and Quilts That Came Before, by Janneken Smucker

1 Janet Catherine Berlo, "'Acts of Pride, Desperation, and Necessity': Aesthetics, Social History, and American Quilts," in *Wild by Design: Two Hundred Years of Innovation and Artistry in American Quilts*, ed. Janet Catherine Berlo and Patricia Cox Crews (Lincoln: International Quilt Study Center at the University of Nebraska in association with University of Washington Press, Seattle, 2003), 9–11; Virginia Gunn, "From Myth to Maturity: The Evolution of Quilt Scholarship," *Uncoverings* 13 (1992): 195–8.

2 Virginia Gunn, "Perfecting the Past: Colonial Revival Quilts," in *American Quilts in the Modern Age, 1870–1940: The International Quilt Study Center Collections*, ed. Marin F. Hanson and Patricia Cox Crews (Lincoln: University of Nebraska Press, 2009), 229–230.

3 Ruth E. Finley, *Old Patchwork Quilts and the Women Who Made Them*, (Philadelphia; London: J.B. Lippincott Co., 1929), 21.

4 See Virginia Gunn's analysis of Finley's theory in "From Myth to Maturity," 198.

5 Marie D. Webster, *Quilts, Their Story and How to Make Them* (Garden City, NY: Doubleday, Page & Company, 1915), 64, 80.

6 Berlo, "Acts of Pride," 25.

7 Gunn, "From Myth to Maturity," 200–01; Jonathan Holstein, Eleanor Bingham Miller, and Shelly Zegart, "The Quilt Journal: Mission Statement," *The Quilt Journal* 1, no. 1 (1992): 1–3.

8 See Sally Garoutte, "Early Colonial Quilts in a Bedding Context," *Uncoverings* 1 (1980): 1–10; Barbara Brackman, *Clues in the Calico: A Guide to Identifying and Dating Antique Quilts* (Charlottesville, VA: Howell Press, 1989), 13–17.

9 Brackman, *Clues in the Calico*, 99.

10 Pat Nickols, "String Quilts," *Uncoverings* 3 (1982): 53–58; Nora Pickens, "New Mexico Scrap Quilts," *Uncoverings* 7 (1986): 39–46; Linda Welters, "Yankee Frugality," in *Down by the Old Mill Stream: Quilts in Rhode Island*, ed. Linda Welters and Margaret T. Ordoñez (Kent, OH: Kent State University Press, 2000), 271–74.

11 Susan Strasser, *Waste and Want: A Social History of Trash* (New York: Holt Paperbacks, 1999), 212–13.

12 Strasser, *Waste and Want*, 55.

13 Susan Strasser, "Customer to Consumer: The New Consumption in the Progressive Era," *OAH Magazine of History* 13, no. 3 (April 1, 1999): 13–4, doi:10.2307/25163286.

A Brief History of Quilts in Contemporary Art, by Elissa Auther

1 As quoted in Sharon F. Patton, *African-American Art* (Oxford University Press, 1998), 225.

From Under the Bedcovers: A Culture Curator's Perspective, by Ulysses Grant Dietz

1 When I discussed this issue with the Newark Museum's curator of the arts of Africa, Dr. Christa Clarke, who is herself a textile specialist, it became clear that American quilt scholars study American quilts while African art scholars study African textiles. No one, as of yet, has really done the work to make this connection clear.

2 See website for Henry John Drewal, Evjue-Bascom Professor of Art History and Afro-American Studies at the University of Wisconsin-Madison who first saw *kawandi* while documenting Siddi expressive culture in 2004, http://www. henrydrewal.com/exhibit_stitching_history. html.

3 Of course, someone needs to determine the point of origin in Africa of the ancestors of the African American quilters, and likewise for the forebears of the Siddi quilters. No one has been able to answer this question on either side, to my knowledge.

Quilts Are Quilts, by Allison Smith

1 See Adamson, Glenn. *Thinking Through Craft* (Berg, 2007) and *The Craft Reader* (Berg, 2010).

2 See Adamson, Glenn. Ibid.

3 Appadurai, Arjen. *The Social Life of Things: Commodities in Cultural Perspective* (Cambridge University Press, 1988).

4 See Brown, Bill. "Thing Theory," *Critical Inquiry* 28, Number 1 (Autumn, 2001).

References

BOOKS

Adamson, Glenn. *Thinking Through Craft*. Berg Publishers, 2007.

Auther, Elissa. *String, Felt, Thread: The Hierarchy of Art and Craft in American Art*. University of Minnesota Press, 2010.

Barthes, Roland. *Camera Lucida: Reflections on Photography*. Translated by Richard Howard. Hill and Wang, 2010.

Benberry, Cuesta. "Afro-American Women and Quilts." *Uncoverings 1980* 1 (1980): 64–67.

——. *Always There: The African-American Presence in American Quilts*. The Kentucky Quilt Project, Inc., 1992.

——. *A Piece of My Soul: Quilts by Black Arkansans*. The University of Arkansas Press, 2000.

Berger, John. *About Looking*. Vintage International, 1991.

——. *Ways of Seeing*. British Broadcasting Corporation and Penguin Books, 1972.

Berlo, Janet Catherine, and Patricia Cox Crews. *Wild by Design: Two Hundred Years of Innovation and Artistry in American Quilts*. International Quilt Study Center, 2003.

Bernick, Susan E. "A Quilt Is an Art Object When It Stands Up Like a Man." In *Quilt Culture: Tracing the Pattern*, edited by Cheryl B. Torsney and Judy Elsley, 134–50. University of Missouri Press, 1994.

Bryan-Wilson, Julia. "Queerly Made: Harmony Hammond's Floorpieces." *Journal of Modern Craft* 2 (March 2009): 59–80.

Canady, John. *What Is Art? An Introduction to Painting, Sculpture and Architecture*. Alfred A. Knopf, 1980.

Cooks, Bridget R. "Back to the Future: The Quilts of Gee's Bend, 2002." Chap. 5 in *Exhibiting Blackness: African Americans and the American Art Museum*. University of Massachusetts Press, 2011.

Donnell, Radka. *Quilts as Women's Art: A Quilt Poetics*. Gallerie Publications, 1990.

Fox, Danielle. "Art." Chap. 2 in *Culture Works: The Political Economy of Culture*, edited by Richard Maxwell, 22–59. University of Minnesota Press, 2001.

Franck, Frederick. "The Way of Seeing." Chap. 8 in *Ordinary Magic: Everyday Life as Spiritual Path*, edited by John Welwood, 77–89. Shambhala Publications, 1992.

Hagood, Margaret Jarman. *Mothers of the South: Portraiture of the White Tenant Farm Woman*. W. W. Norton, 1977.

Hefley, Scott. *Bold Improvisation: Searching for African-American Quilts*. Kansas City Star Books, 2007.

Holt, Steven Skov, and Mara Holt Skov. *Manufractured: The Conspicuous Transformation of Everyday Objects*. Chronicle Books, 2008.

Huff, Mary Elizabeth Johnson. "Just How I Picture It in My Mind." In *Just How I Picture It in My Mind: Contemporary African American Quilts from the Montgomery Museum of Fine Arts*. Montgomery Museum of Fine Arts and River City Publishing, 2006.

Kamps, Toby. *The Old, Weird America: Folk Themes in Contemporary Art*. Contemporary Arts Museum, Houston, 2008.

Kiracofe, Roderick, with Mary Elizabeth Johnson. *The American Quilt: A History of Cloth and Comfort 1750–1950*. Clarkson Potter, 1993, 2004.

Laury, Jean Ray. *Quilts & Coverlets: A Contemporary Approach*. Van Nostrand Reinhold, 1971.

Lubar, Steven, and W. David Kingery, eds. *History from Things: Essays on Material Culture*. Smithsonian Books, 1993.

Meyer, Richard. *What Was Contemporary Art?*. MIT Press, 2013.

Prown, Jules David. *Art as Evidence: Writings on Art and Material Culture*. Yale University Press, 2002.

Przybysz, Jane. "Bay Area Beginnings: The American Quilt Study Group and the Twentieth-Century California Fiber Art Movement." *Uncoverings 2010* 31 (2010): 204–220.

Ramsey, Bets. "Design Invention in Country Quilts of Tennessee and Georgia." *Uncoverings 1980* 1 (1980): 48–54.

Rinder, Lawrence. "Rosie Lee Tompkins, Really." In *Art Life: Selected Writings, 1991–2005*, 37–44. Gregory R. Miller, 2005.

Schlereth, Thomas J., ed. *Material Culture: A Research Guide*. University Press of Kansas, 1985.

Shaw, Robert. *American Quilts: The Democratic Art, 1780–2007*. Sterling, 2009.

Tomkins, Calvin. *Off the Wall: A Portrait of Robert Rauschenberg*, Picador, 2005.

Weeks, Pamela. "One Foot Square, Quilted and Bound: A Study of Potholder Quilts," *Uncoverings 2010* 31 (2010): 131–57.

MAGAZINE ARTICLES

Karmel, Pepe. "The Golden Age of Abstraction: Right Now." *ARTnews*, April, 2013, pp 66–73.

Tompkins, Calvin. "The Mind's Eye: The Merciless Originality of Jasper Johns," *The New Yorker*, December 11, 2006, pp 76–85.

INTERNET ARTICLES

Peck, Amelia. "Anonymous." 3 min., 52 sec.; from The Metropolitan Museum of Art, *Connections*. http://www.metmuseum.org/connections/anonymous.

Schwalb, Robin. "Grids." 4 min., 4 sec.; from The Metropolitan Museum of Art, *Connections*. http://www.metmuseum.org/connections/grids.

FILM

Chanin, Natalie. *Stitch: A Documentary Film*. DVD. Directed by Natalie Chanin. Produced by Fish Film, 2001.

Jefferson, Doug, Ann E. Berman, and Shelly Zegart. *Why Quilts Matter: History, Art & Politics*. DVD. Produced by Doug Jefferson, hosted by Shelly Zegart. The Kentucky Quilt Project, 2011.

Acknowledgments

This book would not have been possible without the assistance, support, help, encouragement, and love of the following group of people. I am enormously thankful and blessed.

Marcel Allbritton

Anonymous makers

Chris Atwood

Elissa Auther

Jane Baker

Nancy Bavor

Hal Zina Bennett

Julius Berman

Lydia Brawner

Sherry Ann & Curtis Byrd

JT Bymaster

Christine Cariati

Julie Casemore

Natalie Chanin

Amy Cheney

Marjorie Childress

Philip Cohen

Michael Council

Joe Cunningham

Patricia Cummings

Raymond Davi

Tom di Maria

Ulysses Grant Dietz

eBay dealers from whom I purchased

Daisy Biddle Eiman

Jack B. Eiman

Melanie Falick

Kaffe Fassett & Brandon Mably

Laura Fisher

Danielle Fox

Mark French

Siobhan Furgurson

Erin Lee Gafill

Cristina Garces

Sarah Gifford

Bonnie Grossman/ Ames Gallery

Beth Gutcheon

Jason Hanasik

Sally Harding

Carrie Heeter

Scott Heffley

Leah Hyams

Mari Iki & Martin Maguss

Becky Jacobsen

Colter Jacobsen

Josef Jacques

Mike Josephson & Rod Macneil

Marjorie Pauling Kiracofe

Gabriel Kyne

Kim Leggett

Eli Leon

Melissa Leventon

Christina Linden & Allison Smith

Marilyn Mamone

Connie & Haig Mardikian

Lynn Evans Miller

Jasmine Moorhead

Abner Nolan

Christopher Nickel

Laura O'Hare

Amelia Peck

Liz & Joel Peirano

Ginger Shulick Porcella & Don Porcella

Yvonne Porcella

Roscoe P. Pug

Quilts-Vintage & Antique Group on Facebook

Eric Rayman

Linda Reuther

Larry Rinder

Sharon Risedorph

Alexander Roe

Stella Rubin

Bob Schloss

Denyse Schmidt

Joan Schulze

Julie Silber/The Quilt Complex

Ryan Chard Smith

Smith Koy Smith

Janneken Smucker

Jill Storey

Amber Straus & Angie Wilson

Margaret Tedesco

Judith Thorn

Deborah Turner Ursell

Karen Van Dine

Nathan Vincent

Bill Volckening

Jennifer Welwood

Marge Wetmore & Hawke

Stephen Wirtz

Steven Wolf

Victoria Findlay Wolfe

Lena Wolff

Published in 2014 by Stewart, Tabori & Chang

An imprint of ABRAMS

Text and photographs copyright © 2014 Roderick Kiracofe

Library of Congress Control Number: 2014930927
ISBN: 978-1-61769-123-2

Photographs by Sharon Risedorph unless otherwise noted.
Photographs on covers and pages 9, 16, 22, 46, 48, 49, 67, 71, 92, 108, 115, 127, 141, 152, 181, 182, 213, 218, 222 by Josef Jacques

Editor: Melanie Falick
Designer: Sarah Gifford
Production Manager: Tina Cameron

The text of this book was composed in Chronicle Display, Sentinel, and Neutra.

Printed and bound in China

10 9 8 7 6 5 4 3 2 1

Stewart, Tabori & Chang books are available at special discounts when purchased in quantity for premiums and promotions as well as fundraising or educational use. Special editions can also be created to specification. For details, contact specialsales@abramsbooks.com or the address below.

THE ART OF BOOKS SINCE 1949
115 West 18th Street
New York, NY 10011
www.abramsbooks.com